W9-DHM-733

THE WORLD OF ATGET

THE
WORLD
OF
ATGET

BY

BERENICE
ABBOTT

HORIZON PRESS
NEW YORK

CONTENTS

THE WORLD OF ATGET

EUGENE ATGET was born on February 12, 1857 in Libourne, near Bordeaux. During his lifetime, photography developed from the single-copy daguerreotype to the multiple-original photograph. Wide popular interest in the new medium stimulated its rapid development. But its esthetic attributes grew more slowly, imposing new disciplines and insights on the man behind the camera.

The trend developed from various images of the daguerreotype to the portraits of Nadar, through the vision of Mathew B. Brady, to later men like Jackson and Lewis Hine in the United States, and finally to Atget in France, who gave photography its full potential as an art in its own right.

The first time I saw photographs by Eugène Atget was in 1925 in the studio of Man Ray in Paris. Their impact was immediate and tremendous. There was a sudden flash of recognition—the shock of realism unadorned. The subjects were not sensational, but nevertheless shocking in their very familiarity. The real world, seen with wonderment and surprise, was mirrored in each print. Whatever means Atget used to project the image did not intrude between subject and observer.

My excitement at seeing these few photographs would not let me rest. Who was this man? I learned that Atget lived up the street from where I worked—at 17 *bis* rue Campagne Première, and that his prints were for sale. Perhaps I could own some. I wanted to see more, and lost no time in seeking him out.

I mounted the four flights of stairs to his fifth floor apartment. On the door was a modest handmade sign, "Documents pour Artistes". He ushered me into a room approximately fifteen feet long, the ordinary room of a small apartment, sparsely and simply furnished.

Atget, slightly stooped, impressed me as being tired, sad, remote, appealing. He was not talkative. He did not try to "sell" anything. He showed me some albums which he had made himself, and I selected as many prints as I could afford to pay for from my meager wages as a photographer's assistant. Fortunately the prints were not expensive. I asked him to put others aside for

me until I could come to pay for them. When I returned he talked more, and took me into his darkroom where a single glass plate was developing in a tray. The developing time was fairly long; he was in no hurry to remove the plate but just let it go on developing after we looked at it under a red safe-light.

And so I returned many times, and we became more friendly. I asked him many questions in reply to which he talked of some of his difficulties, and my impression was that there had been many. His was not the day of the ubiquitous photographer. People were suspicious of him and may even have thought him a spy. He must have appeared a mysterious and suspicious figure with his big camera swathed in a voluminous dark cloth. Mysterious and ominous too were some of the obscure, odd places he chose to photograph.

In reply to my question Atget answered that he never took pictures on assignment because "people did not know what to photograph." How true this statement is few can realize, but I am sure many serious photographers today groan with the weight of its truth. Did the French people appreciate his work? "No, only young foreigners."

He wore old and patched clothes, and was a decidedly photogenic figure. I felt sure he needed money, so I showed the photographs in my possession to nearly everybody I knew, and urged them to go to his studio in the hope that they would buy prints from him. I was amazed, even disdainful, if one and all did not respond enthusiastically.

By that time I had become a portrait photographer on my own, and I persuaded Atget to come to my studio at 44 rue du Bac to sit for his portrait. To my surprise he arrived in a handsome overcoat. I had always seen him in his patched work clothes. It would have been desirable to photograph him in these too, since they were exquisitely photogenic, but time is a fickle unpredictable master and did not permit another sitting.

Later, when I took his portraits to his home to show them to him I missed the little sign "Documents pour Artistes" on his door, went up a flight, then descended to the concierge, and inquired for Monsieur Atget. The concierge told me he had died. I was deeply shocked. Youth is little equipped to accept

or even to anticipate the fact of death. And I had just finished his portraits.

But what had happened to his photographs, I asked. She replied that a Monsieur André Calmette had his belongings. She knew the street where he lived but not the number.

ATGET'S photographs, the few I knew, somehow spelled photography to me. The deep response they evoked in me drove me to track them down with an instinctive fear that they might be lost or even destroyed. Had I realized at that time the general disregard and carelessness that exist—even today—with most photographs, my alarm would have been tenfold. ›

While it never occurred to me then to acquire Atget's collection, my concern for the fate of the work obliged me to try to find André Calmette by going into every house on his street, rue St. Guillaume, as he was not listed in the telephone book. A friend helped by going into the houses on one side while I explored the opposite side. When I finally located the house, I found that Calmette was now living in Strasbourg, where he was director of the Municipal Theater.

In the autumn of 1928, after months of correspondence, and finally, of conferences, I bought from André Calmette, Atget's oldest and closest friend, the entire collection of Atget's prints, and all the plates which had not been bought by Les Monuments Historiques. Calmette had played with Sarah Bernhardt, and was quite the sympathetic and dashing older actor. Someone else had seen Calmette about buying the collection but he preferred me to have it because, he said, he "believed that I loved Atget more." To preserve the plates, my young Dutch assistant Lood von Bennekom and I cleaned each one, placed it in a glassine envelope, then numbered and classified them all. I had not realized the extent of Atget's work, for this operation took months.

I asked Calmette to write a statement for me of everything he knew or could remember about his friend. Nearly all I know of Atget's life comes from these written memories. I quote his letter as a unique document in the history of Atget, the man and the photographer. No friend could be more eloquent:

Mademoiselle, you are quite right in venerating the memory of my old friend Atget, and as some of his photographic documents belong to you, I entirely approve of your desire to publish them, knowing that in this way his name will receive the honor that it merits. You know only his work and you ask me for information about his life, and I can tell you about it because he was my friend from the time of his youth until the day of his death (4 of August, 1927). Atget was from Bordeaux, he lost his parents at an early age and was brought up by an uncle; as he was born in a seaport they wanted to make a sailor of him and he embarked as a cabin boy. He has often told me of his voyages.

But it was only later that I was to meet Atget, in Paris, when he was no longer a sailor but an actor. After having appeared in the provincial theaters, Atget played dramatic roles in the suburbs of Paris; as he had rather hard features, he was given unflattering roles—called "third roles". Such was his profession for a certain number of years, and it was during that time that he met the woman who was to become his "amie", who lived with him until her death a year before his own. Soon the theater offered them fewer and fewer resources so that Atget and his companion established themselves in Paris, where his small savings were soon gone and he was obliged to look for another occupation. What to do?

We had, both of us, a great interest in painting and we knew many painters. Was Atget going to become one of them? No, after several attempts he decided to become a photographer, a photographer of Art. For some time he had had the ambition to create a collection of all that which both in Paris and its surroundings was artistic and picturesque. An immense subject. Atget procured for himself a camera and, loaded down with plates, he took off.

He came back harassed and courageously made the prints. But the difficulty was to sell them. One day, one "beau jour" Luc-Olivier Merson bought some for fifteen francs. Atget, thus encouraged, was saved; every morning, getting up at dawn, he went everywhere, entered everywhere. Victorien Sardou told him which houses, which sites and chateaux, which spots

were doomed to disappear. Paris and her old churches, her monuments, her miseries and her treasures were photographed by Atget. Possessed by a sure taste and an artistic audacity that was extraordinary, Atget came to be known by painters, sculptors, architects and editors. He sold his documents; proud and happy, he made a living from his work for himself and his companion. The difficulties had appeared insurmountable but Atget triumphed over them. Previously refused everywhere, he was now welcomed by everyone and exercised magnificently the profession he had chosen.

But the War broke out. The second war that Atget had seen, and he had horror of it. He loved his work very much but he no longer sold anything. Years accumulated on his head and when peace finally came Atget had grown old. He produced less and less. He lived on his reserves. However "Les Monuments Historiques" had bought from Atget all the negatives bearing on the history of Paris—the Paris which under the guns of the enemy had all but disappeared.

I often went to see Atget in his curious little apartment-studio in le rue Campagne Première. We four would talk together, his wife and mine, Atget and I; but one terrible day Madame Atget, much older than he, died. She was 84 years old. Atget, desperate, was alone and always more and more bent, more and more sad and tired; but always courageous, he continued to work. One morning, a messenger brought me a scrap of paper on which were traced six tragic words written by a desperate hand ". . . I am in agony come quickly!" . . . We went at once . . . too late. Atget could not be saved. For twenty years he had lived on milk, bread and bits of sugar. Nobody, nothing, could convince him that these were not the only useful nourishment; all other food was dangerous poison to him. In art and in hygiene he was absolute. He had very personal ideas on everything which he imposed with extraordinary violence. He applied this intransigence of taste, of vision, of methods, to the art of photography and miracles resulted.

The way that his genius led him to look at, or rather see, an object, applied to his photography and produced unique results, and thanks to "Les

Monuments Historiques" and thanks to you, Mademoiselle, it is to be hoped that his work will not be lost.

We had begun to believe that he was about to triumph over his grief, but Atget died a year after his companion died. Paris will no longer see that strange silhouette, the face with its expression of energy, this Balzacian personage, always enveloped in the immense worn overcoat, an old round hat on his head, hands eaten by the acids necessary for his profession.

He was one of the most curious men I have ever met. May all the amateurs of what he had so much loved—I mean Paris, and all its treasures—in admiring what still exists, or in looking at the beautiful images that Atget made, pronounce his name, which is that of an artist, strong and courageous, an admirable image maker.

/s/ André Calmette
Artiste dramatique
Directeur du Theatre Municipal
de Strasbourg

HIS work can tell us directly even more than André Calmette tells us of Atget's life. The photographer cannot miss that picture of himself. It is his stamp and map, his footprint and his cry.

At the time that Atget took up photography he had arrived at a crisis in his life. He had been an actor from approximately 1885 on. He played the third roles, mostly in the provinces and in suburban theaters—limited dramatic parts offered him less and less frequently with advancing years. In a sense he was pushed out of the theater and forced to take up a new profession. His age was now very near forty-two.

This was one of the nodal points in life when some might resign themselves to oblivion, but if the fire is bright enough, and health adequate, one is reborn, possessed by a more dedicated, less diffuse objective, all the richer with mature experience.

He had assets. His health was good. And the life of the sea and of the theater had formed a rich background. Conditioned by this fruitful life, he was now ready to build a career purely his own and worthy of his greatest potential. It was to be a medium newly adapted to the expression of his time. Fortunately he had a little money.

A writer may be far ahead of his time, as in the case of Vico or Lucretius, and yet, though miserably checked by poverty, as Vico was, he can manage to find the means for the writer's tools, the paper and pen he needs for the expression of his thoughts. It is not so with photography—born of a scientific era. Cameras, lenses, all kinds of equipment, are costly, as are plates, chemicals and paper. Atget had saved some money from his acting days and so was able to buy the bare equipment to launch him on this new undertaking.

The mistress he had met in a theatrical troupe in the provinces was devoted. Ten or eleven years his senior, she was the granddaughter of a former actress of the Comédie Française. They lived together for half their lives, to the very end, her death preceding his by a year.

Not the least asset for Eugène Atget was the character of Paris as a city. It was an intellectual center where art flourished and was respected. The soil existed, therefore, for growth, even of a pioneering venture, and hope sustained him. No doubt this hope was justified; it is not hard to imagine his profound joy when the celebrated historical mural painter, Luc-Olivier Merson (1846-1920), the designer of the French one hundred franc note, bought a print from Atget, as André Calmette has told us.

Paris was the world's focal point for painting and Atget, who had friends among artists as most theatrical people do, had toyed with the idea of becoming a painter. He made a few paintings, principally of trees; if judged by the number and infinite variety he was to photograph later, he obviously had a passion for them.

I recall a talk with a friend of Frank Lloyd Wright who told me of a walk some years ago through the hills of Taliesin, the architect's home. The two

men were engaged in animated conversation when Mr. Wright stopped in the middle of a sentence and stared intently into space. His friend followed his gaze and found that he was looking at the branches of a tree. The leaves were stirring in a soft breeze and all the tree seemed to flutter in the morning air. The architect stood silent for a long time and finally said: "If our educational system knew how to teach the sense of a tree to our youth, they'd never have any need of television or any other entertainment."

A worship of trees goes far back in man's history. Often Atget's trees represented all the trees of time. He seemed to impart to them a life of their own, and a reality that I have not seen equalled. Fortunately Paris is famous for its magnificent parks and regal settings, whose trees are well cared for.

I make a guess that the tree was a symbol to him of himself, as it was for Hölderlin: "I stand in the peaceful morning like a loving elm tree, while life sweetly plays and twines around me like vines and clusters of grapes . . .". The trees he photographed also survived the blows of time and fate. They, too, were sturdy of physique and could withstand the pounding of the elements and the struggle of existence.

Painting was not Atget's forte, and he had enough wisdom to realize it without loss of time. For reasons unknown to us he turned to photography. It is possible that at least one factor in this decision was his sympathetic friendship with Victorien Sardou (1831-1908), a popular French dramatist, whom Atget had met in the theatre and who, like Atget, was a passionate lover of Paris.

For Atget, the transition from acting to photographing evolved naturally. He had not fragmented his life by being an actor who saved money in order to photograph. (The ubiquitous amateur with the little camera hung from the neck did not exist then.) He had first lived the life of a full-time seaman, then of an actor. Now he was to be a full-time photographer, and he knew what he wanted to photograph. It was not the making of pretty pictures that interested him. He had a subject, and that subject was immense. It was the City of Paris!

BEGINNING a new profession at forty or more is fraught with uncertainty, if not with danger. Absorbed and challenged as he was by this new leviathan, Atget still knew he had to make a living for himself and his companion. As he weighed the economic situation, precarious to say the least, he hit upon an idea which, though it would not make him rich, might nevertheless make a modest living for them, and earn the means to buy necessary materials. This idea sprang from the conditions peculiar to his time, the early twentieth century, and the place, Paris, which had more artists collected within its borders than any other city on earth. Among these he would find sufficient customers to use his photographs as documents in the numerous ways in which artists use such details. Fortunately for Atget, it was not a time when many painters were non-objective or disdainful of recognizable subjects.

In looking at his mountain of pictures, from which future historians and art lovers will reap such rich rewards, one has the impression that Atget struggled and fumbled for a while with the physical and technical problems of the new medium, as well as with the complex task of learning to see photographically. At the very beginning he made more or less uninspired prosaic records of chateaux and historical buildings, most of which appear to be on the outskirts of the city. Here he could take his time and not be annoyed by the curious. As a novice he may even have been reluctant to put up his big camera in the Place de l'Opéra or in the middle of Montparnasse, but on the outskirts of the city he could feel his way. There must be a difference between facing the public on the stage, and defying a public curiosity stimulated by ostrich-like drapery and huge apparatus.

But this self-apprenticeship was brief. He sloughed off the record-making stage and discovered a bright new shiny medium. He was very excited about this discovery; the visual world fanned his imagination and demanded overwhelming energy. André Calmette recalled that Atget was happy. He was embarking hopefully on a whole new passionate adventure. It was extremely lucky for him, and for us, that traffic as it was in the first quarter of this century did not ruin his lungs or prevent him from placing his camera virtually wherever he chose.

I BELIEVE the photographer's eye develops to a more intense awareness than other people's, as a dancer develops his muscles and limbs, and a musician his ear. I cannot agree with M. Jean Leroy who said in *Camera Magazine* that Atget was merely a disappointed painter or actor, and a little ashamed of his medium. While both photographer and painter produce visual images on two-dimensional surfaces, they differ fundamentally in their ways of seeing. In most cases it is the *act* of painting that absorbs the painter. But this act is highly subjective. His focus is on the canvas itself; his fancy is purely his own.

The photographer's act is to see the outside world precisely, with intelligence as well as sensuous insight. This act of seeing sharpens the eye to an unprecedented acuteness. He often sees swiftly an entire scene that most people would pass unnoticed. His vision is objective, primarily. His focus is on the world, the scene, the subject, the detail. As he scans his subject he sees as the lens sees, which differs from human vision. Simultaneously he sees the end result, which is to say he sees photographically.

In Atget's time, photography was so young and so new a medium, that the custom of adopting it solely and formally as a profession was not yet established. There were almost no schools for photography; it was not considered an art. At best, it was a commercial trade or a hobby for the wealthy.

Today this has changed. There are schools of all shades of excellence, and young people set out on careers of photography. This is quite natural, since the language of the lens is attuned to the accelerated pace and tension of our time. Photography as an art is the offspring of the scientific age.

There have been repeated references to Atget's "naïveté", conjectures that he did not really know what he was doing, that reflections in his shop front windows were accidents which he did not even see. It is of course impossible for this to be true. Most photographers today use small cameras and consider this to be "modern." They see their subjects through a very inadequate view finder, reduced to a "fine print" size, incapable of giving full detail, especially detail in shadow. Or they may use the small ground glass where the eye is rarely shielded sufficiently from light to see completely. A scene reduced to a dim image on a ground glass even 4 x 5 inches in size does

not bring to the eye all that is in the scene. Such photographers are often surprised when they see details in the print that they never noticed at the scene.

I invite those who think that Atget's reflections in his shop fronts were "accident" to look more than once at a fair-sized ground glass. Seeing reflections in windows is as natural for photographers as seeing shadows and the wonders of light. Reflections are mysterious and suggestive. They are a very legitimate montage effect in reality itself. Is there anything more mysterious than reality? The photographer particularly is endowed by nature and necessity to probe and search these mysteries. A man who knew so unfailingly where to place his camera knew very well what he was doing.

With a hand camera there is often accident. Background figures may not be related and can appear unexpectedly. Speed negates precise framing and spatial relationships. Any number of unforeseen things can happen. Some photographers even use the accident as a crutch. The experts are few and they know the type of subject matter to be handled by such a camera.

When a camera is firmly attached to a tripod, and the large ground glass is carefully scanned for overall focus under a huge dark cloth, draped to shield the eyes from light, it becomes possible to see all parts of the image. Not only does focusing become an act of decision (Atget had to make many peculiar ones) depending on action, depth of field, light intensity, to mention only a few factors involved, but it can also become a subtle and conscious creative act. Before that, the photographer has another important decision to make: that one best spot to place his camera. What must the perspective be? That question alone requires a number of decisions, with final careful adjustments. Every step in the process of making a photograph is preceded by a conscious decision which depends on the man in back of the camera and the qualities that go to make up that man, his taste, to say nothing of his philosophy.

Atget began to understand the effects of light and shade, of texture and mood, of perspective and depth—qualities inherent in the art of photography.

GOETHE had said, "There is no variety of Art that should be looked upon lightly. Each has delights which great talent can bring to fulfillment". If Atget had not had this talent he would have been just another record producer of the travel guides variety—tourist fare. Everything he had ever done seems to have prepared him for his new undertaking. His travels as a seaman may not have been the least important.

As an orphan, raised in a seaport by an uncle who was Chef de Gare, Department de Gironde, it was natural for the boy to take to the sea. He sailed in commercial vessels on long voyages, and he was to relate many exciting adventures to his friend later on. That experience won him independence of spirit and means. He saw the world on his own, outside of France, and gained valuable perspective; and finally he experienced nostalgic feelings for his own country. It appears that such was his life well into his twenties. It is most likely that he then tired of the seaman's life and found his way to Paris.

Why or how he became an actor I do not know. Calmette wrote to me in answer to further questions that Atget became an actor in 1887, or, at most, a few years before that. His life in the theater may have lasted about fifteen years; but in any case his theatrical itinerary broadened his knowledge of Paris and its environs, and so must have stimulated his historical curiosity as well as his esthetic appreciation.

Inter-relation of actor with audience developed a psychology for human exchange and sympathy, evident in his pictures of people, who appear to have coöperated with the photographer. He did not treat these pictures as still-lifes. Human dignity is expressed in each and all of them. This could only result from his sure and sympathetic approach and handling of even the most recalcitrant subjects.

To Atget the visible world became the stage; man himself and the effects of man, the great drama. Men and women in the Paris streets became the cast of characters. He knew how to dramatize his subjects, but his photographs

were never merely theatrical. The stage was now transformed to the larger scene in front of his lens, and the photographs repeatedly suggest the stage setting which one beholds after the curtain goes up.

This new calling became an act of discovery. He pursued it with the passion essential for any great artist through whatever medium he may function. What else could have driven Atget to the exhausting task of physical drudgery, with an unbelievably heavy load of glass plates, large view camera, tripod, holders, and the like? Twelve plates alone weigh four pounds. And a camera the size of his, with accessories, can weigh from forty to fifty pounds. This load he carried over and around and up and down Paris, to his last year.

On top of this, consider the years of painstaking drudgery in the darkroom, where patience and accuracy are of absolute necessity. Furthermore, identification was written on each print, which was then stamped and placed in an album, itself annotated and numbered.

To sell his pictures for the money to buy plates and other materials he made innumerable trips across the city to prospective clients. In his notebook, on the face of which is printed "Repertoire", he listed many names of buyers and the particular interests of some of them. This is a partial list of professions to which he catered: designers, illustrators, amateurs of Old Paris, theatrical decorators, cinema (Pathé Frères and many others), architects, tapestry makers, couturiers, theater directors, sign painters, editors, sculptors and painters, among them Bourgain, Vallet, Dunoyer de Segonzac, Vlaminck, Utrillo, Braque, Kisling, Foujita, and many more. He noted the hour at which they could be seen, at which floor and which door, and at which Metro exit. Some trips were made to get permission to photograph certain places.

There are also entries of the prices he received, indicative of the value placed on photographs by his French clientele. Masterpieces of photography sold for pennies. The prices range from 0.25 francs to 1.25 francs by 1911. Occasionally there were thirteen for 12 francs, but the prices went up later, from 1.50 to 5 francs.

THOSE people who have contended that Atget did not know what he was doing, that he was a "primitive", must be the "erudites" and pundits to whom Vico ascribed "all sorts of errors issued to their conceit and credulity". If by "primitive" is meant the innocence of an unhampered vision, uncluttered by conventional trappings, I would agree. But if "primitive" means the naïve simpleton, unaware of the value of his work, then such a notion is ridiculous. Can a man produce so great a volume of work that is consistent throughout and not know what he is doing?

Time rapidly changes the appearance of things with new cars, new clothes, new sites, new methods. Most good photographs will look "primitive" after a few years because they reveal a vanished time, and the visible past is frequently laughed at. But many things in life, perhaps most, are primitive. Life in Paris, the art center and the most cultured city in the world, with its rich past, changes too—and with increasing speed. It too is primitive in some of its aspects when mirrored in realistic visual images—pictures which bring many people up short, and even seem to scare them. Does this impact come, perhaps, from the image of themselves they see?

The delayed recognition of Atget's genius stems in part from the delay in understanding the nature of photography itself. The new realistic image was most baffling for "art" connoisseurs. It was "mechanical." "Anybody could do it." All that was needed was a good "machine." Or maybe too many people liked it. Were not Atget's photographs "almost good enough to be paintings" to people who could not yet grasp the significance of a new type of expression, or had not the "imagination for reality" which Goethe mentions as the superlative one.

In this confusion Atget was a "sport," a mutant of his time, who emerged full-grown after a brief period of self-training. When he was making his monumental documentation of Paris, much of the art world either completely ignored photography or regarded it as beneath contempt.

The usual comment "How beautiful for a photograph" has a deprecatory

overtone. Yet artists did not hesitate to use parts of his "documents" for their paintings. They were even inspired by them. The truth is that while painters could portray idyllic views of life, omit or add details, the lens was limited to unadulterated realism, to the warts and wrinkles of the immediate scene.

Atget accepted this unique feature and never tried to evade it; for to him it was all the more a training to the eye and a challenge to the artist. Realism came into its own. Was not reality more fantastic by far than fiction? Perhaps the surrealists responded to this particular insight. Is it not easier to accept fiction than reality? Was not this medium with its swift visual insight the challenge par excellence for the artist of the twentieth century with its stepped-up tempo and new demands on awareness? Atget knew how to work within the limitation of a medium that was only beginning, and to make the most of it.

He was probably surprised when only a few souls responded to his photographs. While he had the courage to be himself, to embark, as it were, on an uncharted course, most people were simply not used to seeing, or prepared to accept, such sharp images as art.

Although photography became popular quite rapidly, mostly with portraits and for its commercial uses, people had to get used to looking at photographs in general, and in particular at the seemingly odd subjects Atget took. In any case, I don't believe photography caught on in France as enthusiastically as it did in the United States. It is difficult enough to recognize the merit of work by contemporary artists in the established mediums. How many people appreciated Van Gogh or Cézanne while they were producing? How much more difficult it is to recognize the genius in a bastard art that itself has no recognition.

The photographs heralded as art in France in the early part of the century were the worst arty pictorials that existed anywhere. Photographers not only tried to make their photographs look like paintings or charcoal drawings; but they chose as their subjects pastoral and genre scenes, inane pictures of the

female, the "pretty." Pictorialism is still the sad leech of the photographic medium that clings to the fringes of painting to this day.

The lack of understanding of his work drew Atget more into himself; he did not try to make a case for it; he did his work and was silent. That he did not try to sell himself as a "great artist" may be another reason for the curious notion that he did not know what he was doing.

ACCLAIM is, after all, not the essential reward. The act of creating has its own reward, and it is primary. When one embarks on an uncertain venture, silence is often an ally. Anonymity becomes an asset, if not a necessity.

Pierre MacOrlan, the noted French writer, had met Atget once during the twenties and noted that he was not talkative. By then he was about seventy and must have long before given up any concern about recognition, so that anonymity had become his shield and his protection. Youth has more time, to say nothing of energy, to create its own legend. Atget was too busy, too preoccupied, too tired, to promote his reputation. It is interesting that Marcel Proust, a contemporary, had noted, "True art has no use for so many proclamations and is produced in silence."

Photography requires an inordinate amount of hard physical work, even drudgery. Preoccupation with this monumental volume of work crowded out vanity or any conscious search for approval by this group or that, this style or that. It excluded opportunism. Fortunately for Atget there was in his vicinity no oracle nor cult, that bête noire which suffocates so many photographers in the United States. Where the cult exists there is more talking than action. There is preciousness in the concern with the means rather than the end. (How sad it is to become precious about a medium that is too hampered in its technical progress even to be ready for preciousness. Did you ever take apart a shutter— only one small part of the mechanism of a camera—and see how extraordinarily complex it is?) There is an inordinate concern about photography being Art, and the cult members, always in closed groups, consider themselves very

special people. Atget was spared such essentially frivolous distractions.

On the other hand, Atget's enforced anonymity had its disadvantages too. Paris attracted painters like a magnet (some say 20,000 in all). In this creative climate the painters could aid and stimulate each other. They benefited from social acceptance and the appreciation of their time as well as from exchange of thought, experience and camaraderie. Not so for photographers. There was no solid recognition of their role or importance, no stimulating interchange of thought, no critical judgment to sustain and sharpen the imagination.

Atget was alone. Whether he ever knew other photographers I have no way of knowing. He must have known the work of Nadar, which, without question, would have commanded his respect. But Nadar, having retired from his studio in 1880, died in the year 1910 and it is doubtful that he and Atget ever met. I do not know whether he knew the work of Brady or Jackson in the United States, men who, in my opinion, can be called great photographers. In any case, he seems to have worked toward such a clear-cut personal objective that there appear to have been no immediate influences.

In a worldly sense, his was a thankless and unrewarding task at best. Yet creative satisfaction must have sustained him, and since he did not live in a vacuum he probably had some appreciation from a few trusted and tried friends, including, no doubt, Madame Atget herself.

The wealth of material in the most beautiful city in the world piled up on his shoulders and left him little time for social life. His Gallic eye scanned the city with objective appraisal, leavened with humor and sensitive awareness. The subjects that excited him were infinite in variety. All were photographic in nature and even the most picturesque subject never became merely pictorial, remotely "arty," or like a painting. With Atget photography stood on its own feet. His self-confidence was implicit and developed from strength.

On rag-pickers' hovels and on the heights of Parisian elegance, at Versailles and St. Cloud, he directed his lens; on vehicles of all sorts, shop fronts, interiors, tradespeople, the streets and parks of Paris, the parks of St. Cloud,

Bois de Boulogne, Luxembourg, Fontainebleau, Versailles; doorways, stairways, courtyards, balconies, fountains, old signs, the environs of Paris, trees, flowers, farms, the quais, the Seine and its bridges, historical buildings, the decorative arts as seen in door knockers; on churches, chateaux and mansions.

When a series of photographs best expressed his subject he would proceed along an entire street or up an entire stairway, with a moving-picture-like sequence. Trees he continued to love and photograph, whole and in part, in groups, close up and at a distance.

WHEN the subject has significance it challenges the photographer to the utmost. All his faculties are exerted, because to express that subject means to understand it and feel it in his bones. But then he must be able to construct the ground glass image in such a manner as to convey to the viewer the meaning of his photographic statement. He must convince the beholder that here lies truth—without veils or obscurity, confusion or bias. The recognition of significant truth is forever startling. Expressing a subject means to simplify it; there is no room for flourishes or frills. Atget was never guilty of that conspicuous composition made to overwhelm the eye.

For Atget, the subject was the important thing. The structure, the composition, was dictated by the subject. His compositions, so consistently flawless, were merely a means to clarify and express that subject as simply as possible. The subject creates its own design and the "style" of the photographer, more dominated by his subject than other visual expressionists, is principally faithfulness to it.

The language of art frequently wears a veil, obscure in meaning and expression. It rivals the words of law and the legal contract. The language of photography is different. It is direct and clear. Thus discerning selectivity becomes the keynote.

Many people travel around a city but each will "see" entirely different subjects. Thus selectivity results from personality and becomes a very personal and individual stamp. Atget knew very well what to select and how to give it

significance. Everything that fired his imagination on those tireless trips across the city became a subject for his lens. Increasing visual perception tempered this selectivity to a hard core consistency. What it has given us is a very fine portrait of the city of Paris, a vivid comprehension of French civilization and culture and of the past to which they are related.

To photograph Paris, Atget was inescapably drawn into ever increasing awareness of its vast history. There are innumerable evidences of his interest in history in his choice of buildings, streets, churches, details, ruins, palaces, bridges and works of art; and enough photographs of these to supply volumes of historical material. In his notebooks are names of "amateurs of Old Paris" with whom he must have exchanged ideas. His projected book about Old Paris and its captions further testify to historical awareness.

The history he brought to life for us is not confined to parliaments and congresses. It recites the everyday activities of those men and women who are the stuff of which history is made. Like those incredible noseless and armless Roman sculptures, carefully treasured to give us that awesome awareness of the past, the worn stones and bricks of the city's material fabric give us the sense of history which is evident as well in the furniture, clothes, lights, bridges, machines and other elements of the age.

Atget's lens would not always capture the historical subjects that interested him, so he photographed paintings of earlier views and personalities and drawings of costumes. Rouen as an ancient city with considerable historical interest demanded his time, and he copied old drawings of it to show how it had looked in an earlier era.

The photographer's punctilio is his recognition of the *now*—to see it so clearly that he looks through it to the past and senses the future. This is a big order and demands wisdom as well as understanding of one's time. Thus the photographer is the contemporary being par excellence; through his eyes the now becomes past.

For this kind of comprehension Atget's maturity was undoubtedly another

of his assets. The approach of a photographer to his subject is the result of his qualities and experience as a man. If he is sound and healthy he uses his mind, his imagination and his emotion. If he approaches his work with intellect alone, the result can be cold and curiously inhuman. If his approach is with heart alone, the result may be tiresome and sentimental. It is a combination of these forces that adds up to understanding and maturity for a photographer so that he may recreate his subject and bring it to new life.

The emptiness of technique per se would seem self-evident when one regards the effusions of many photographs dripping with "print quality" above all. It is as true of photography as of the other arts that technique alone is static. If the photographer is too burdened with concern about technique, he can easily get lost in the dizzy and frenzied chase after every last gadget and fancied miracle. When he is challenged by a subject worthy of his mettle, the technique required to realize his intention is usually found.

The only valid reason why technique is of such interest in photography is because it is so young a medium. This is why there are today so many how-to-do-it books on the subject. Contrary to popular opinion, the techniques of photography are still primitive and have a very long way to go. Greater basic improvements are overdue and will unquestionably come about.

ANY fair judgment of a photographer's work must be made strictly within the framework of his time. And yet I think no apology is necessary for Atget. The technical means he used were perfect for him. He found the method best suited for his purpose and stayed with it. Once it was found, he concentrated on the more important problem of seeing and selecting.

He knew that one of the intrinsic properties of photographic excellence is clear-cut sharp detail. This meant a large negative and a contact print, regardless of whether they were considered old-fashioned or not. I feel certain he would have used the same equipment today, as many photographers do, with the possible exception of film instead of glass plates. (Most of the glass plates he used were made by Lumière and marked "extra rapide".) Plates are

virtually impossible to find today, but they are superior; they lie flat in their holders, are a better support for the emulsion, and give finer resolution and grain. But they are also much heavier and can break.

The French never placed the importance on technical matters that has obsessed Americans. Photography defies perfection as much as it does preciousness. And I believe one proof that technique is not so all-important as the American school of photography would have us believe is that even with a broken plate, with darkened corners, with occasional mis-fires or blurs due to camera motion or unavoidable movement of a person (apparent "carelessness" which can happen to any photographer), not a particle is taken away from that wonderment of seeing "wie am ersten Tag" which characterizes Atget's work.

The dark corners in many of his prints are due to the long barrel of the rectilinear lens he used. When it was necessary to raise the front of his camera to include more height, the upper corners of the print would be cut off and appear dark in the prints. He used a "trousse" of rectilinear lenses which was made up of components of various focal lengths used in the same long brass barrel. This would correspond to our convertible lens today. Thus the dark corners would be unavoidable.

For prints he used, without manipulation, the simple printing frames that can be seen in the photograph of his own interior. He could make simultaneously as many prints as he had frames for since the paper was the slow "printing out" type. His prints were superb. I believe gold chloride paper was the type used; it had, in my opinion, a tonal range and quality superior to those obtainable today. There are now very few quality papers on the market, when one can find them at all. It is for the photo-finisher and other mass-producers that faster and cheaper papers called "improved" are manufactured today, at least in the United States.

Atget had no car to transport him. There were no flash bulbs, no exposure meters in his day. Nevertheless there is remarkable consistency in his negatives

and they seem well suited to match the tonal range of the paper he used. Today our papers lack that range, so that Atget's negatives are difficult to print because of their contrast.

He did not use filters, nor was the rectilinear lens color-corrected. It is possible there were no panchromatic plates at that time. But he did not aim at cloud effects; and the fact that his skies are bare all the more pulls the eye to the scene. Curiously enough, clouds can sometimes interfere and detract, particularly when they are over-emphasized, as one sees so often today.

Once only is one aware, because the sky over Versailles was a stormy one, that he tried to dodge in clouds; and in that particular case they would have been a wonderful addition. But his dodging was disastrous and hit down over the buildings themselves. The hours-long exposure required for printing out paper would doom local "dodging" in the print. In a number of prints, he nevertheless achieved the effect of darker skies, without the use of filters, by photographing in wet weather.

As there was never any preciousness in his entire approach, neither was there any in his finishing methods. It is quite possible that there was no time for it. Prints were not trimmed; I doubt if he owned a trimmer. But on a few occasions he used scissors to remove the edges. He had composed his photographs to the very edges of the plates so that the clamps which held the plates in the plate holders intrude upon the picture.

Dry mounting appears to have been unknown in France then, but even if it had been known a dry mounting press would not have been found in Atget's studio; it was too costly and would have required too much meticulous time-consuming care, all of which was reserved for his trips far afield. The prints were placed instead in hand-made albums, according to subject, in four-cornered slits—a method which also provided him with a simple filing system. The documentation consisted of writing briefly on the back of the print the address, number, and sometimes the hour or month or special condition, such as Mai 7, 7 a.m., fog. Specific years were rarely noted and were limited mostly

to the albums. The captions for the plates in this collection are in the main translations from these notes made by Atget on the reverse side of his original prints.

The most damaging thing that Atget did was to varnish the plates and scratch numbers directly into the emulsion at the lower right-hand corner. This was for sure identification, but has caused damage in some instances.

Looking ahead, Atget thought of himself as "Auteur Editeur" and anticipated having his work published. Toward this end he designed a large formal book, *L'Art dans le Vieux Paris,* professionally bound with printed title-page and captions which were separately printed, cut out by hand and pasted under the photographs. This time photographs and captions were mounted on pages made of thin but quite stiff cardboard. It is assumed that the binder or printer did the mounting, which does not appear to be dry mounting as we know it in this country. The more conventional pictures were used for this dummy to entice, I imagine, a publisher's interest. It is indeed a pity that many such books of his were not published, to give to the world that needed picture of a city that rightfully belonged to it. If the surrealists claimed Atget, more power to them—but so will others of different schools and beliefs. All sides claimed Balzac. They both belong to the world.

According to Calmette, Atget worked with diabolical dedication. Calmette spoke also of the "intransigence of taste and of processes" of his friend, emphasizing that he had decidedly personal ideas on everything, including his own technique, which he imposed with vehemence. He was very independent, "headstrong", and had little patience with people's ideas and conventions; but with his own work he had all the patience in the world. Patience is indeed the indispensable ingredient in the photographer's make-up. But it is the kind of patience that a cat has: it can seemingly wait forever, but then it can also pounce with lightning speed at the crucial moment when the shutter is clicked. The actor's cue to come on stage, to follow up his lines, must have a similarity with that cumulative moment when the photographer clicks the shutter.

M USIC, painting, sculpture, architecture, poetry and writing have been part of civilization's fabric for millennia. But photography is young. Atget was born a mere 31 years after Niepce produced the first photographic image in 1826. About seventy years later Atget was busy turning out his masterpieces.

This "primitive" was surely well in advance of his time. In an age when "sophisticates" thought of photography as a sport, a game, or a curiosity, as when a prominent man once asked Faraday what good this gadget, his electrical motor, was, Atget was sure enough of himself and of the potentialities of the camera not to imitate any other techniques but to stay within the laws of his own medium. When his contemporaries were conditioned (if not saturated) by painting, Atget persisted in his choice of "un-pictorial" subjects and in his quest for sharpness of image and clarity of detail. Straight photography, without tricks, served and realized his purpose. So he trudged about Paris and its environs, as far afield as Amiens and Rouen, with the great burden of camera and glass plates which he carried up to the time of his death and which alone speaks so eloquently of his devotion.

On the way to Sceaux, where he made some of the most memorable photographs of morning mists and lonely elegance, not far from Montrouge where he had performed as an actor, and next to Arcueil where he had scanned the ancient Roman aqueduct from every possible angle, Atget was buried on August 4, 1927, in the cemetery of Bagneux.

Though he had not received the material rewards he merited and which might have kept him going for a longer time, his infinite pains were in the end, at least, rewarded by that monument, his immortal work. He will be remembered as an urbanist historian, a genuine romanticist, a lover of Paris, a Balzac of the camera, from whose work we can weave a large tapestry of French civilization. Yet perhaps his most haunting photographs show simply a plow in a field near the city, a crop of wheat, or one of the trees he loved so well.

Berenice Abbott

THE PHOTOGRAPHS

PLATE 1 / ROAD

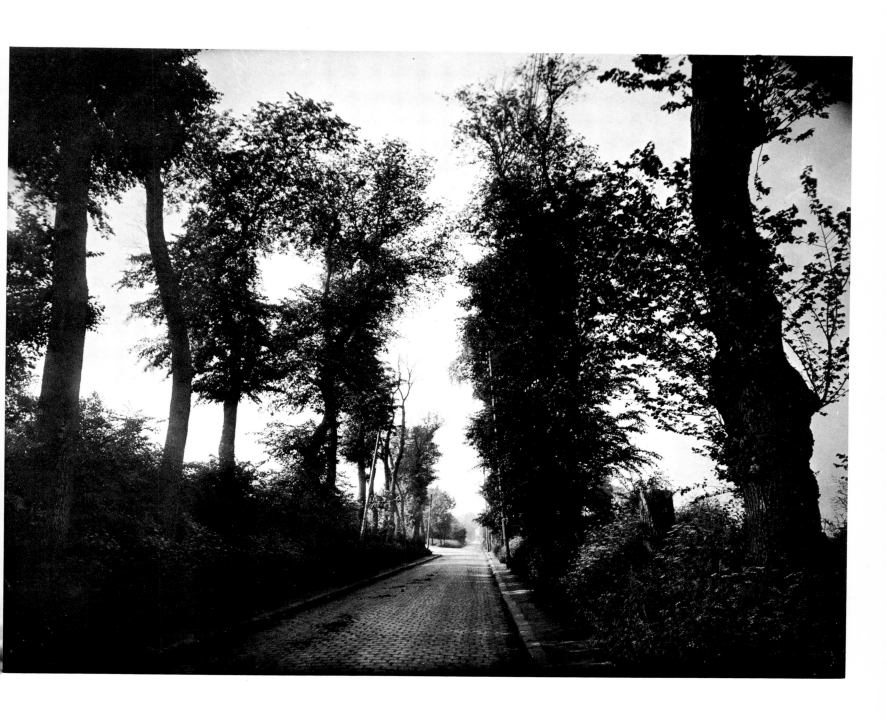

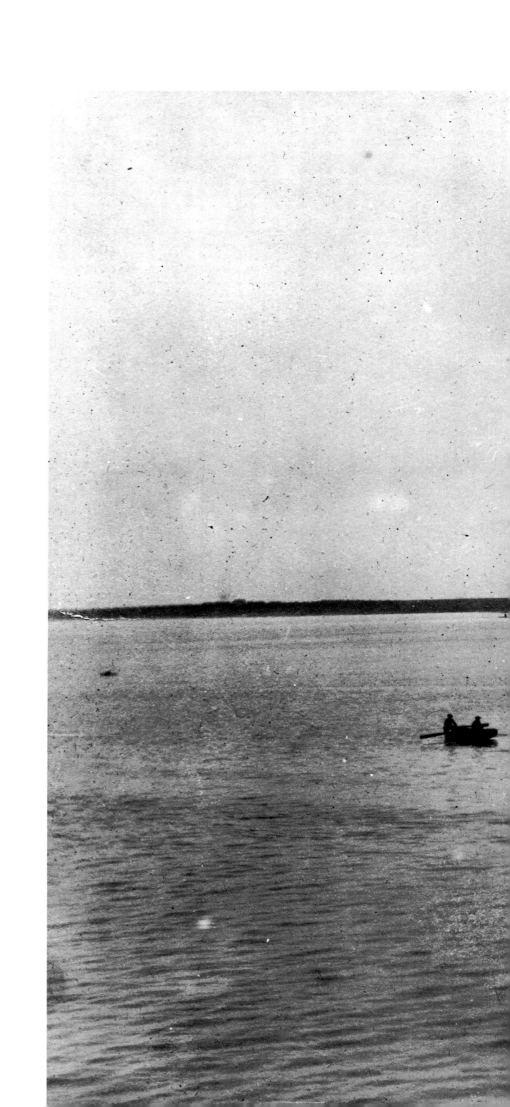

PLATE 2 / BOATS AT LA ROCHELLE

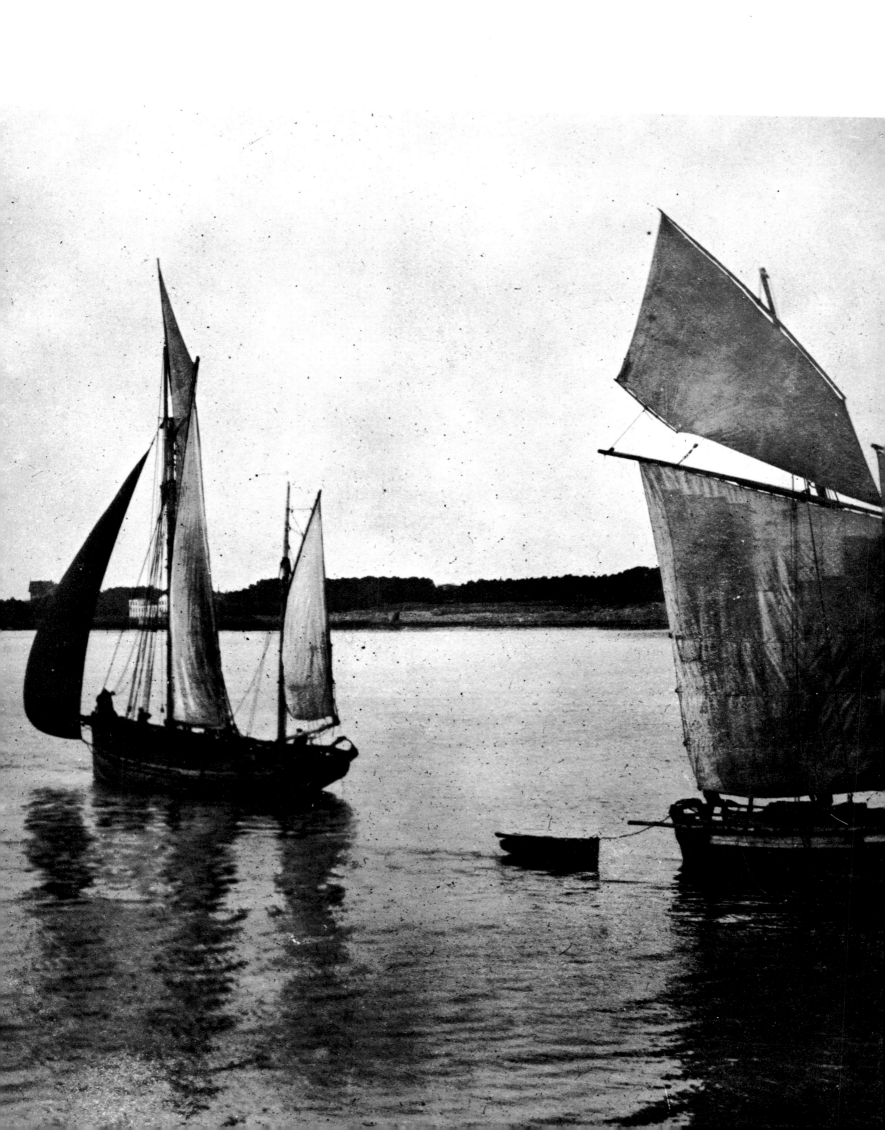

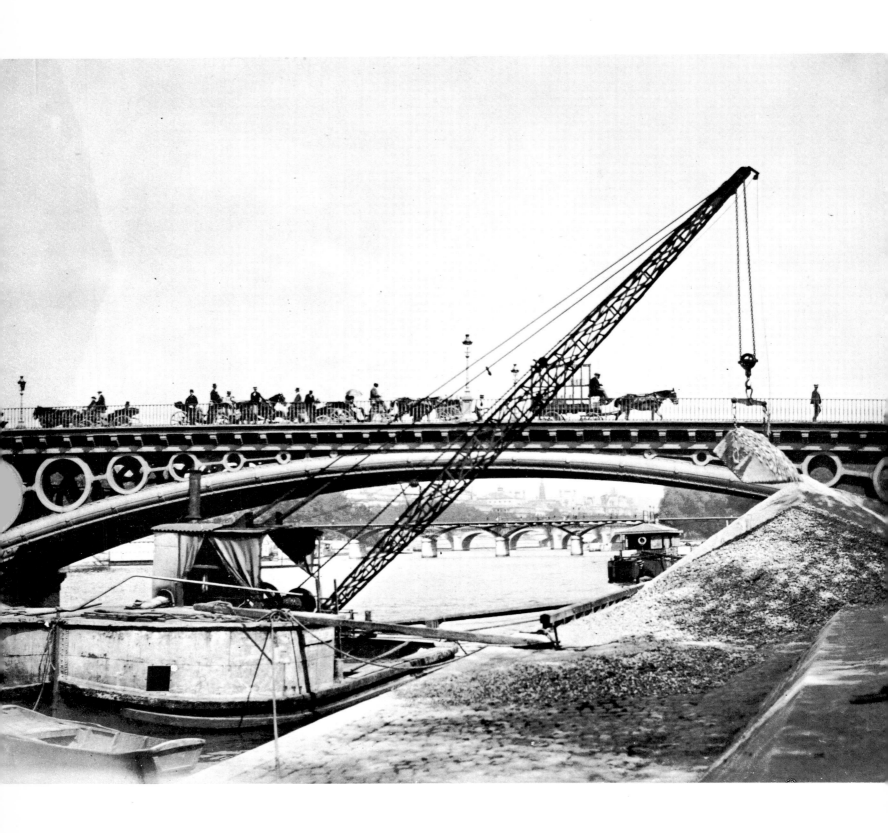

PLATE 3 / CARROUSEL BRIDGE

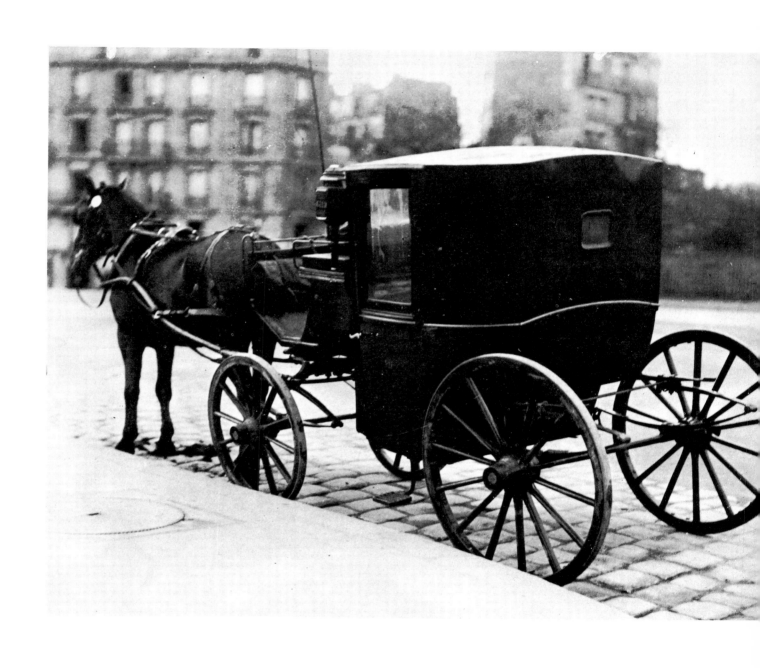

PLATE 4 / FIACRE, BEFORE TIRES

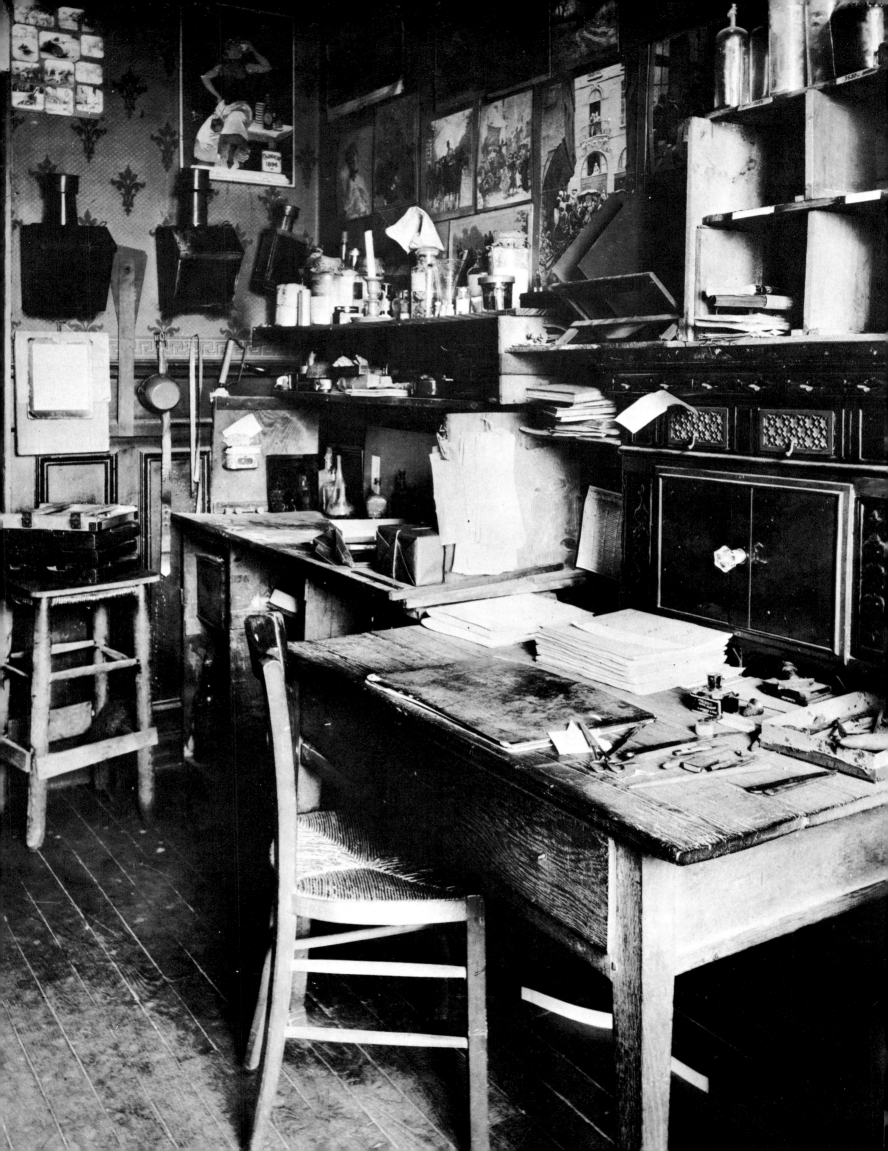

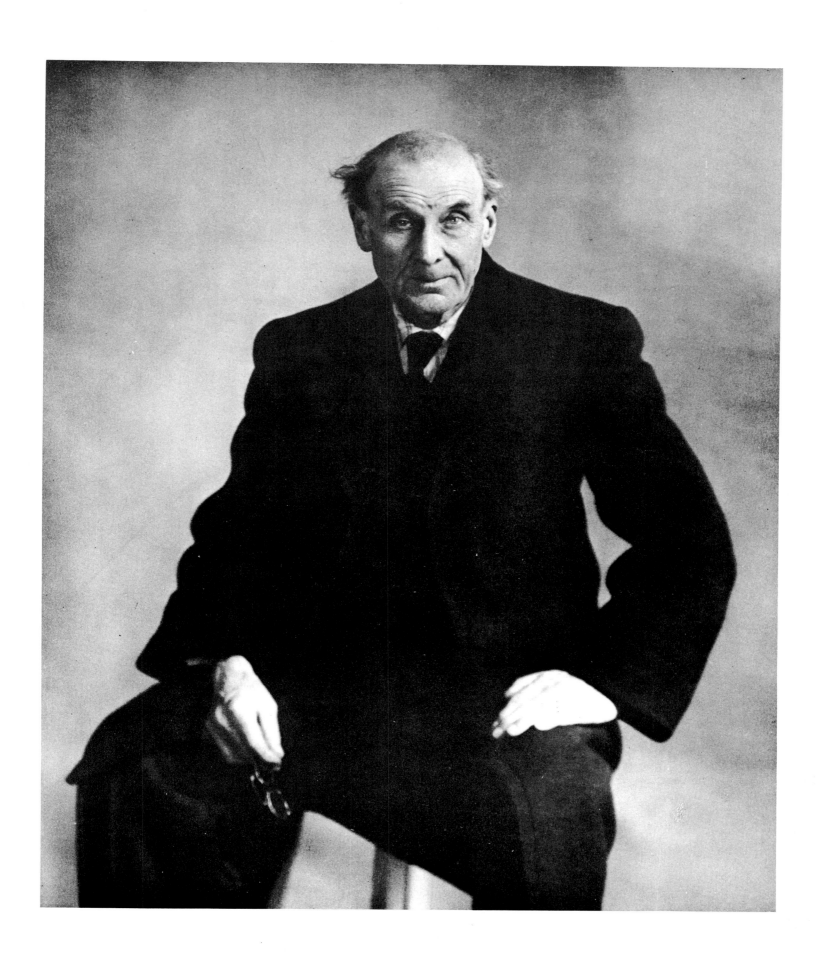

PLATE 5 / ATGET'S WORKROOM

PLATE 6 / ATGET BY BERNICE ABBOTT

PLATE 7 / PUPPET SHOW

PLATE 8 / DOLL SHOP

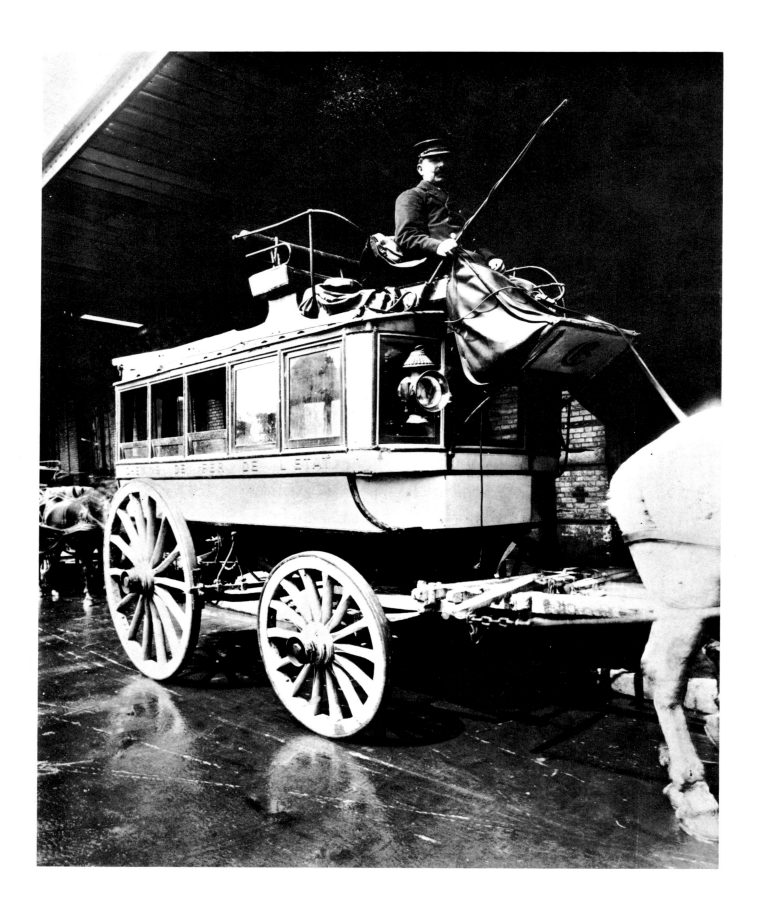

PLATE 9 / TRAIN COACH

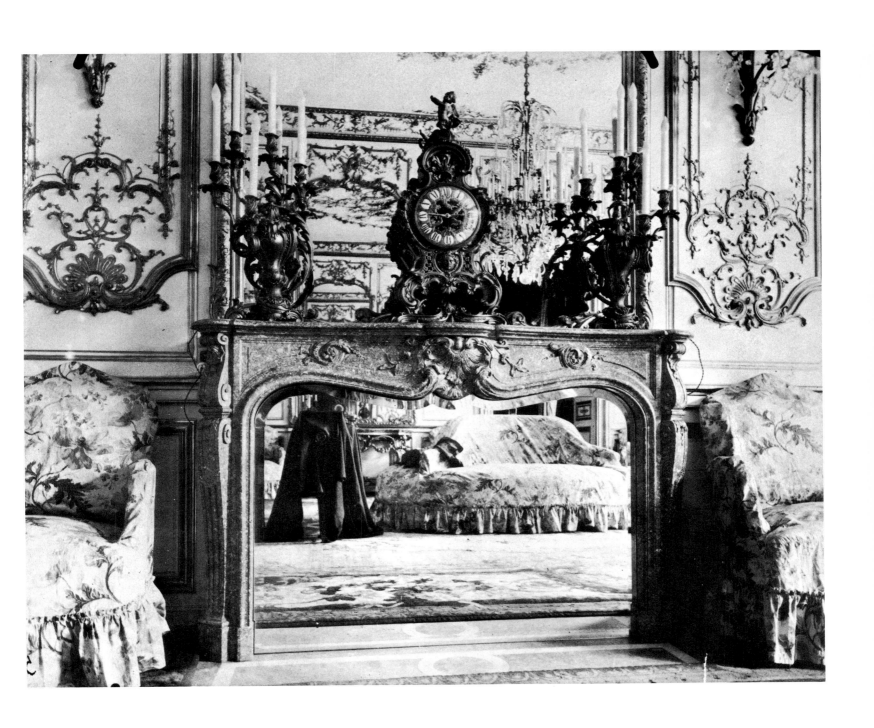

PLATE 10 / AUSTRIAN EMBASSY. 57 RUE DE VARENNE

PLATE 11 / STREET VENDORS

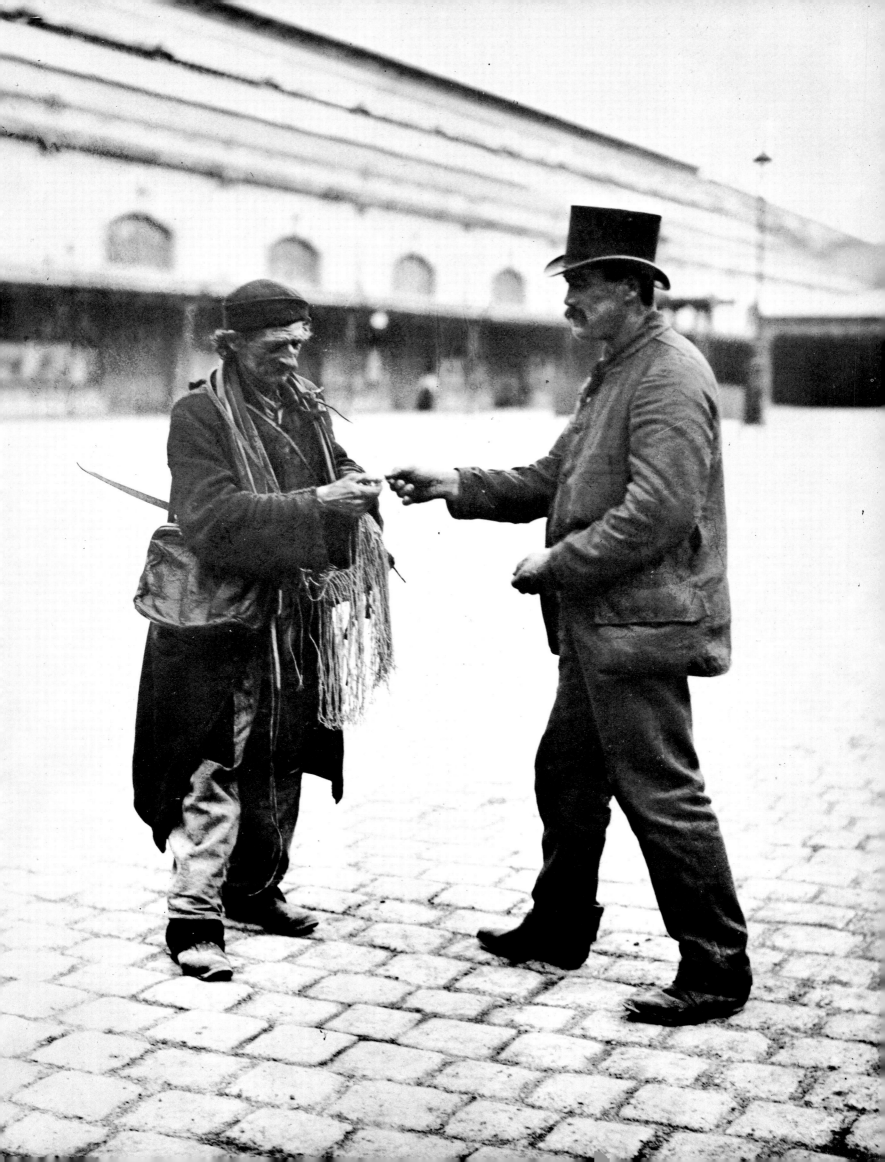

PLATE 12 / THE SEINE

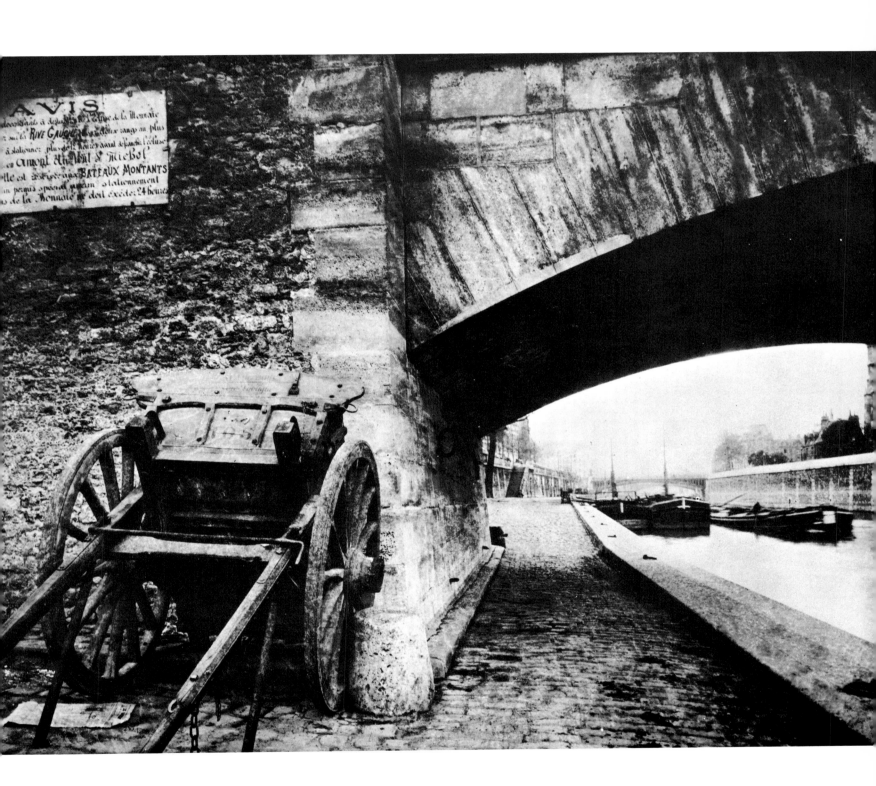

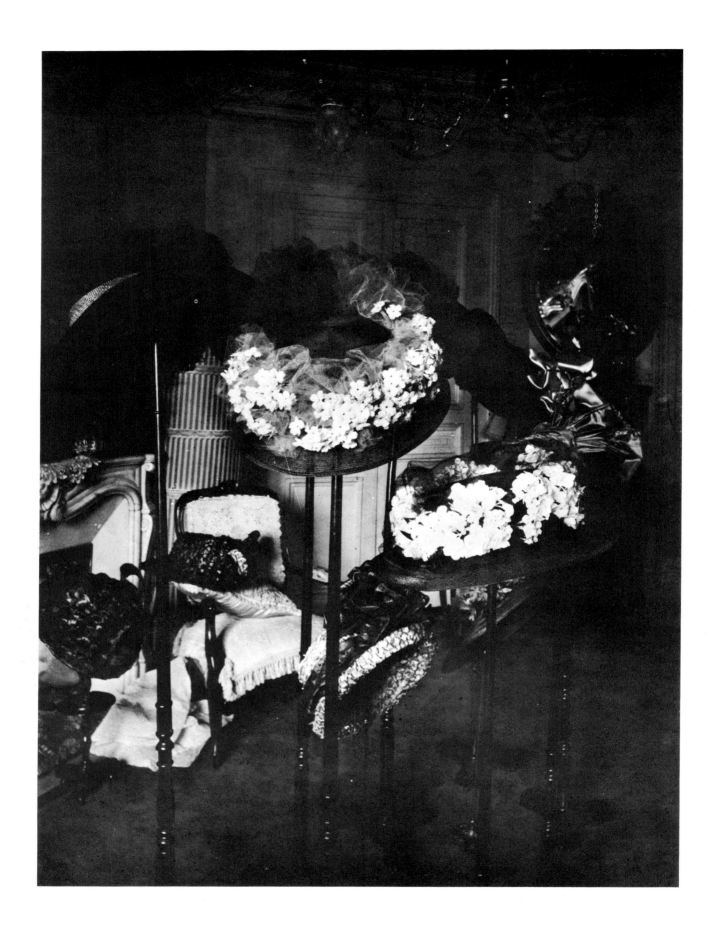

PLATE 13 / BOUTIQUE

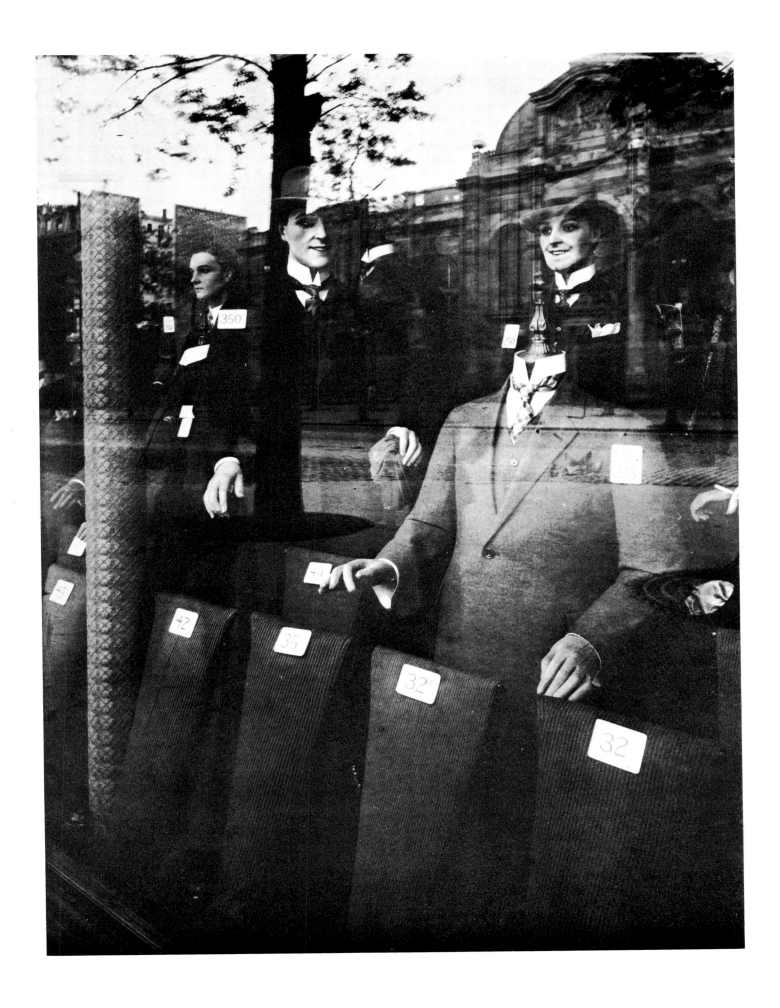

PLATE 14 / STORE

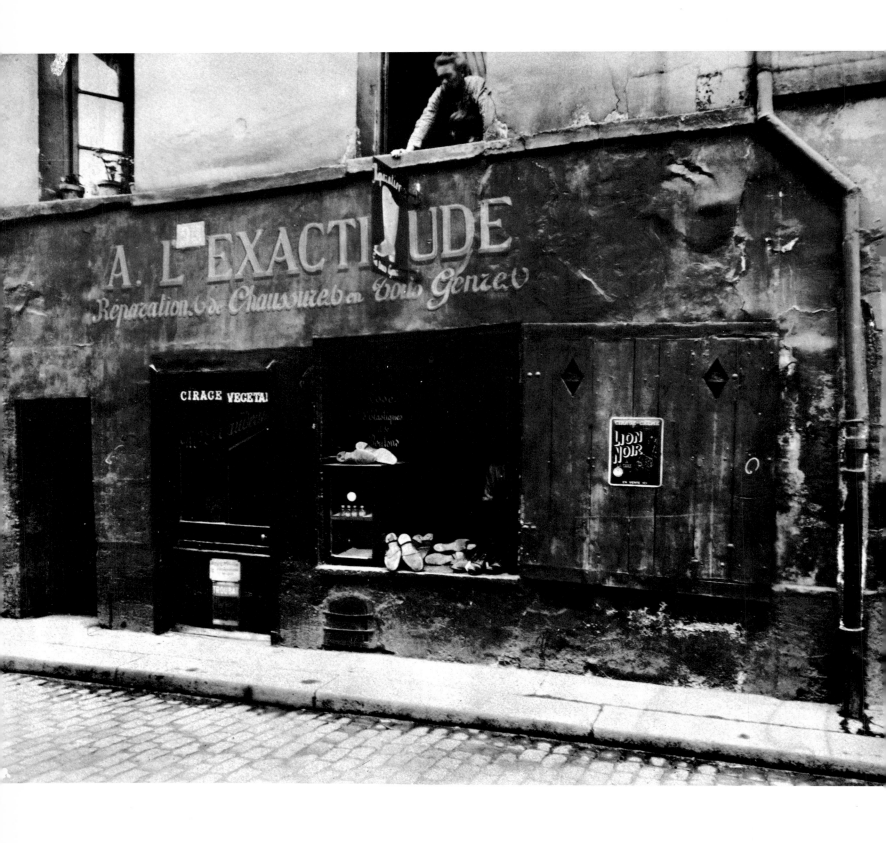

PLATE 15 / SHOE SHOP. 93 RUE BROCA

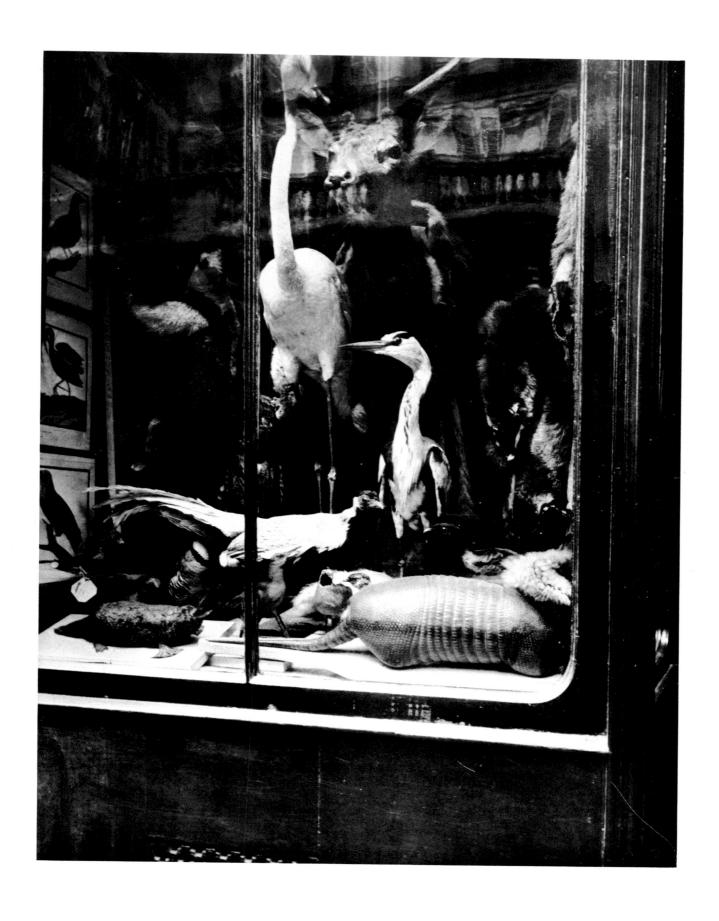

PLATE 16 / TAXIDERMIST

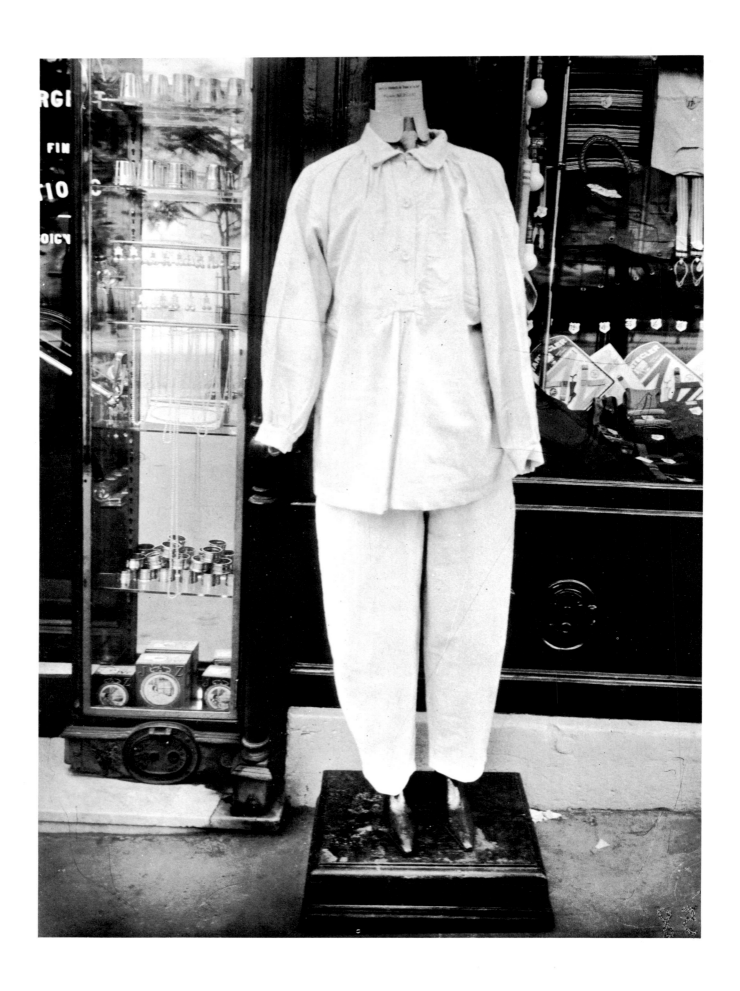

PLATE 17 / MANNIKIN

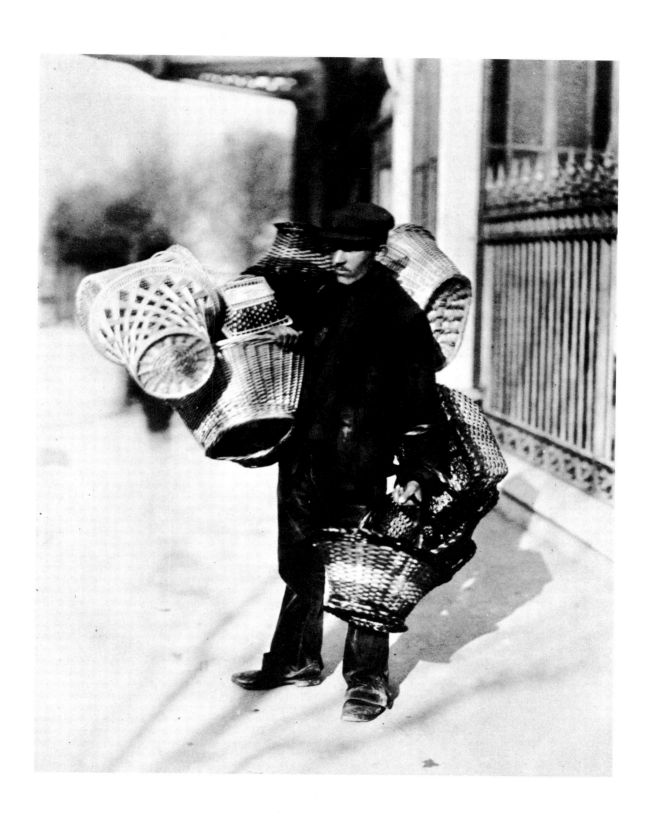

PLATE 18 / STREET VENDOR

PLATE 19 / INTERIOR

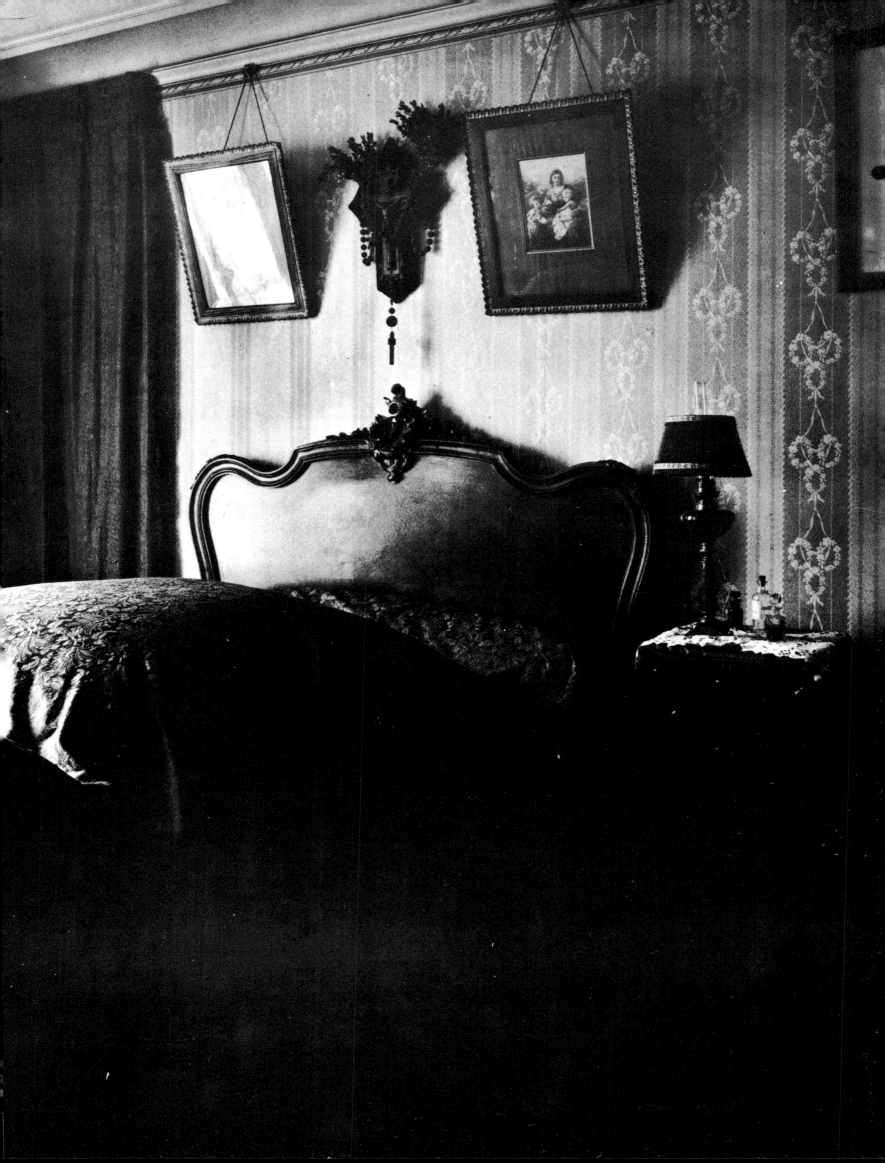

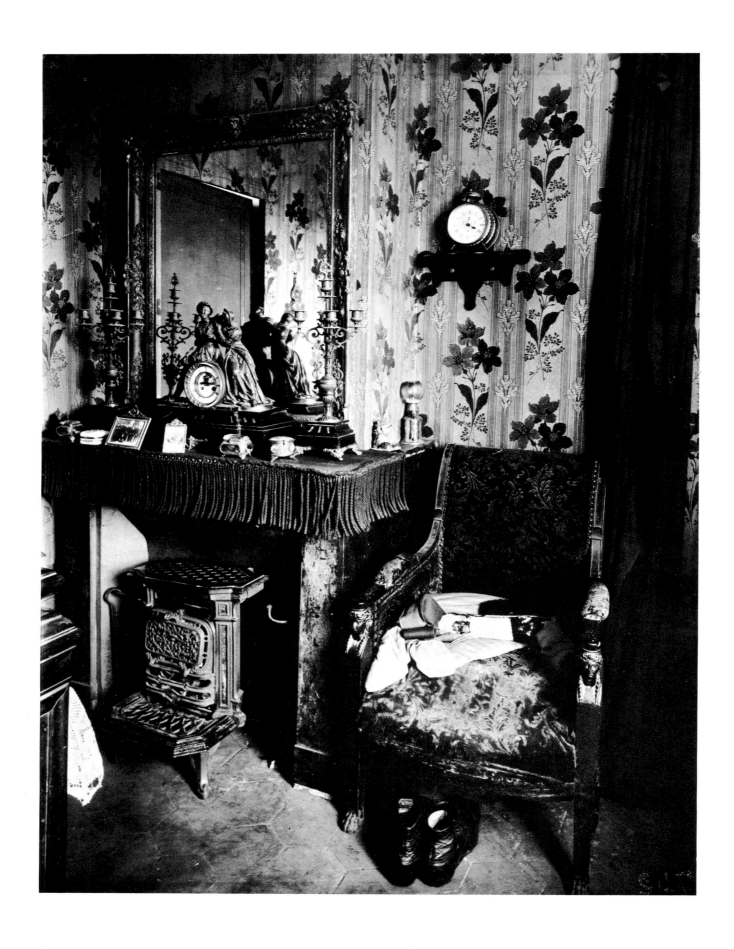

PLATE 20 / INTERIOR

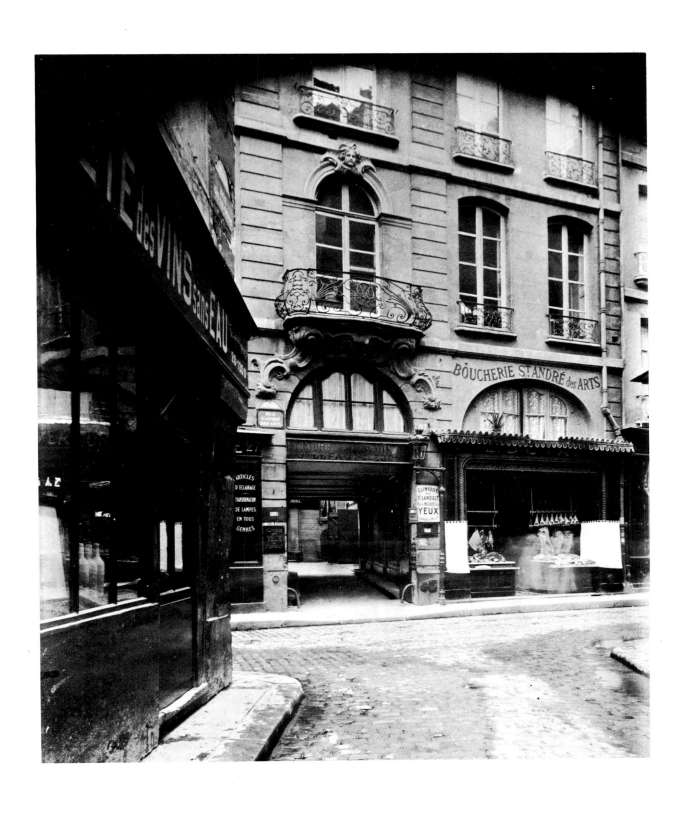

PLATE 21 / HOUSE OF THE HISTORIAN, ANDRE DUCHESNE. 27 RUE ST. ANDRE DES ARTS

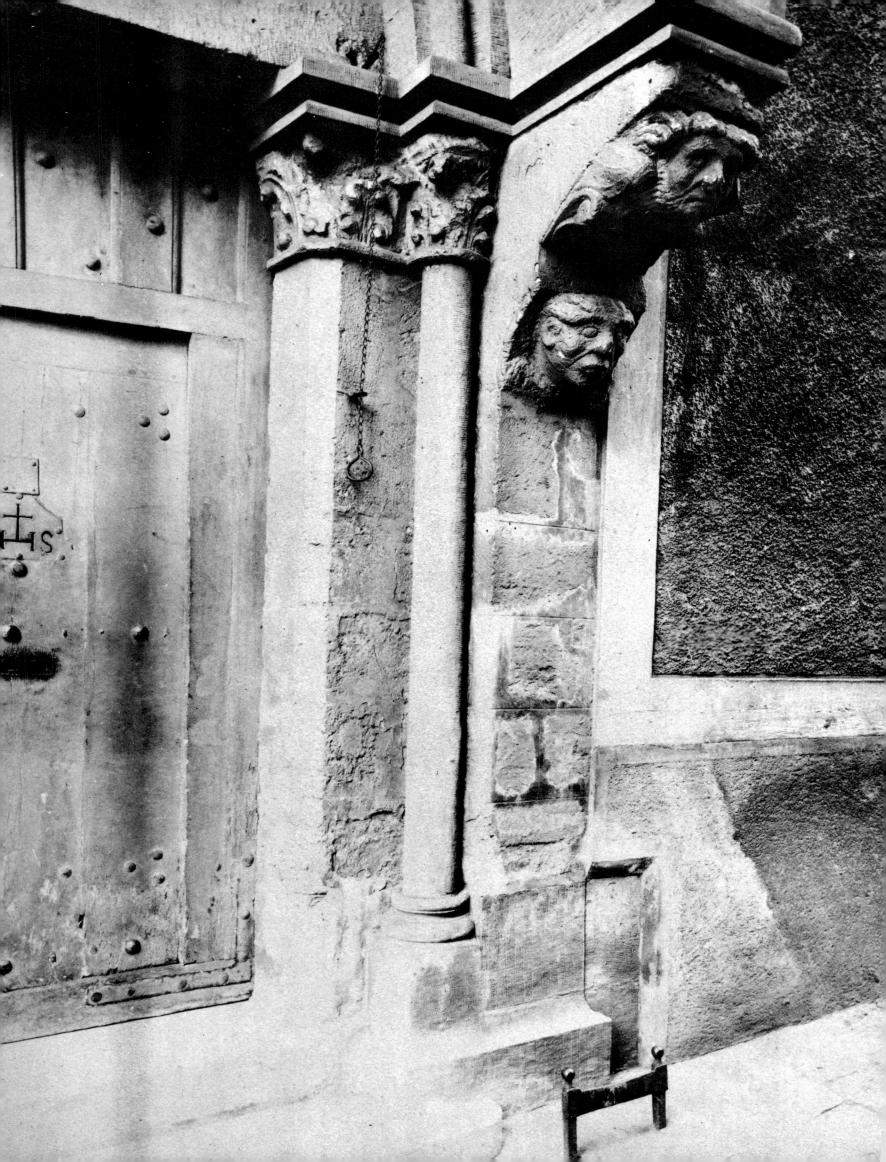

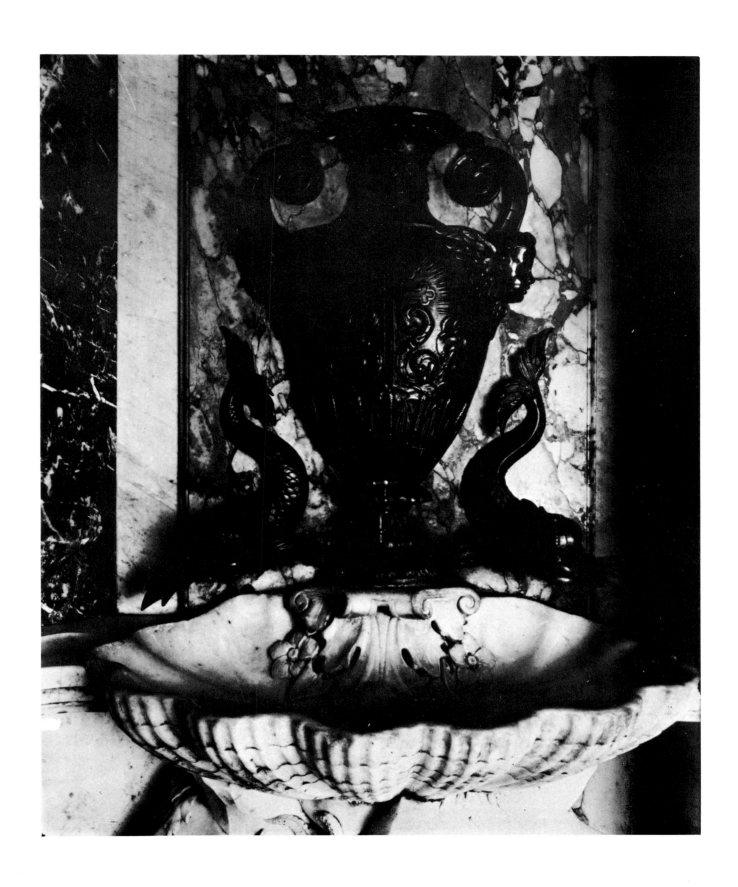

PLATE 24 / STREET-WORKERS

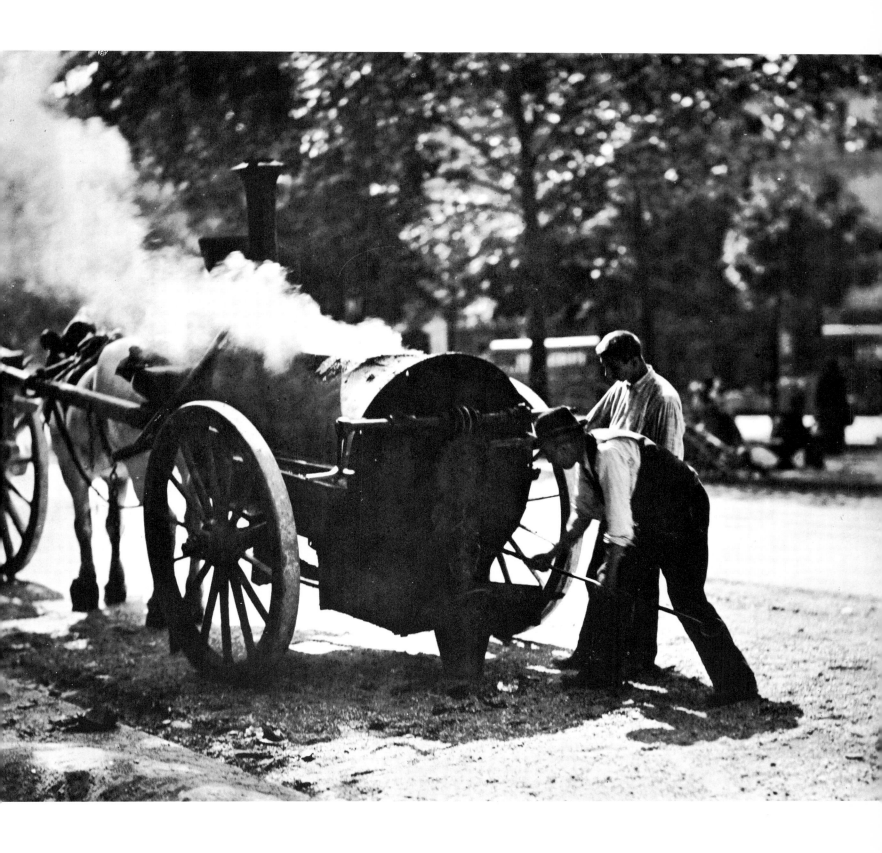

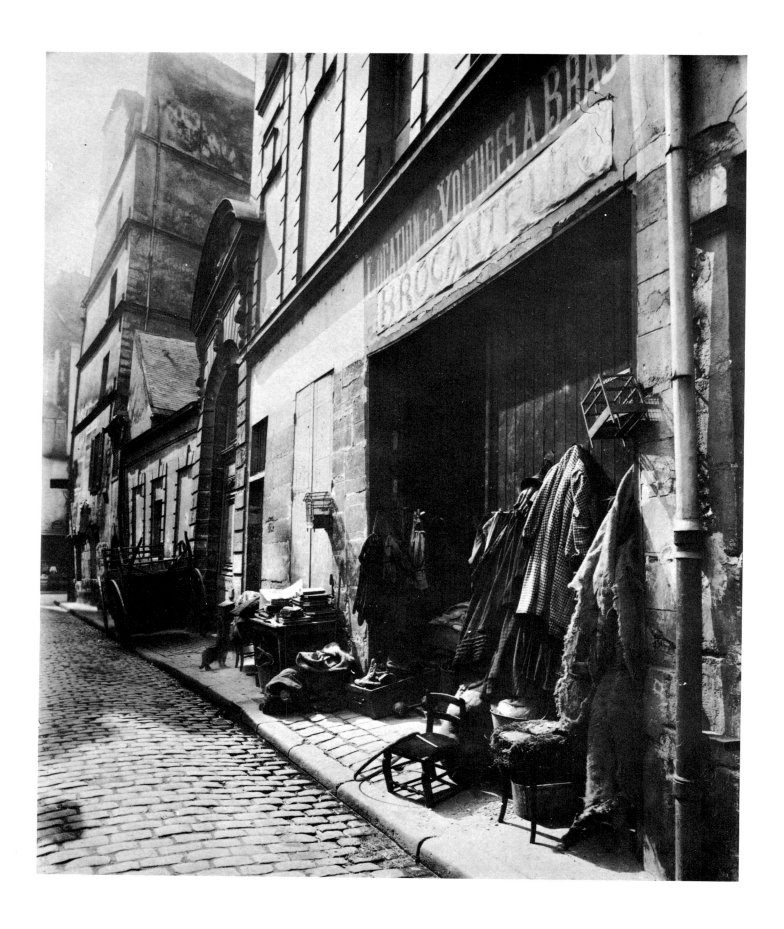

PLATE 25 / SECONDHAND

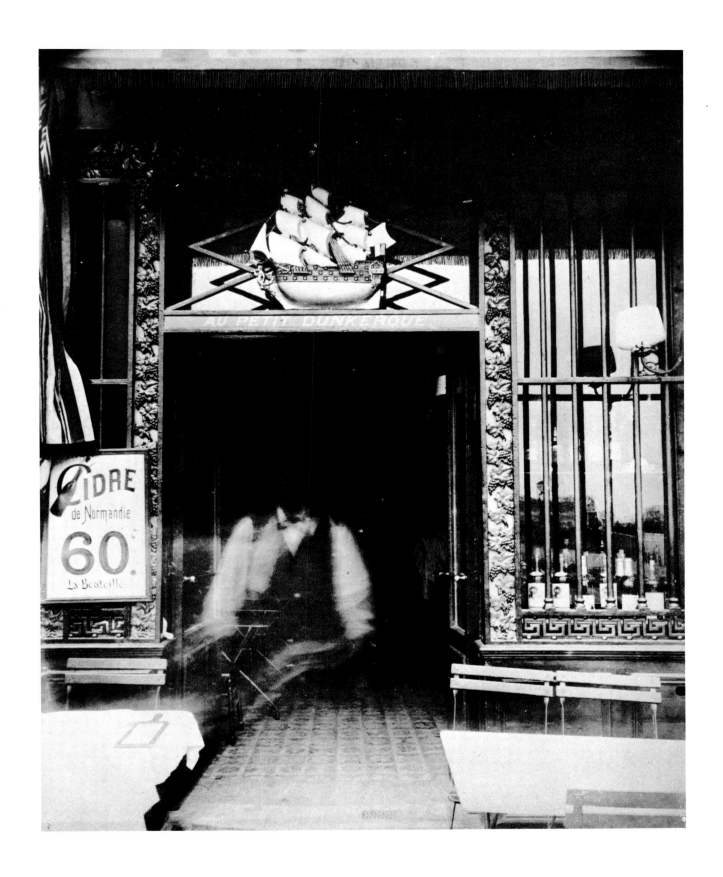

PLATE 26 / CAFE

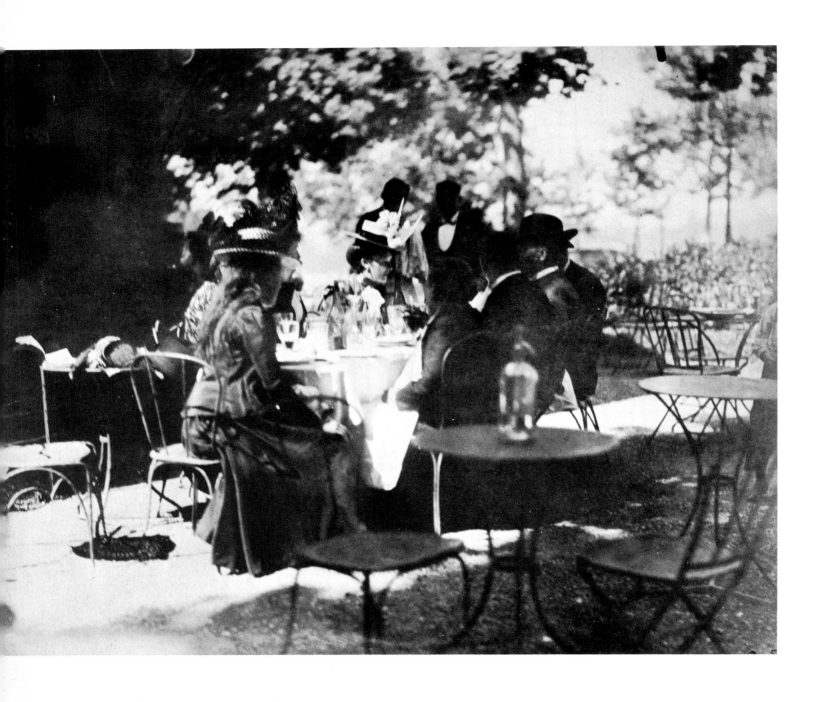

PLATE 27 / CAFE

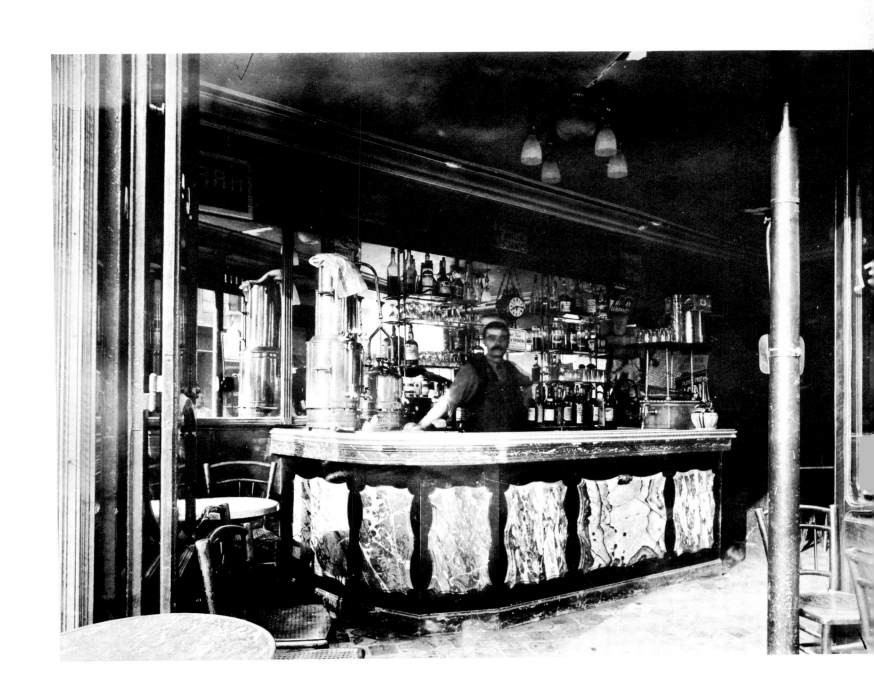

PLATE 28 / SMALL BAR

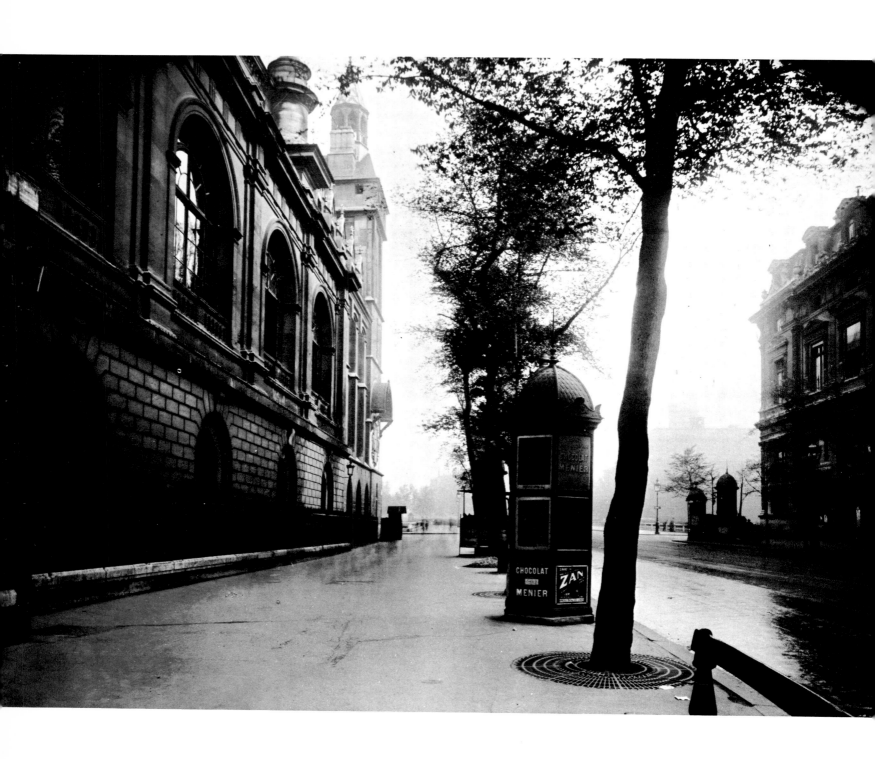

PLATE 29 / STREET SCENE

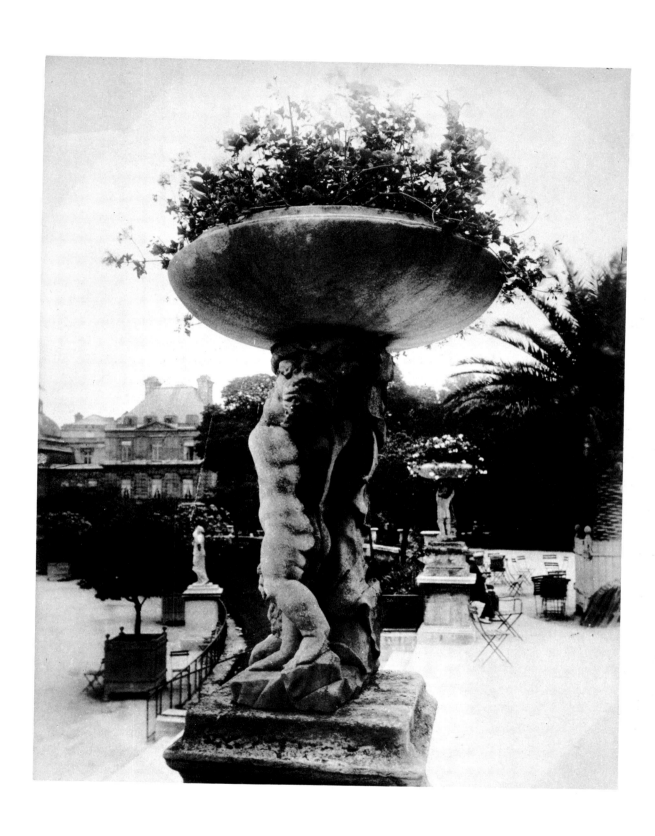

PLATE 30 / LUXEMBOURG

PLATE 31 / STREET

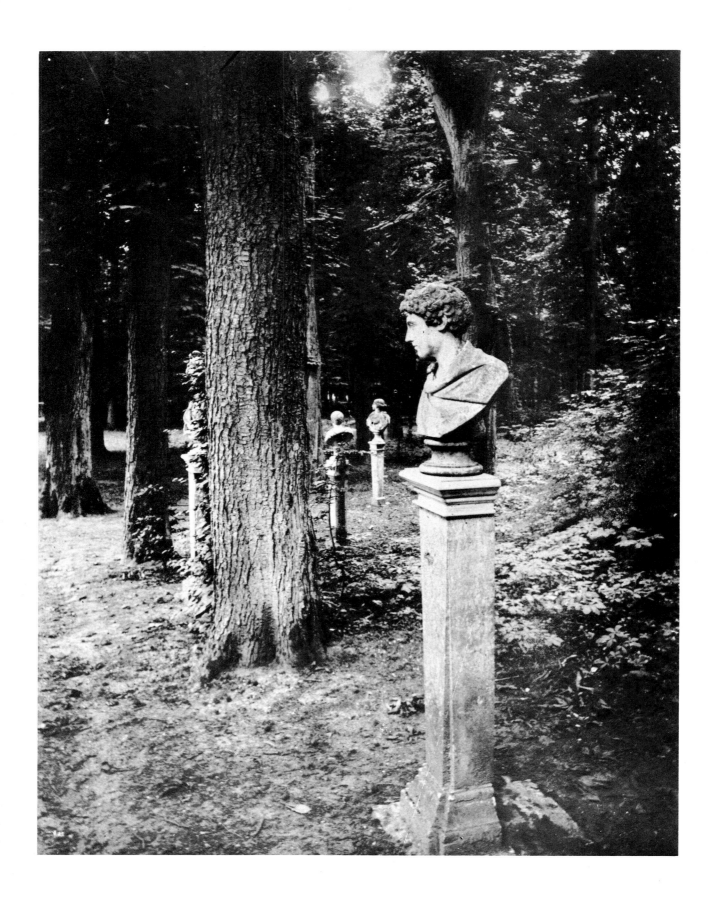

PLATES 32 & 33 / STATUARY AT TRIANON, TWO ASPECTS

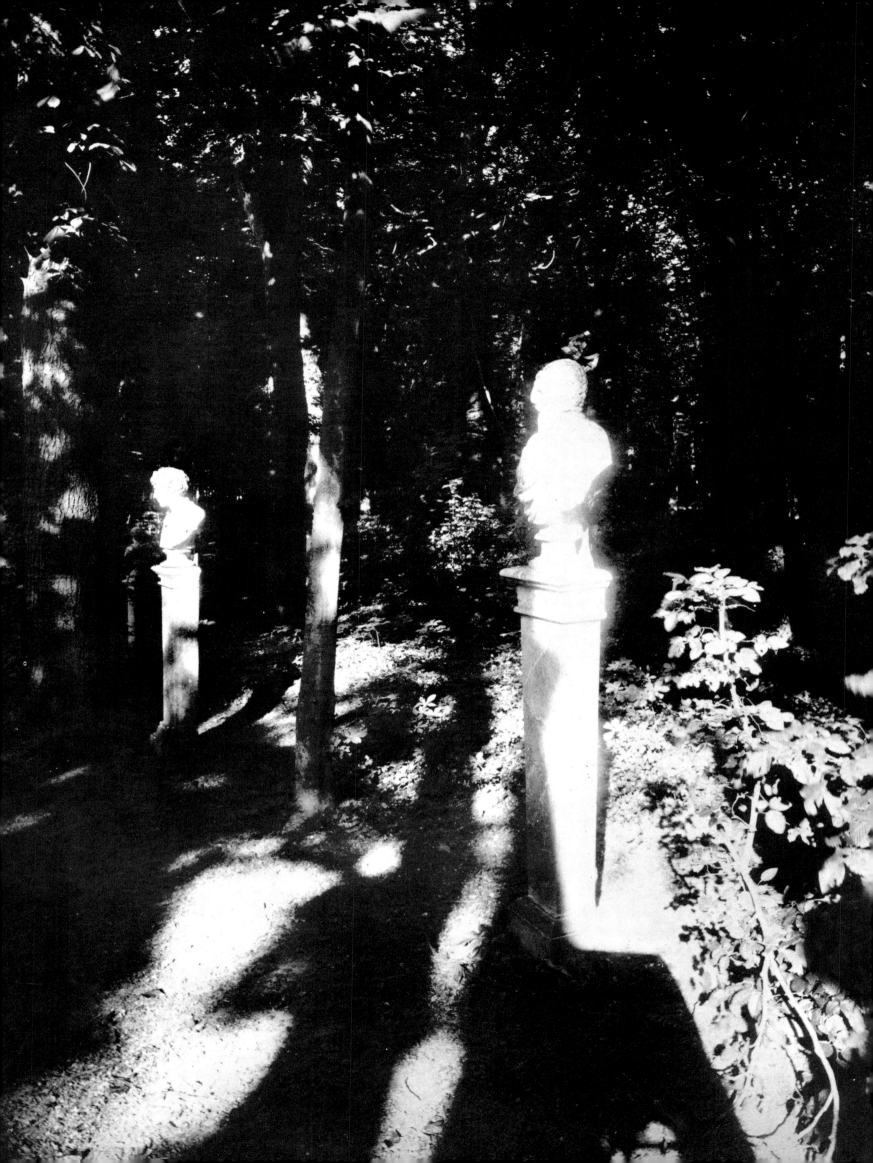

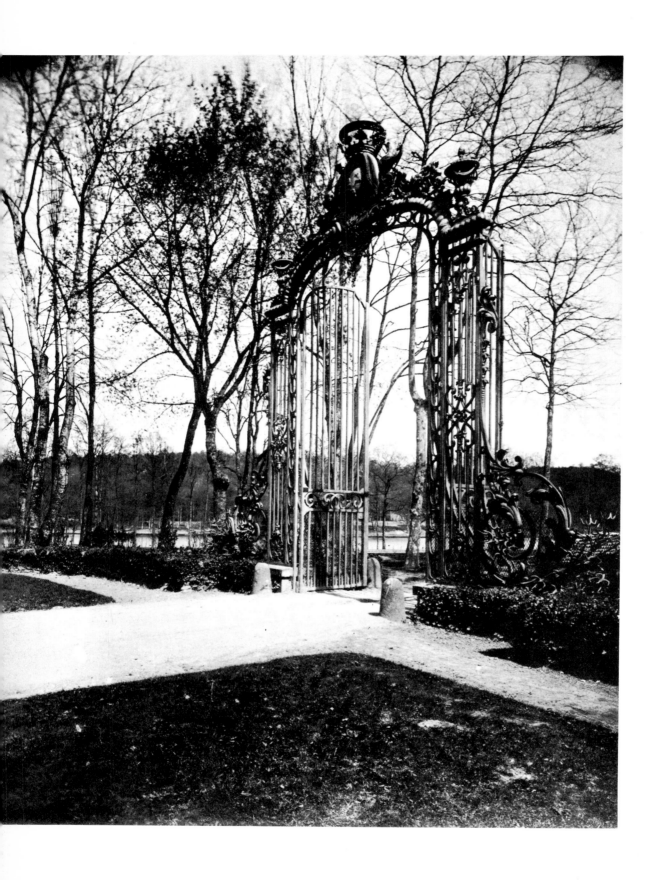

PLATE 34 / GATE TO THE CHATEAU. VAUX DE CERNAY

PLATE 35 / DETAI

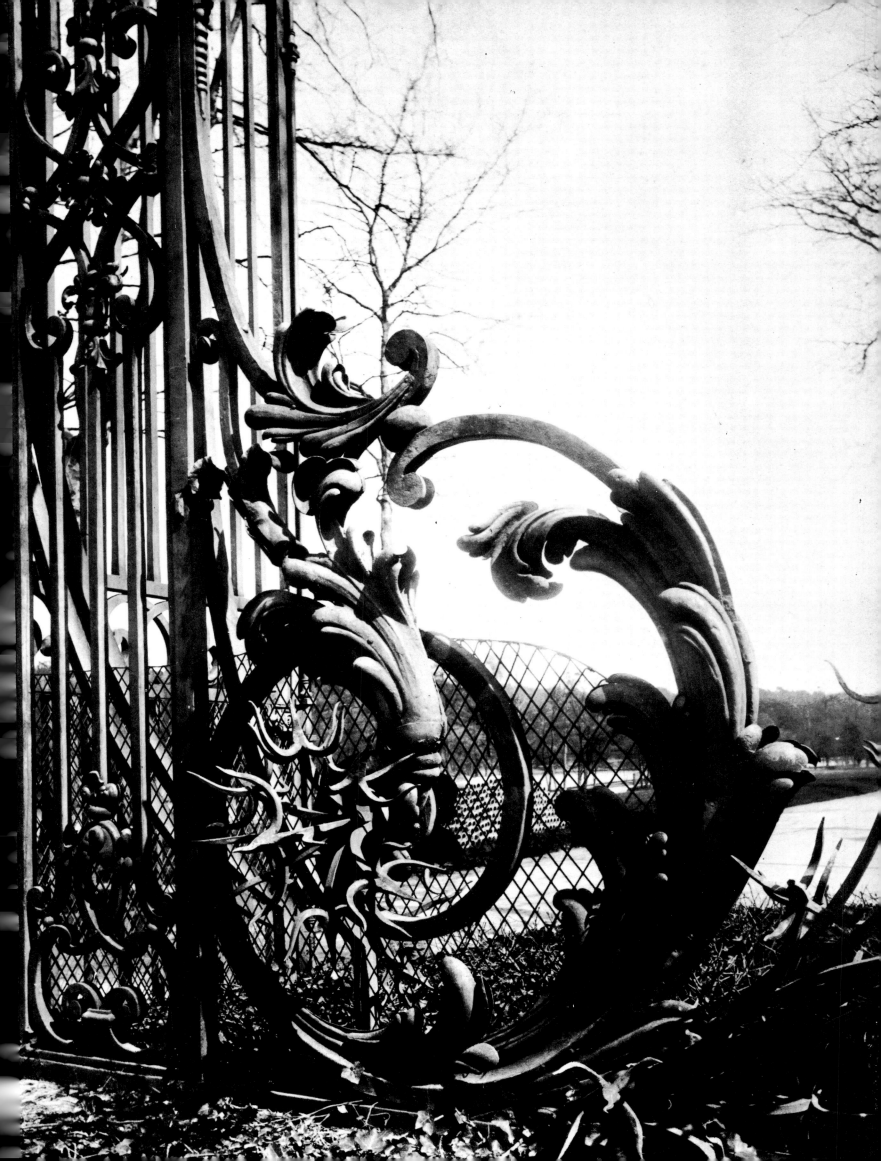

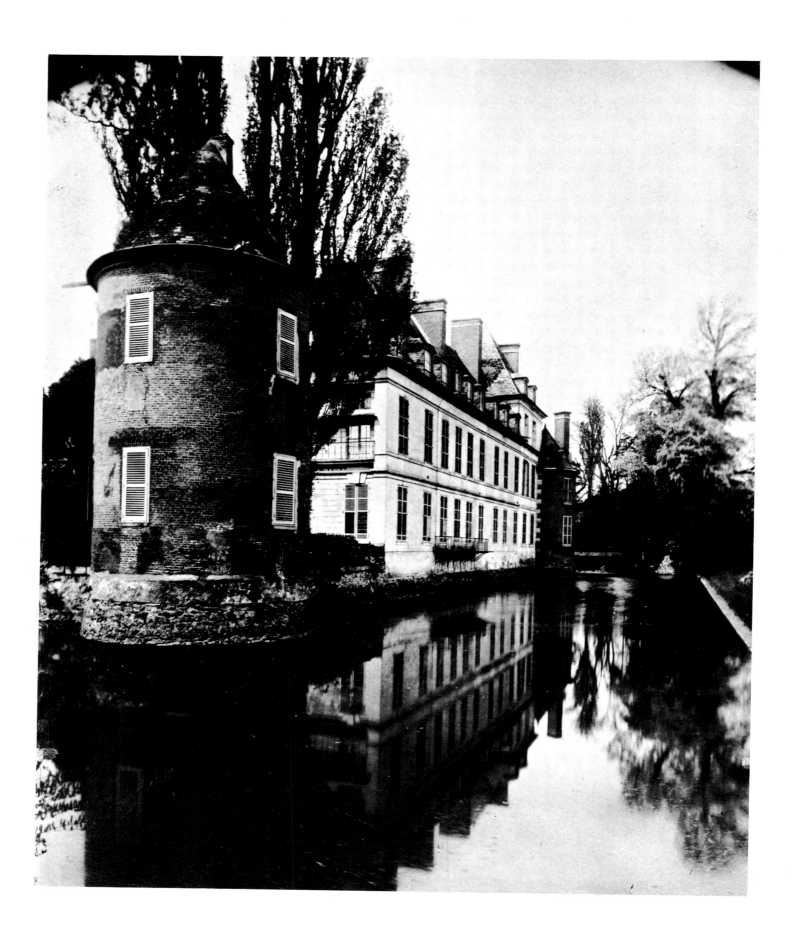

PLATE 36 / CHATEAU DE SAVIGNY. ST. ORGE

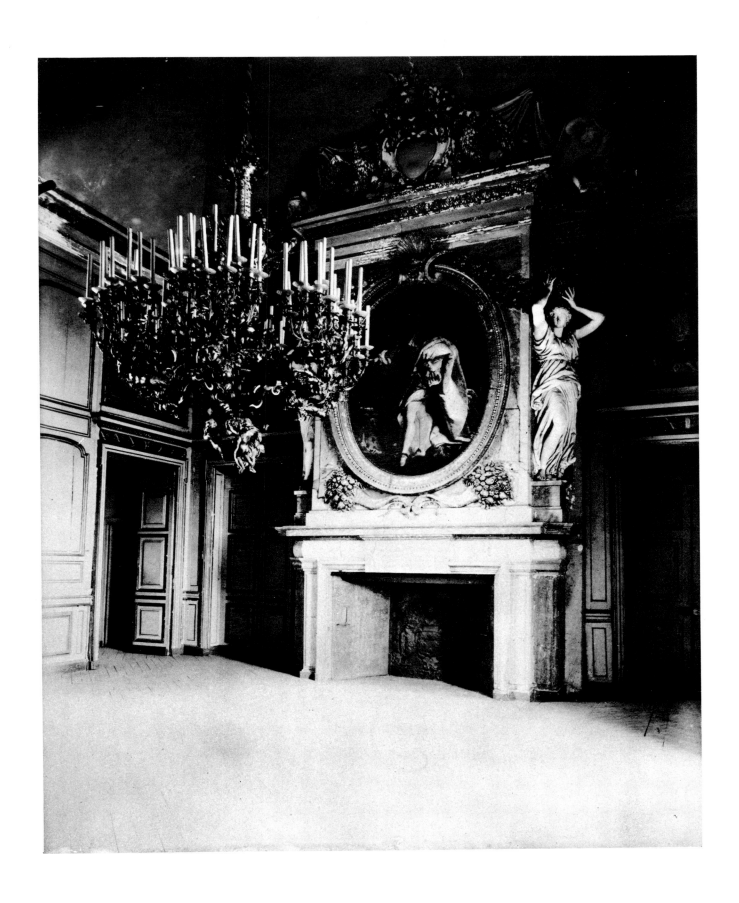

PLATE 37 / INTERIOR. CHATEAU DE MAISONS-LAFFITTE

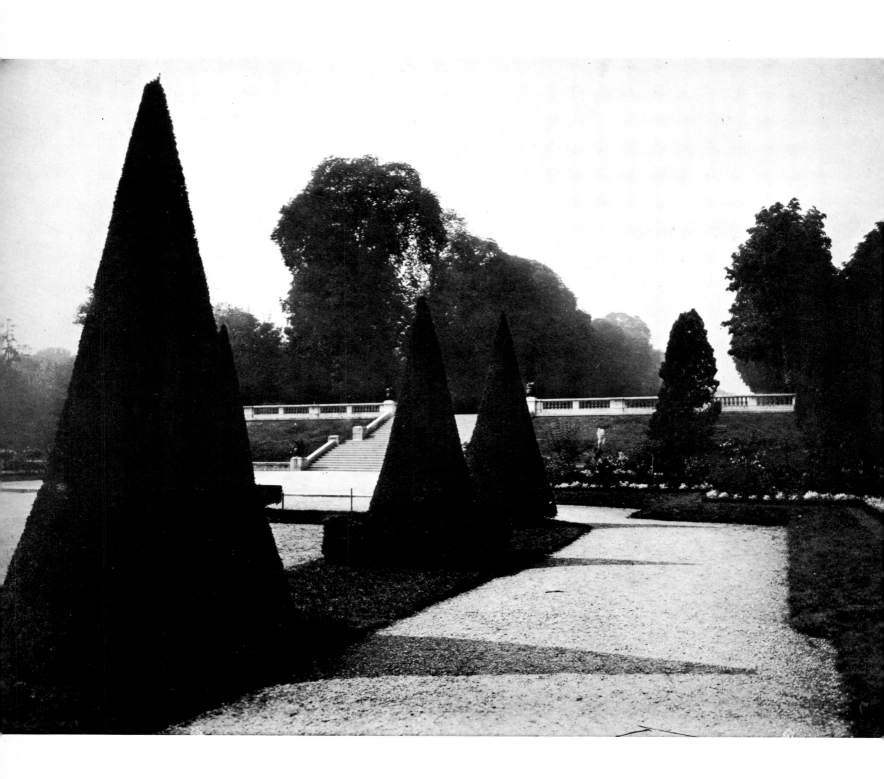

PLATE 38 / GARDEN. VERSAILLES

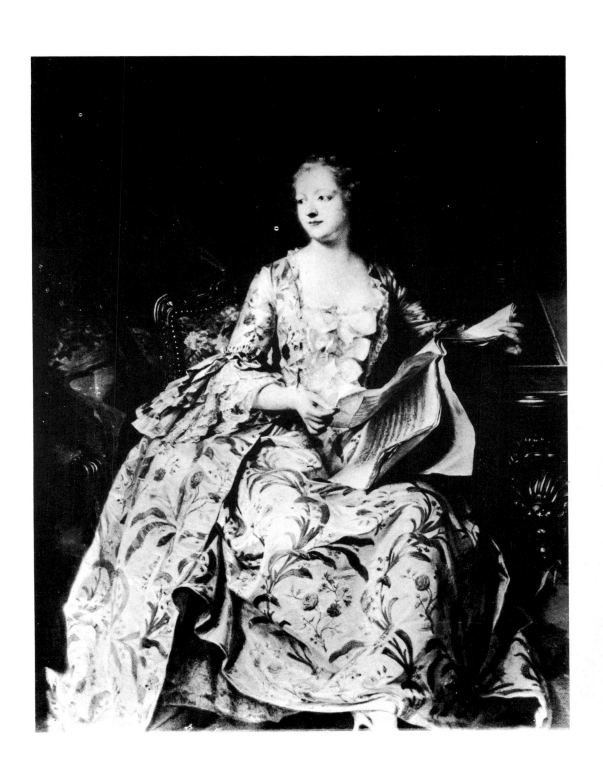

PLATE 39 / PHOTOGRAPH OF PAINTING. MADAME DE POMPADOUR

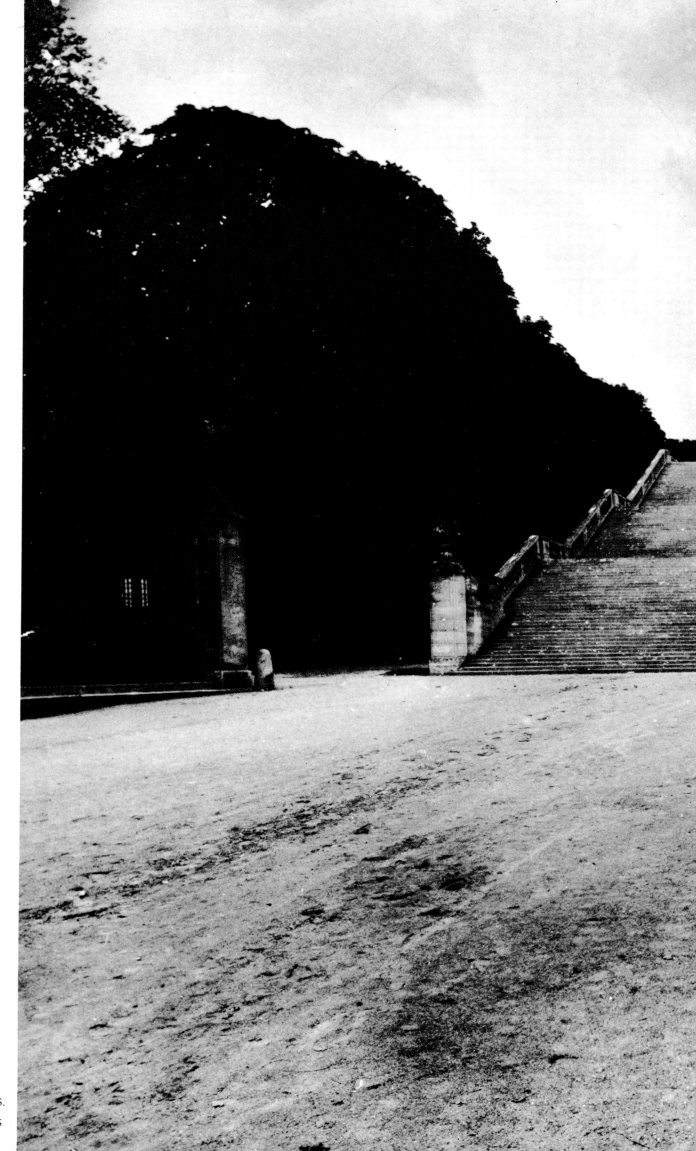

PLATE 40 / THE GREAT STEPS.
VERSAILLES

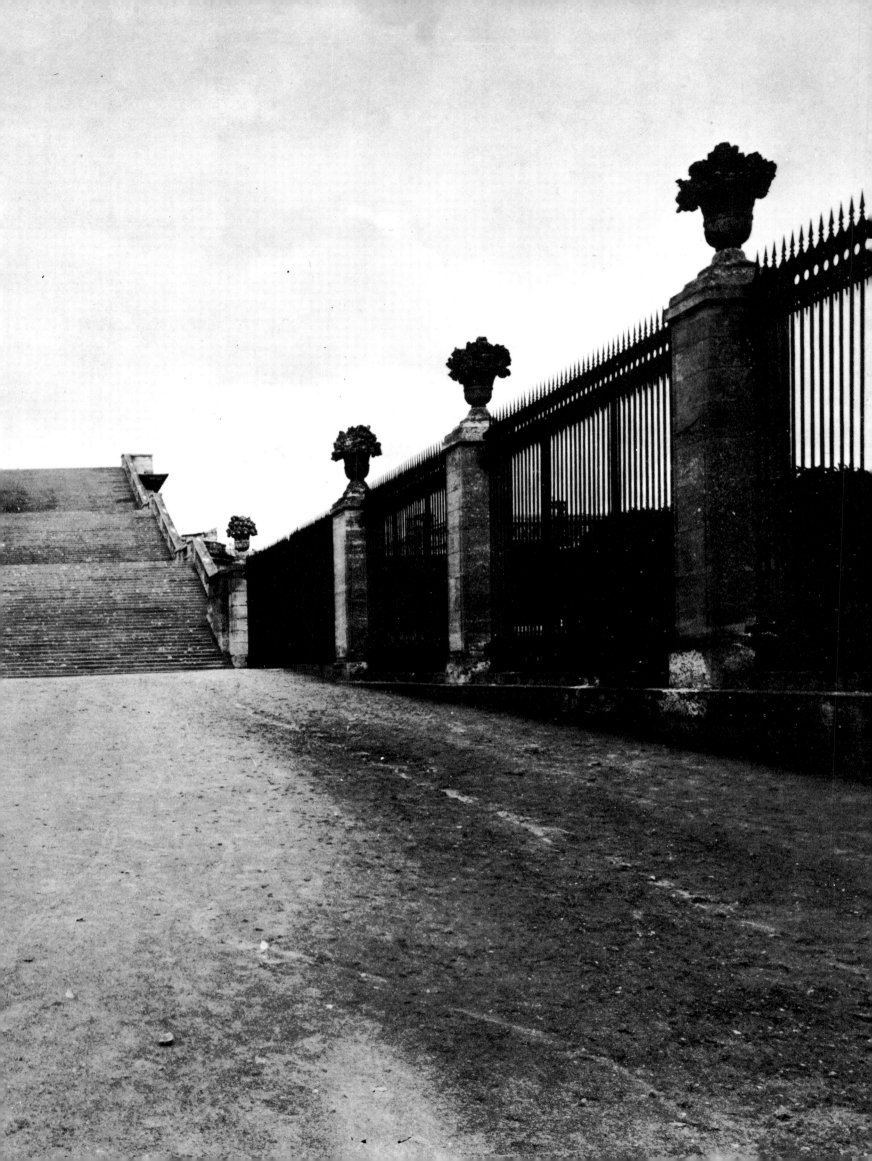

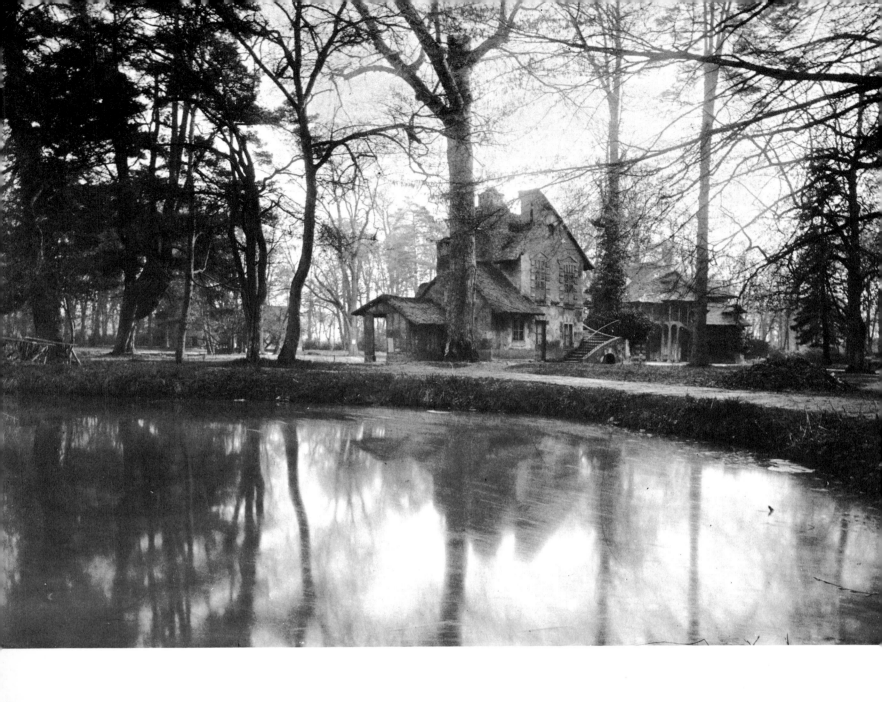

PLATE 41 / POND. TRIANON

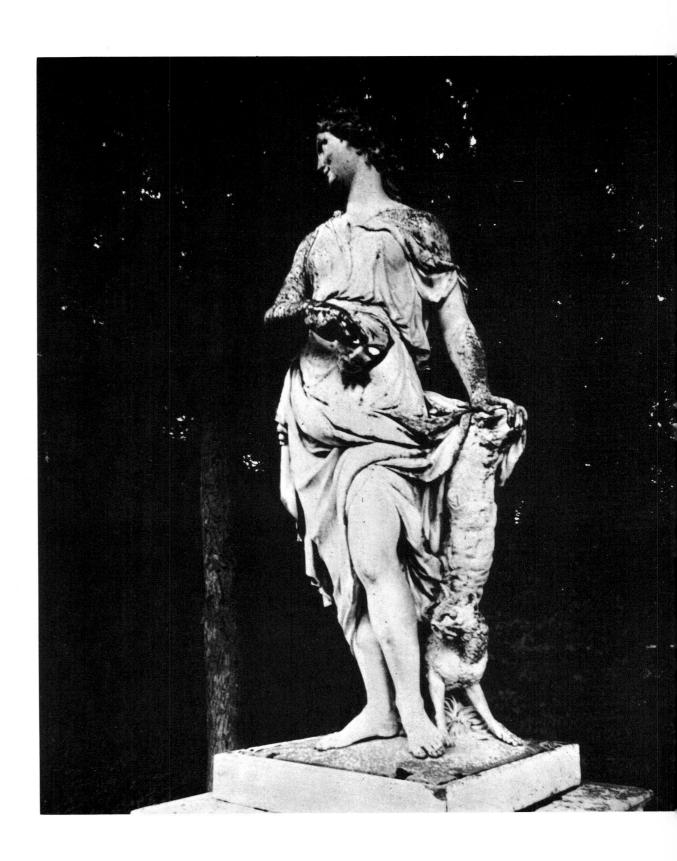

PLATE 42 / STATUE

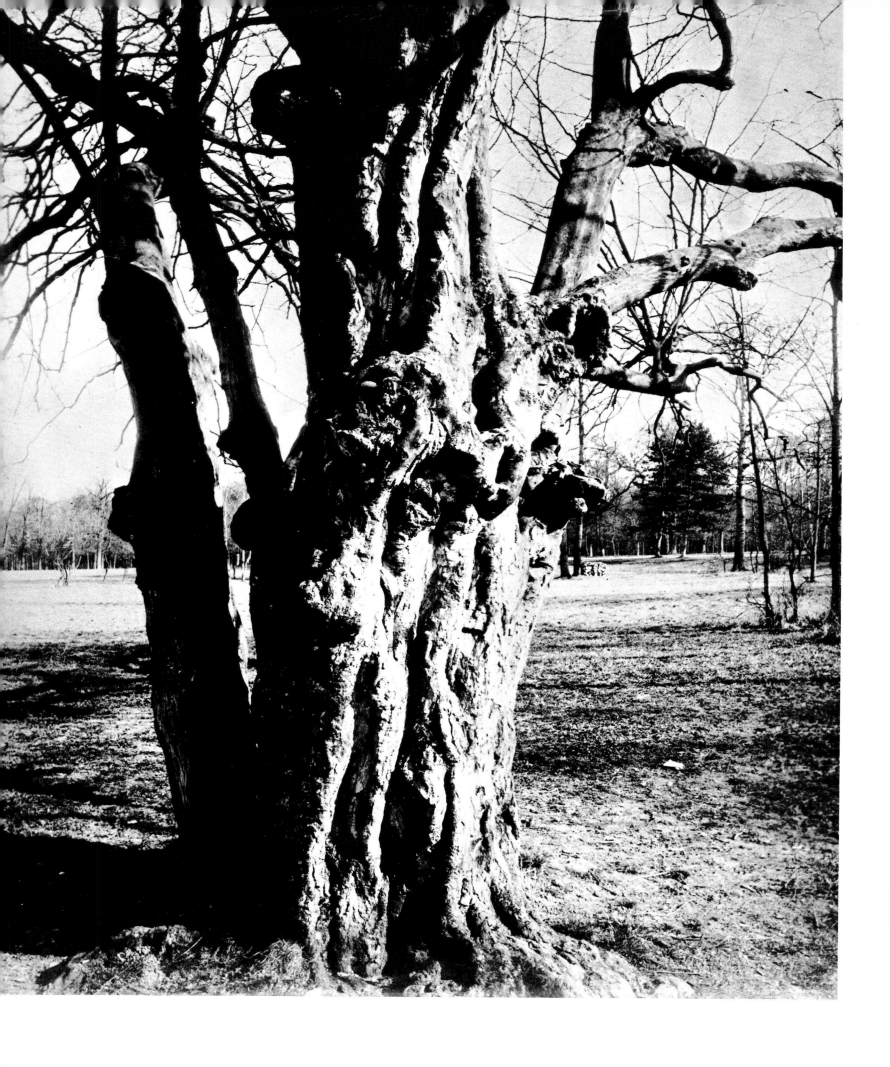

PLATE 43 / TREE. ST. CLOUD

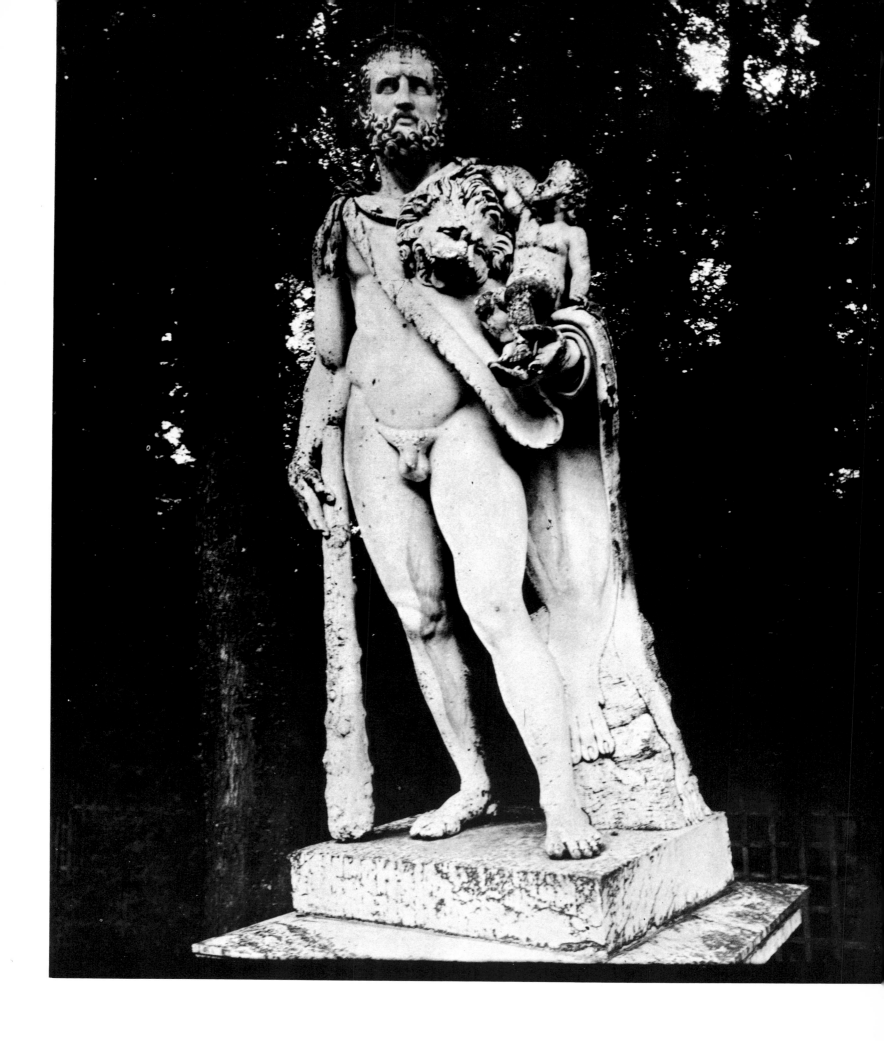

PLATE 44 / ACHILLES BY VIGIER. VERSAILLES

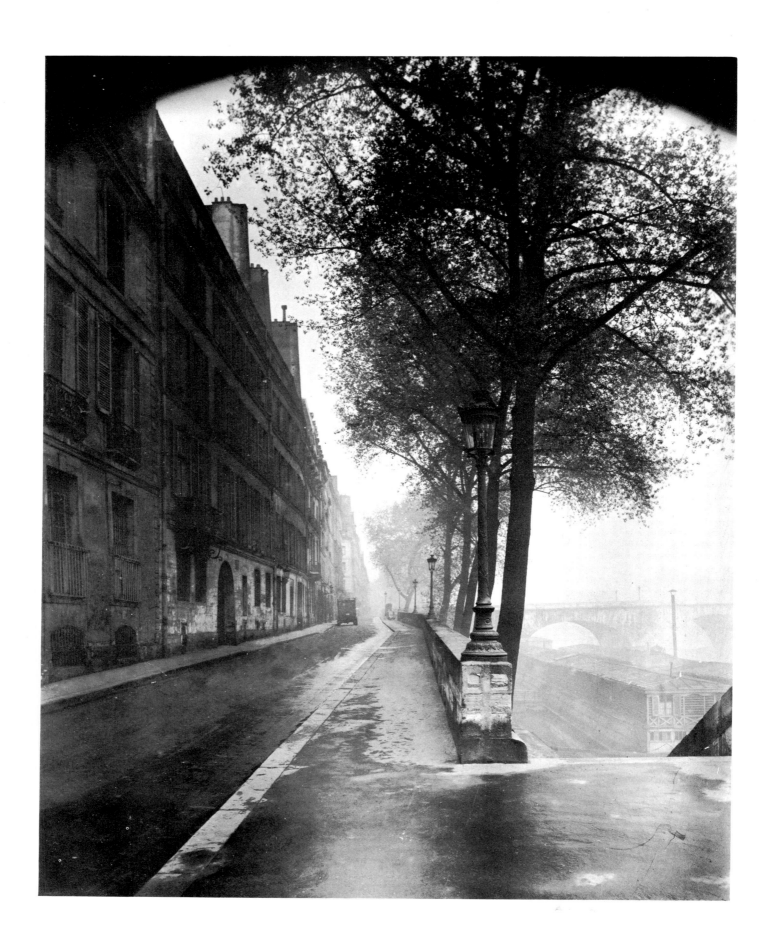

PLATE 45 / QUAI D'ANJOU ON A MISTY MORNING

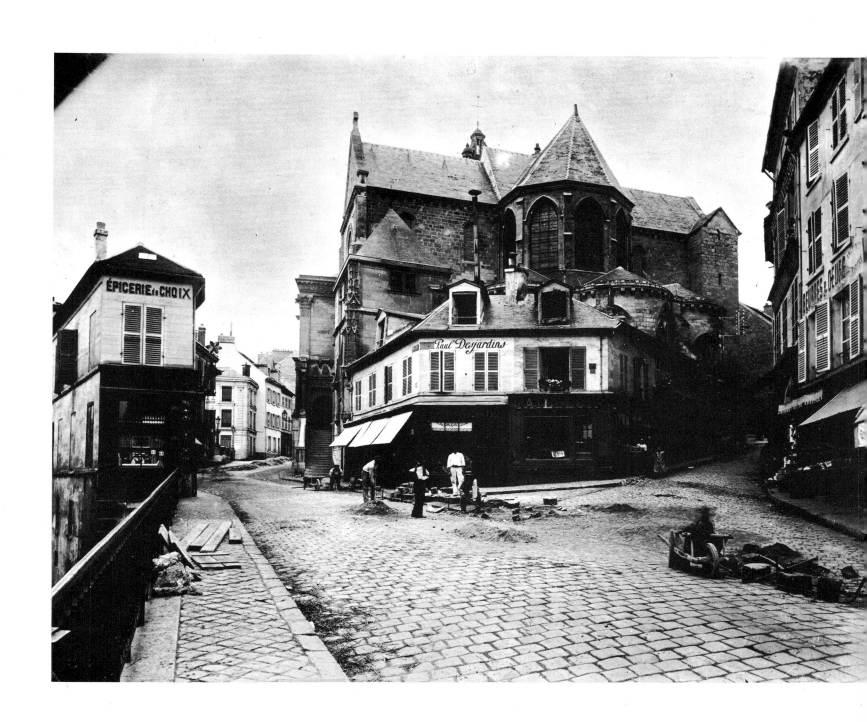

PLATE 46 / ST. MACLOU. PONTOISE

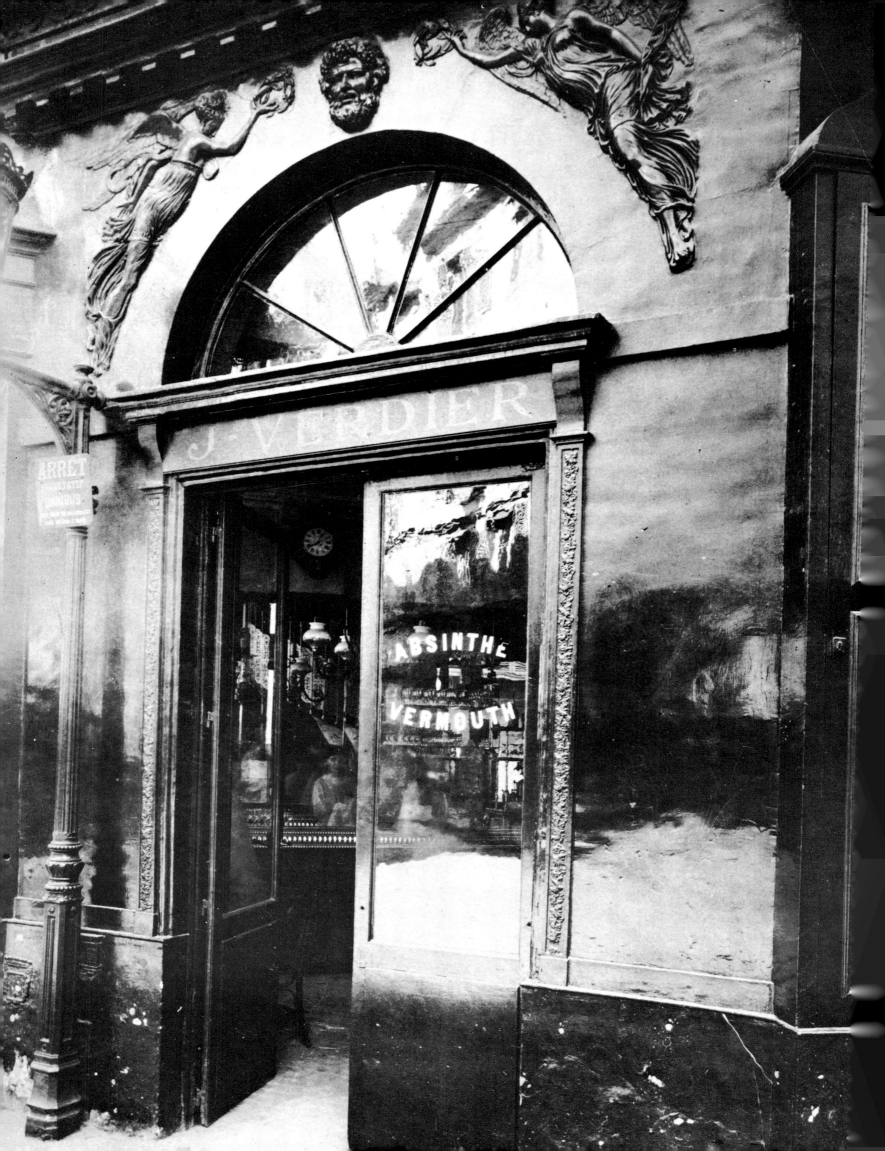

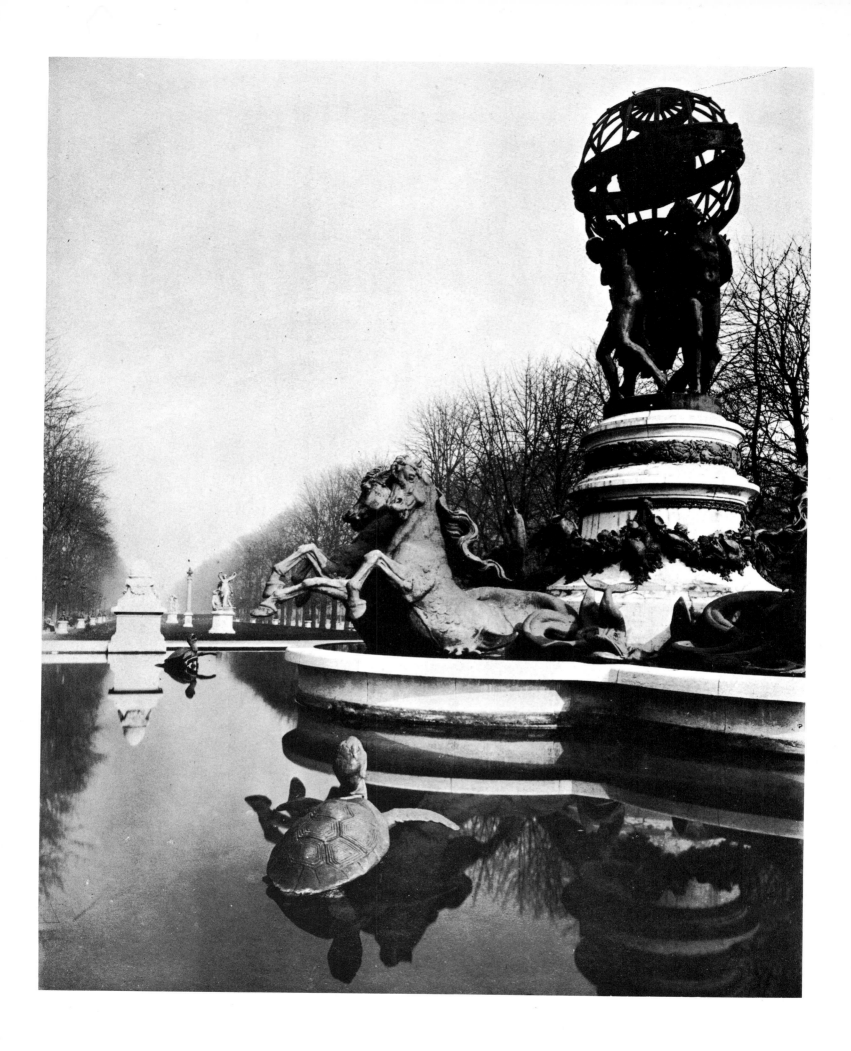

PLATE 48 / FOUNTAIN BY CARPEAUX. LUXEMBOURG

PLATE 49 / ORGAN-GRINDER AND STREET-SINGER

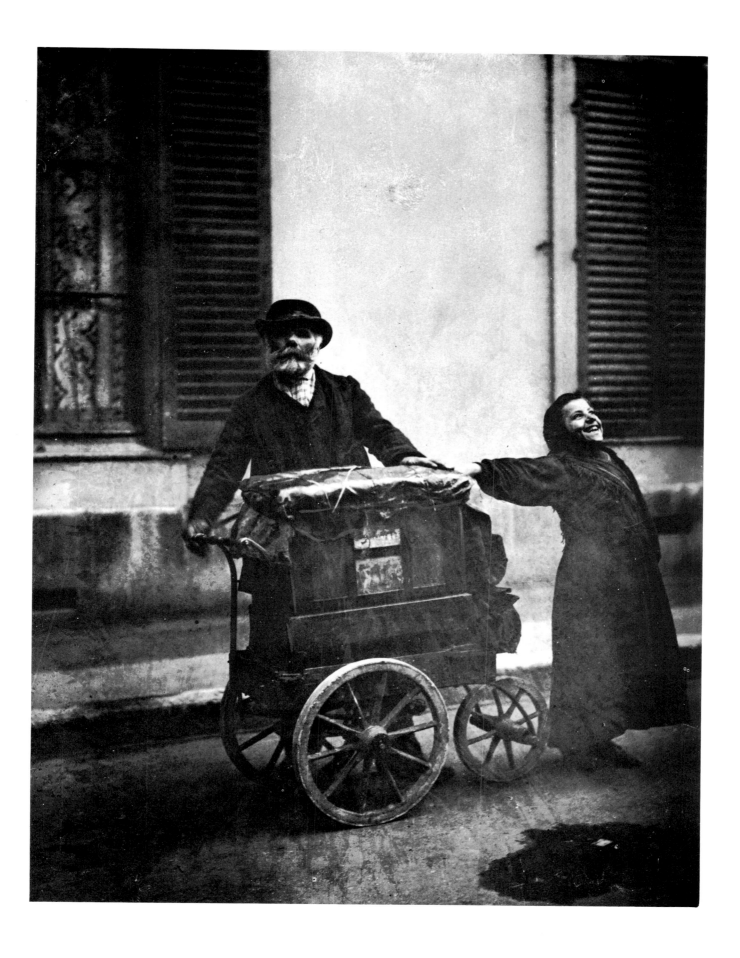

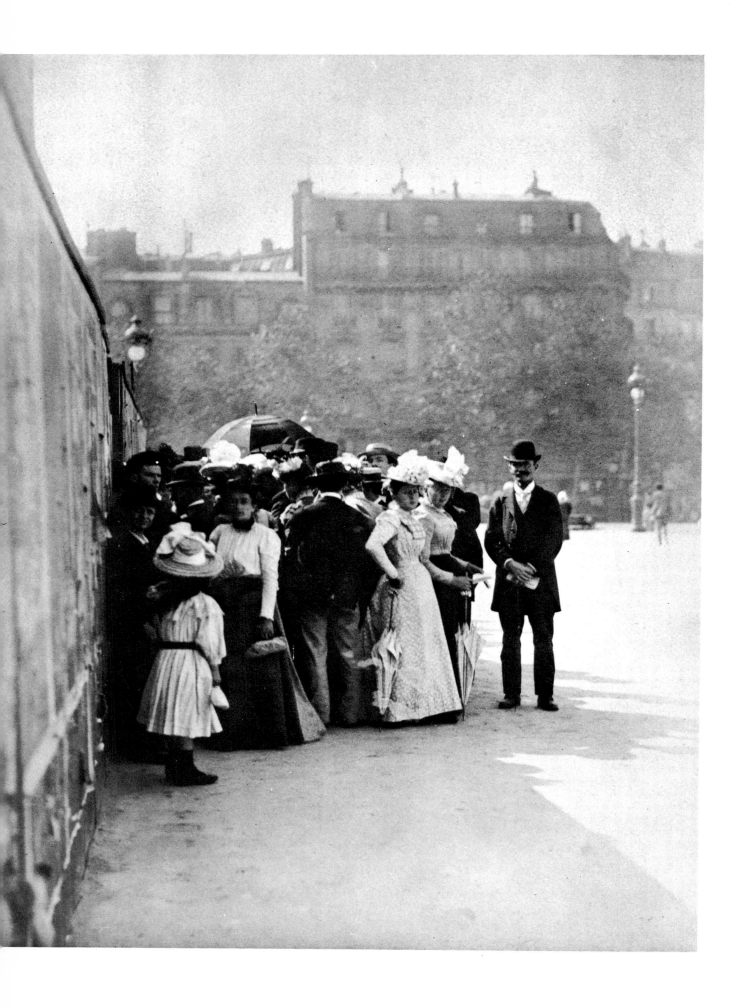

PLATE 50 / STREET SCENE

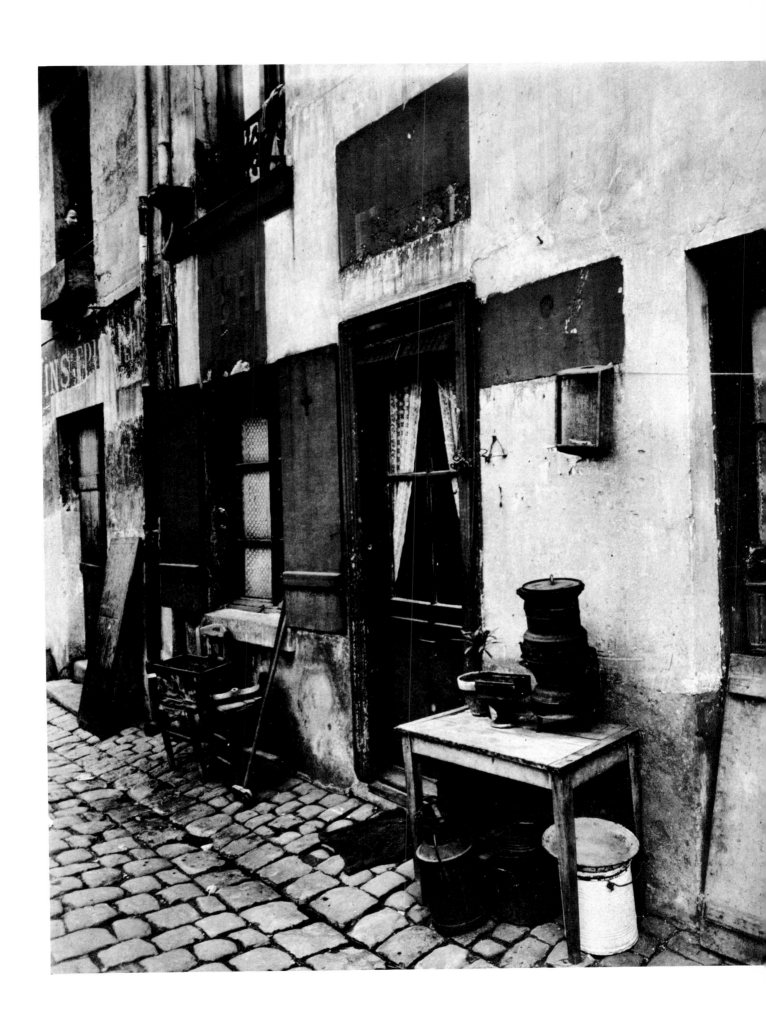

PLATE 51 / 90 BLVD. DE LA GARE

PLATE 52 / RUE RATAUD

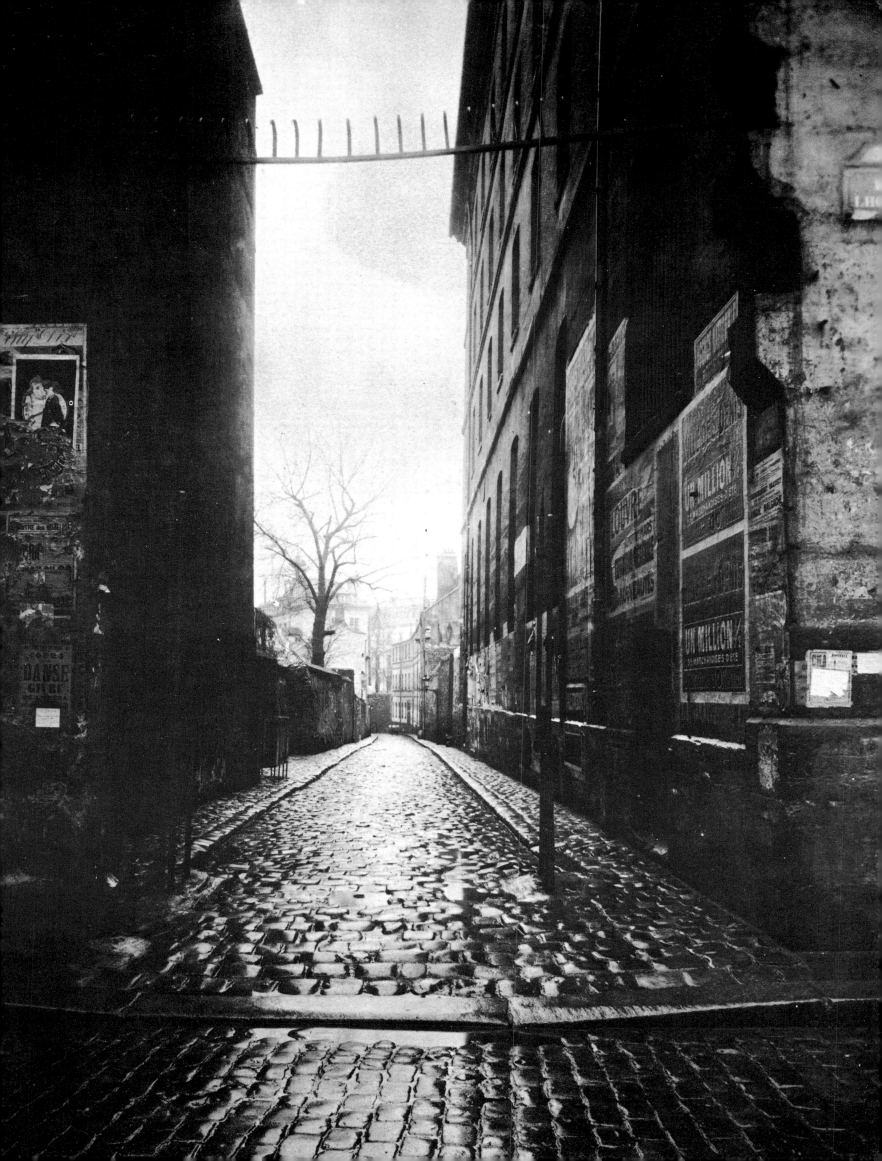

PLATE 53 / METAL BRIDGE

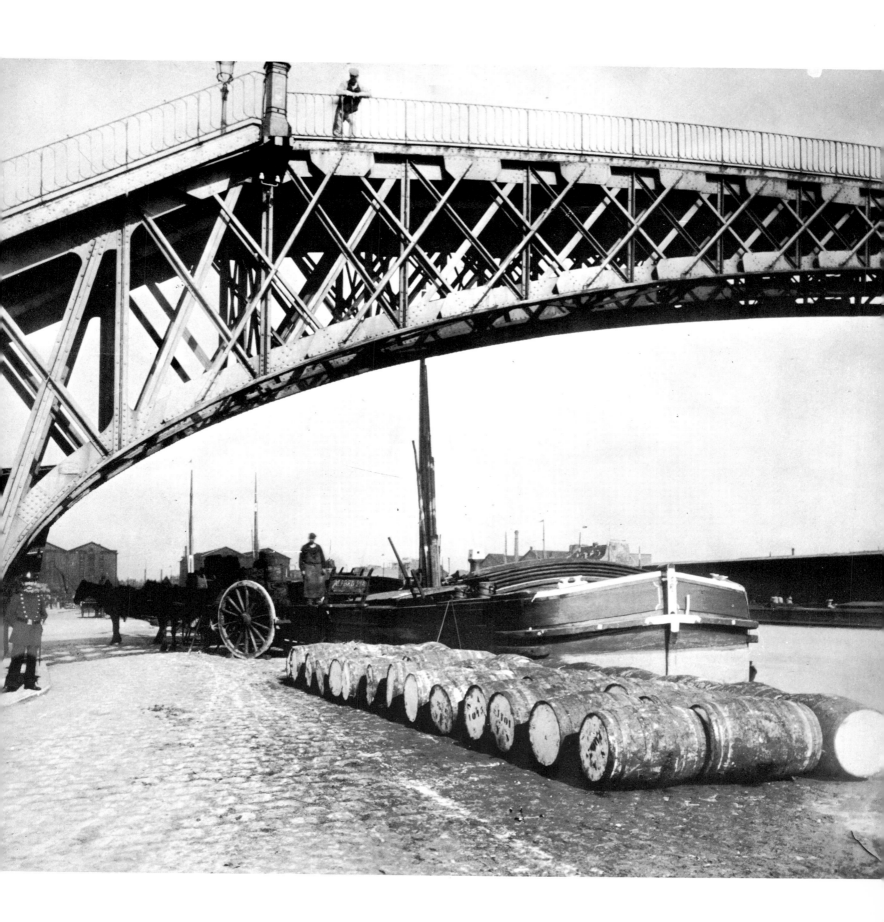

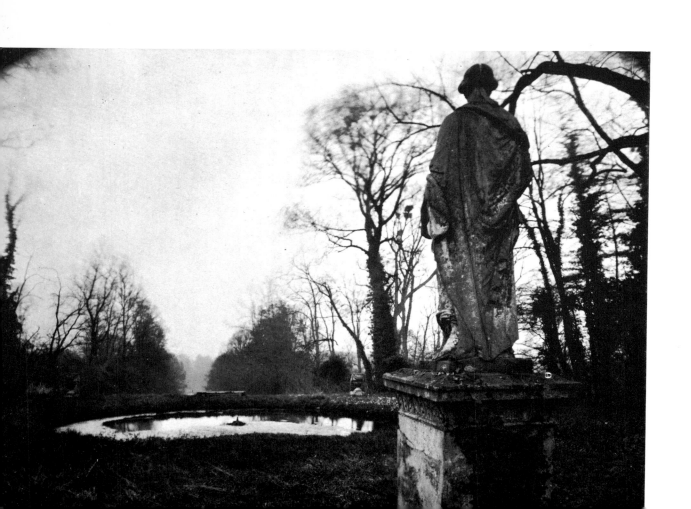

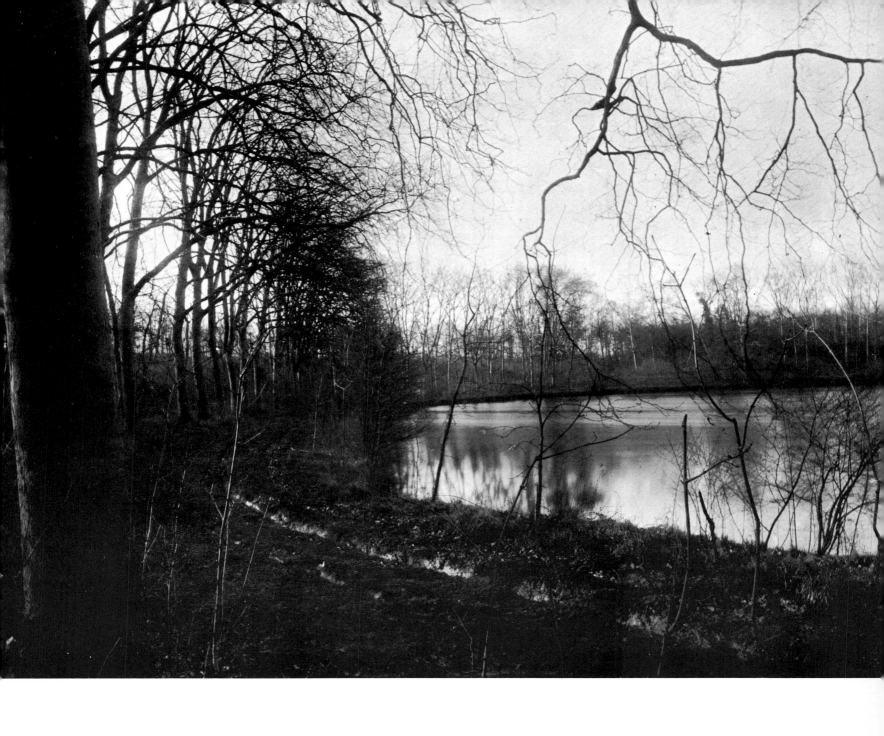

LATE 54 / POOL. SCEAUX PARK PLATE 55 / POND. SCEAUX PARK

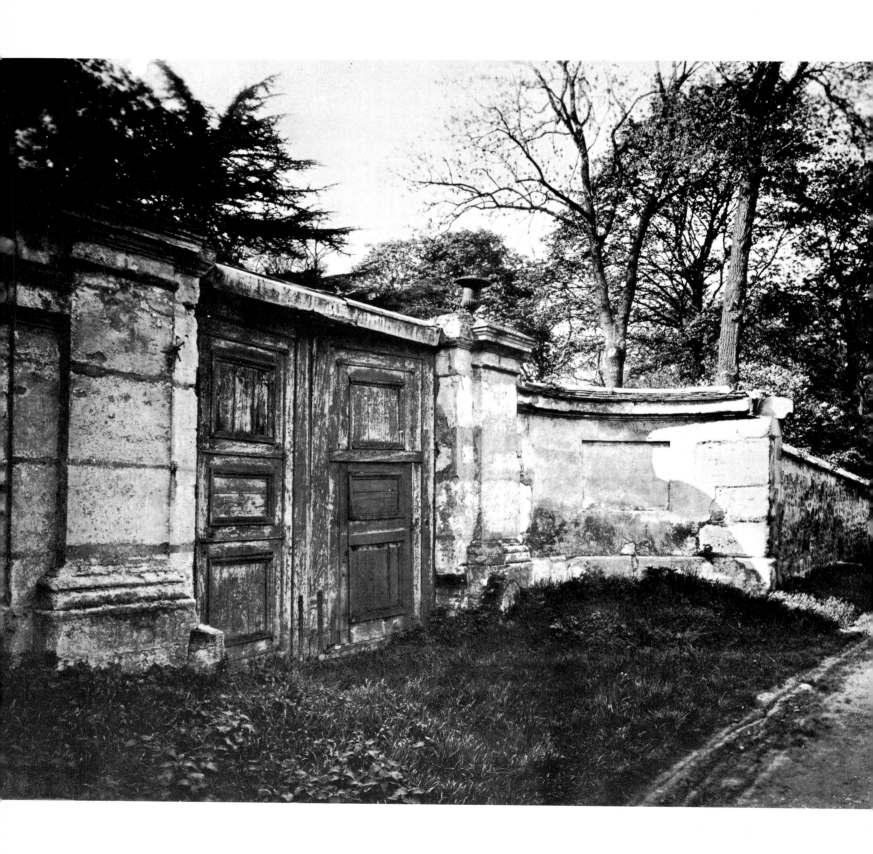

PLATE 56 / GATE TO AN OLD CHATEAU. CHATILLON

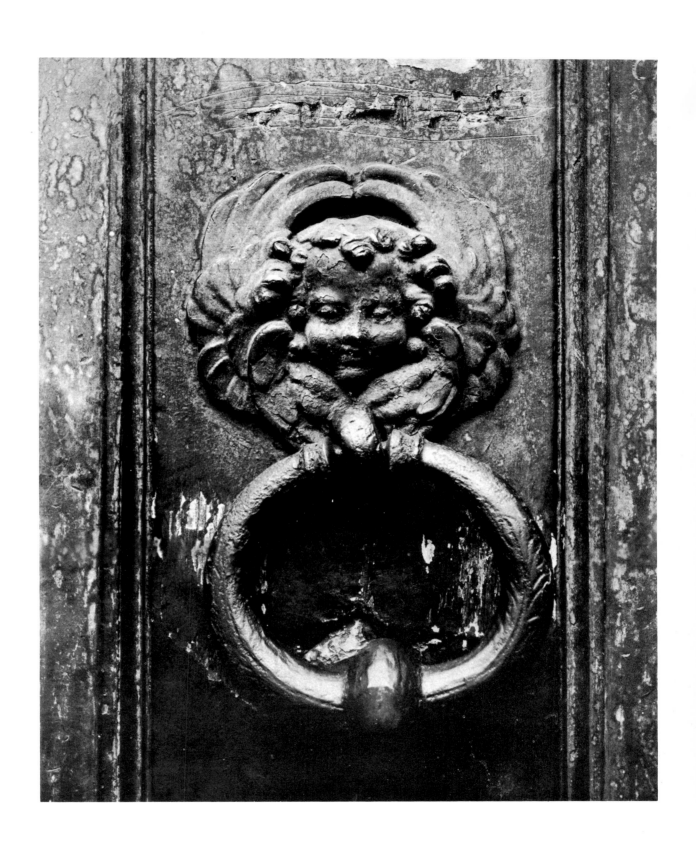

PLATE 57 / KNOCKER

PLATE 58 / INTERIOR

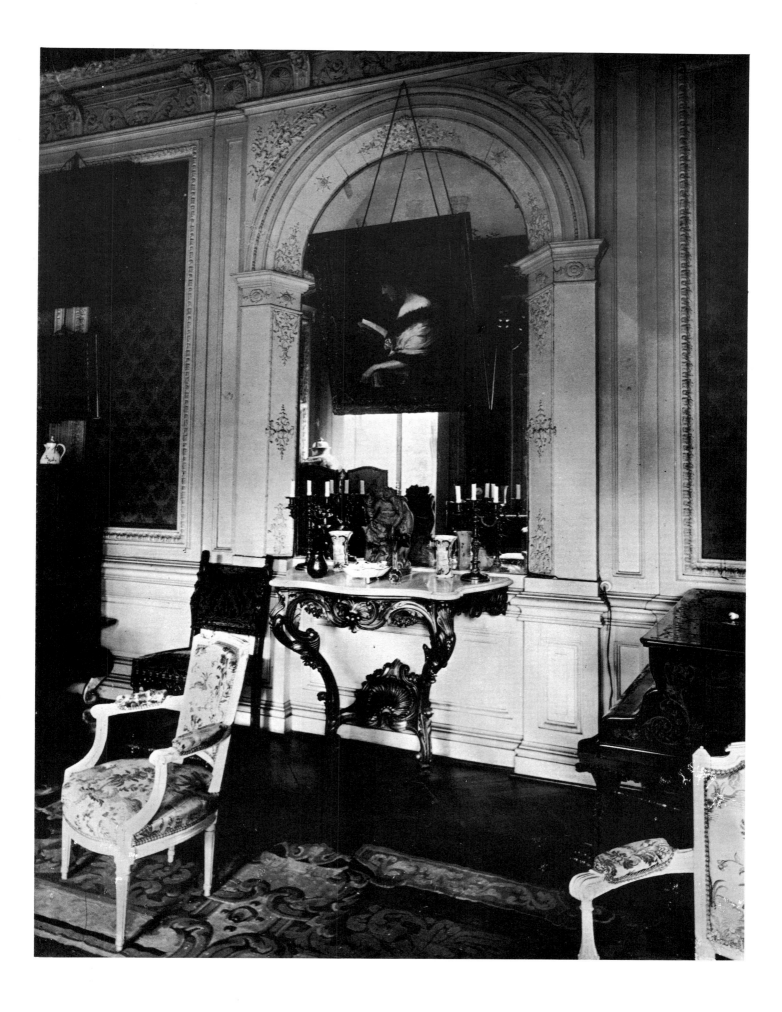

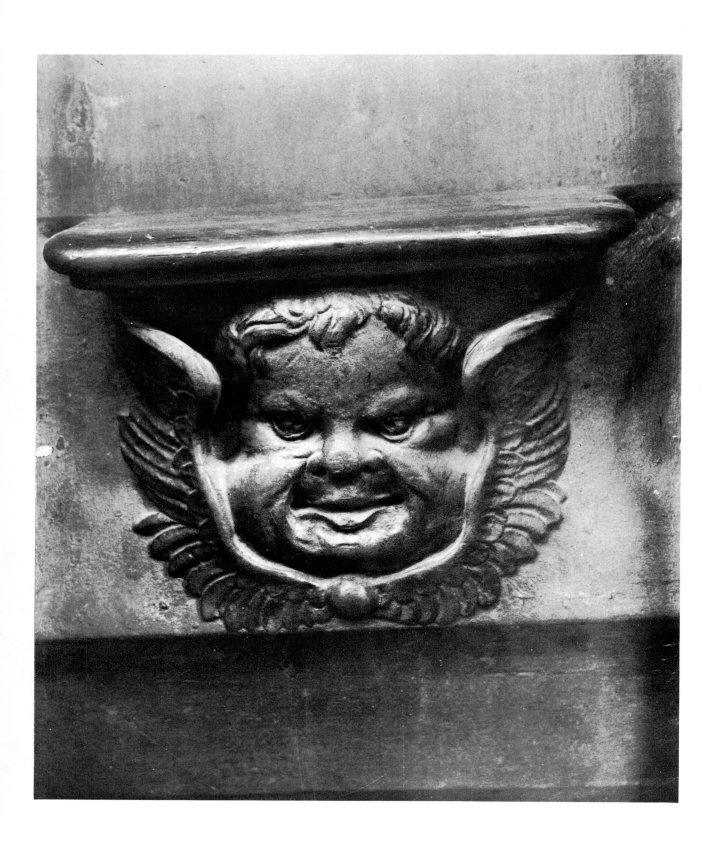

PLATE 59 / DETAIL. STS. GERVAIS AND PROTAIS

PLATE 60 / STALLS. AMIENS

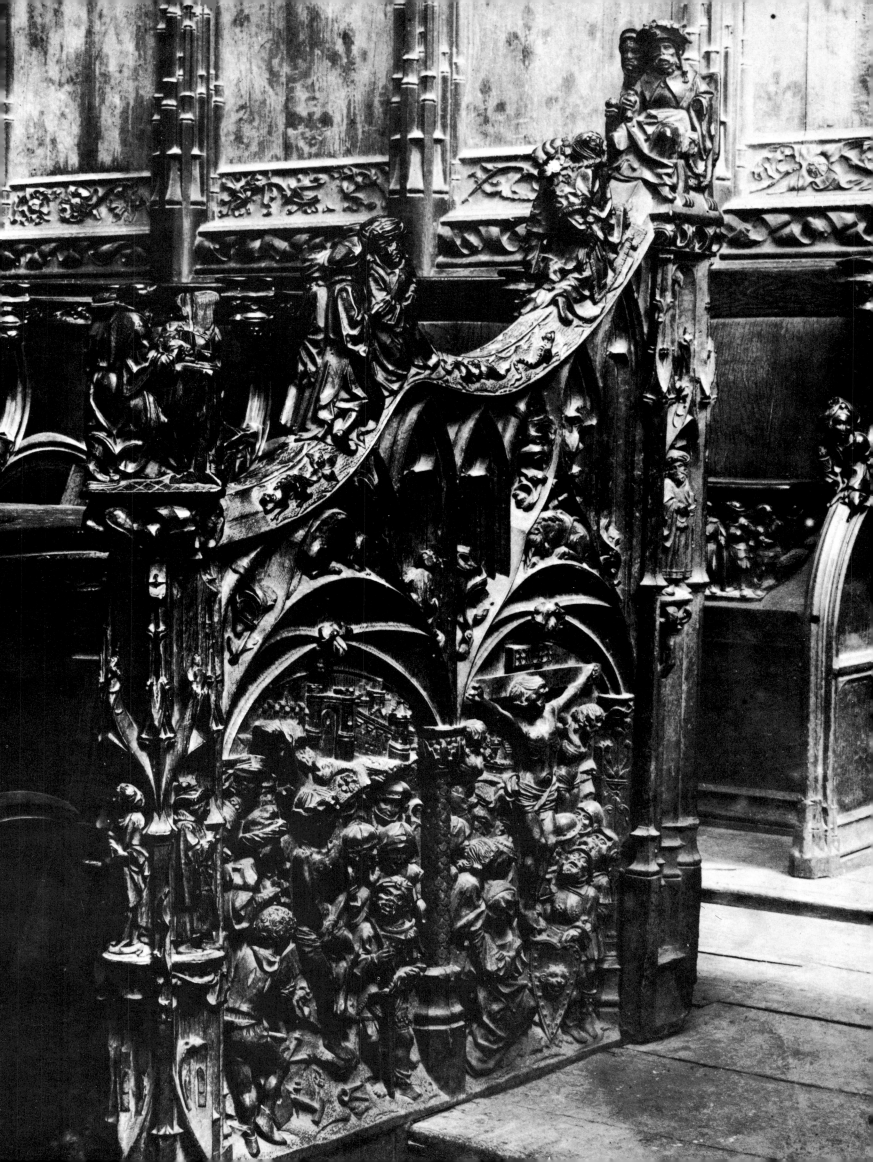

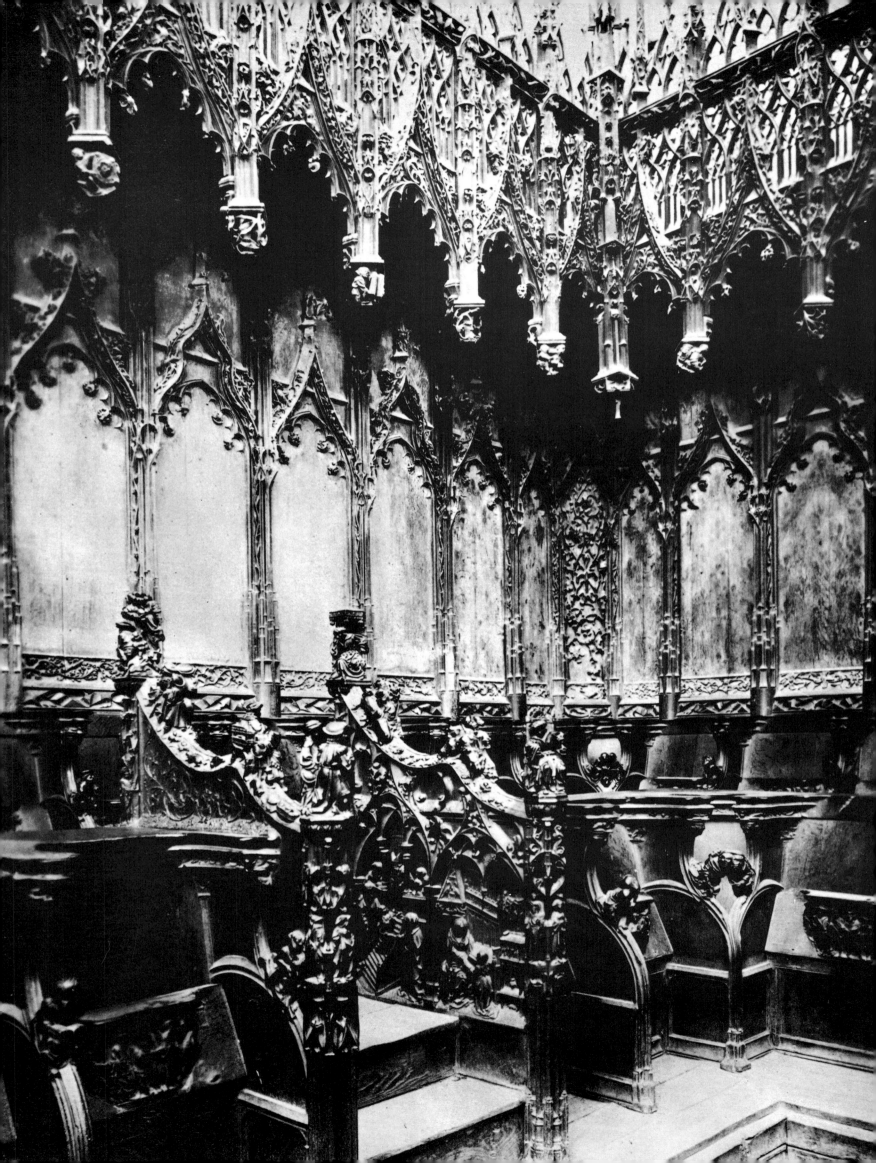

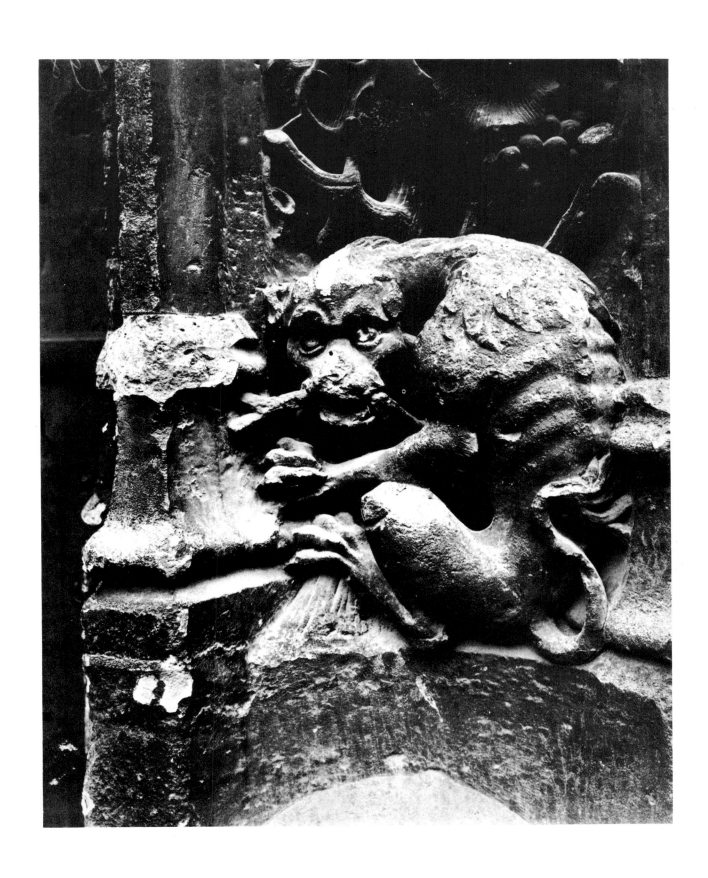

PLATE 61 / STALLS. AMIENS

PLATE 62 / DETAIL. PORTE DE CLUNY

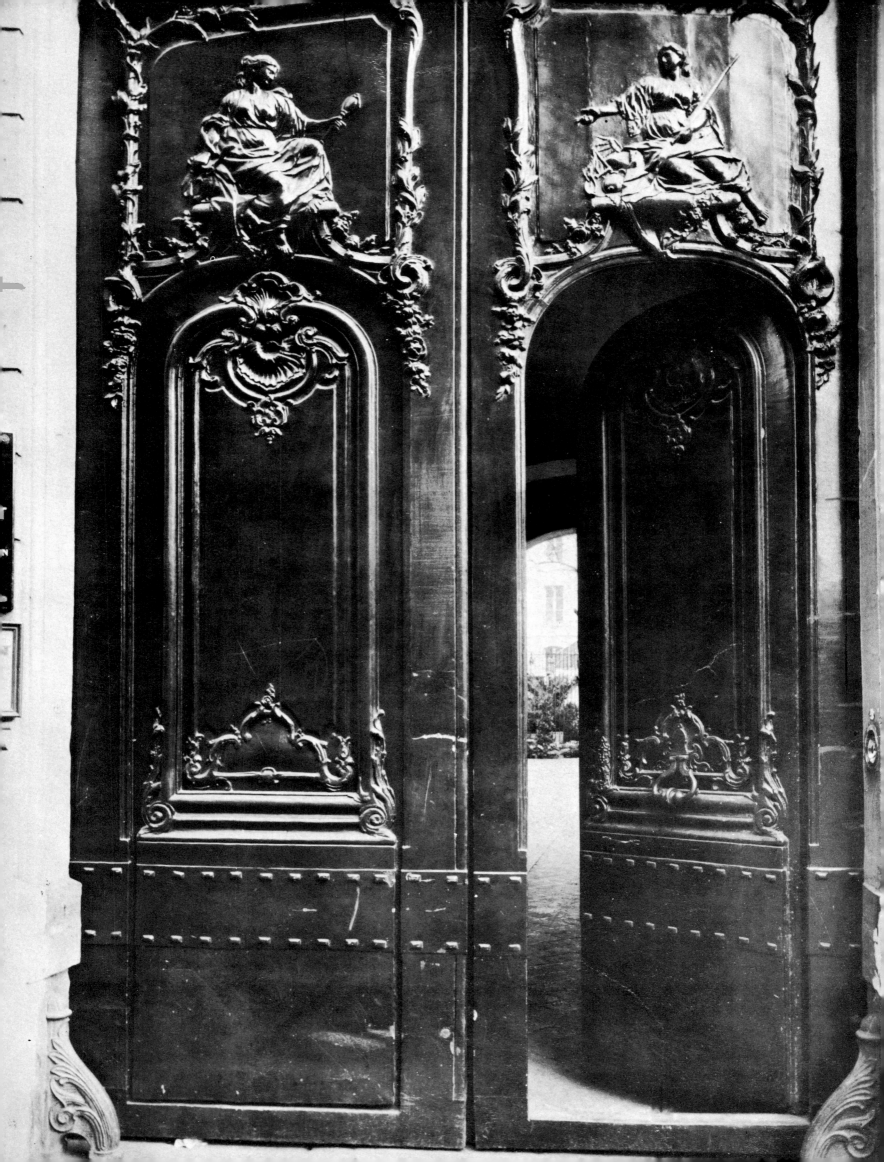

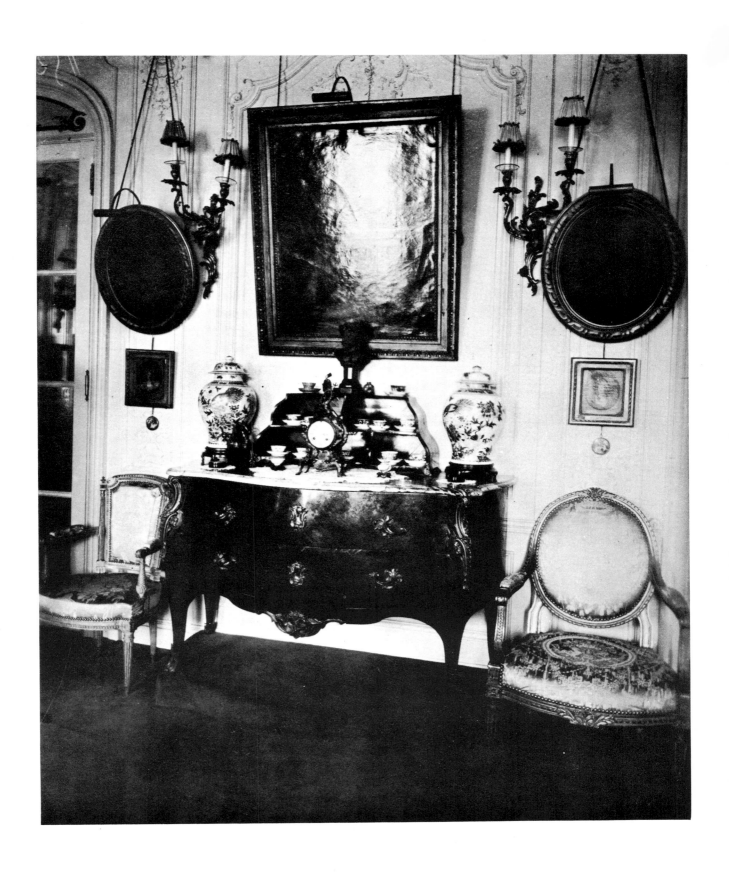

PLATE 64 / INTERIOR

PLATE 65 / WINDOW

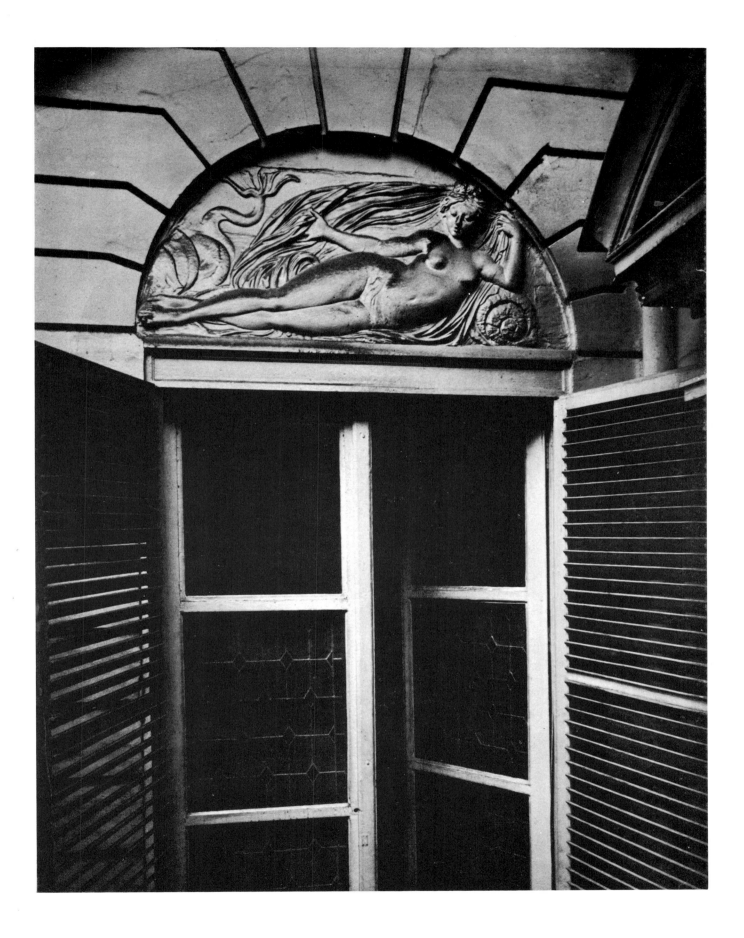

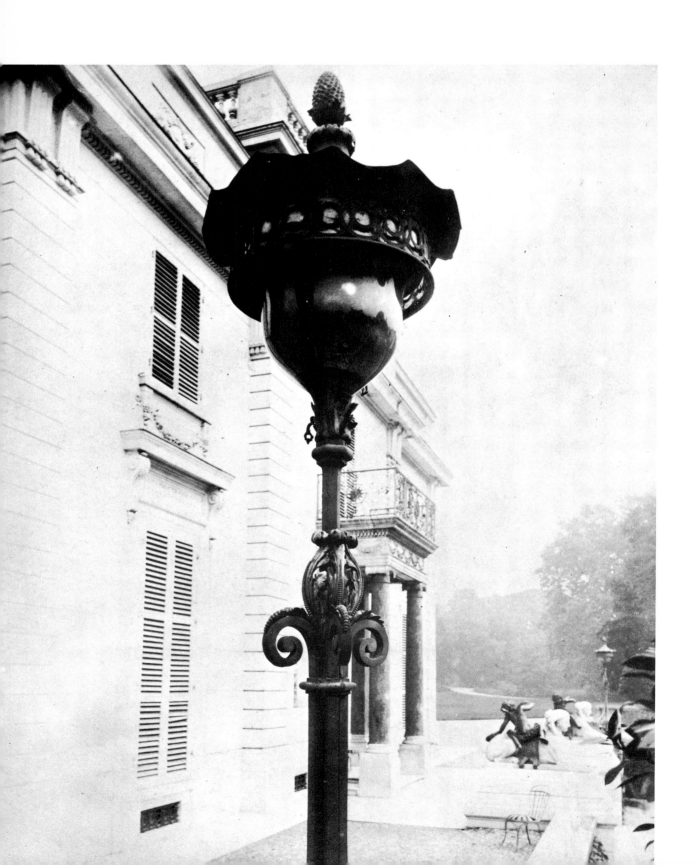

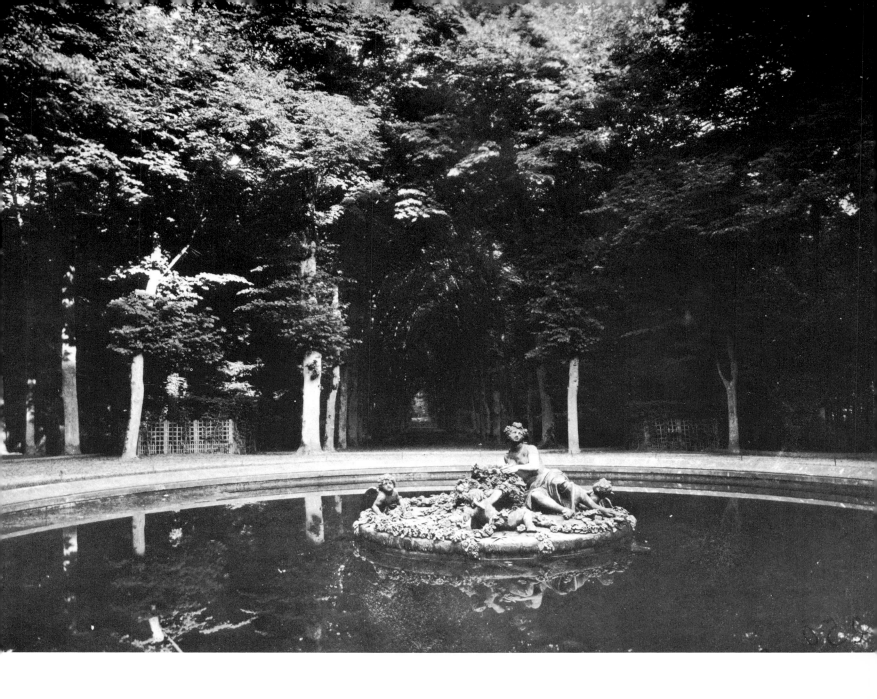

PLATE 68 / VENUS BY COYSEVAUX. VERSAILLES

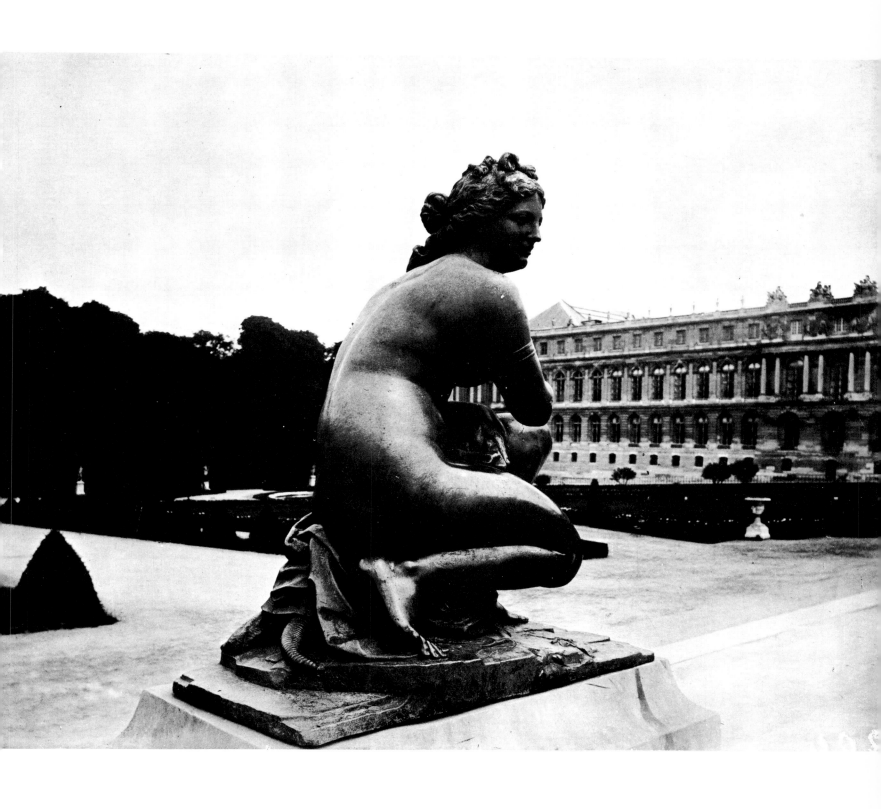

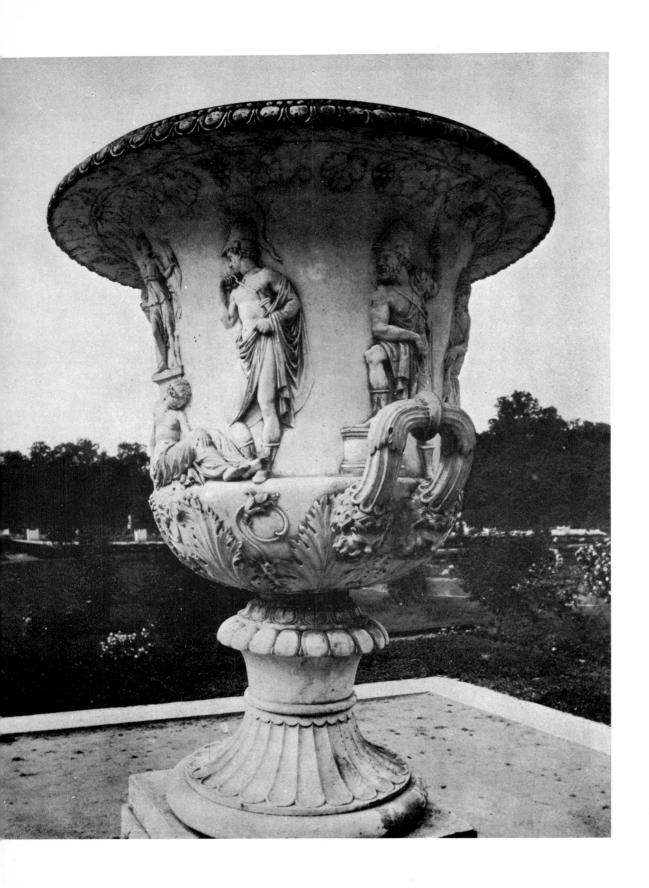

PLATE 69 / URN. VERSAILLES

PLATE 70 / AQUEDUCT. ARCUEIL-CACHA

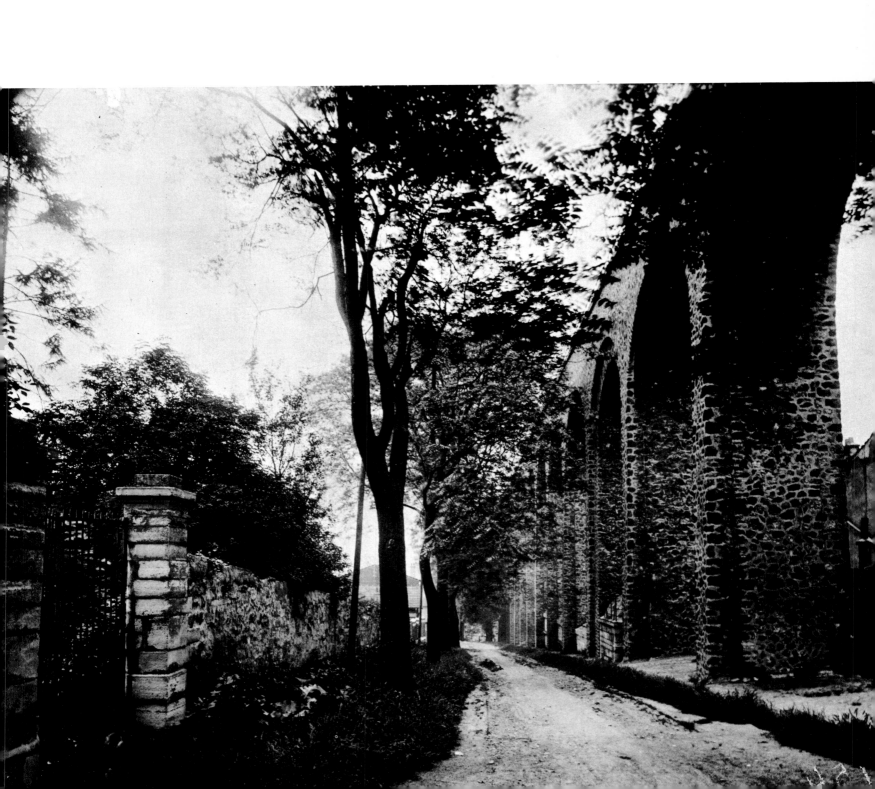

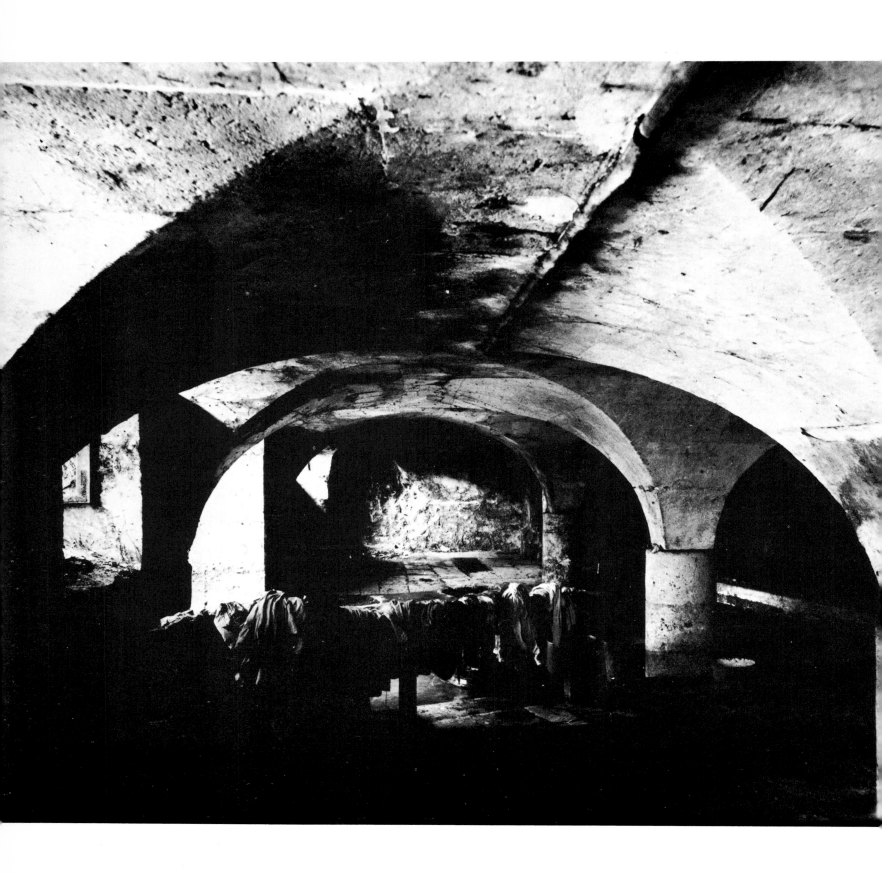

PLATE 71 / OLD AGE HOME. ST. DENIS

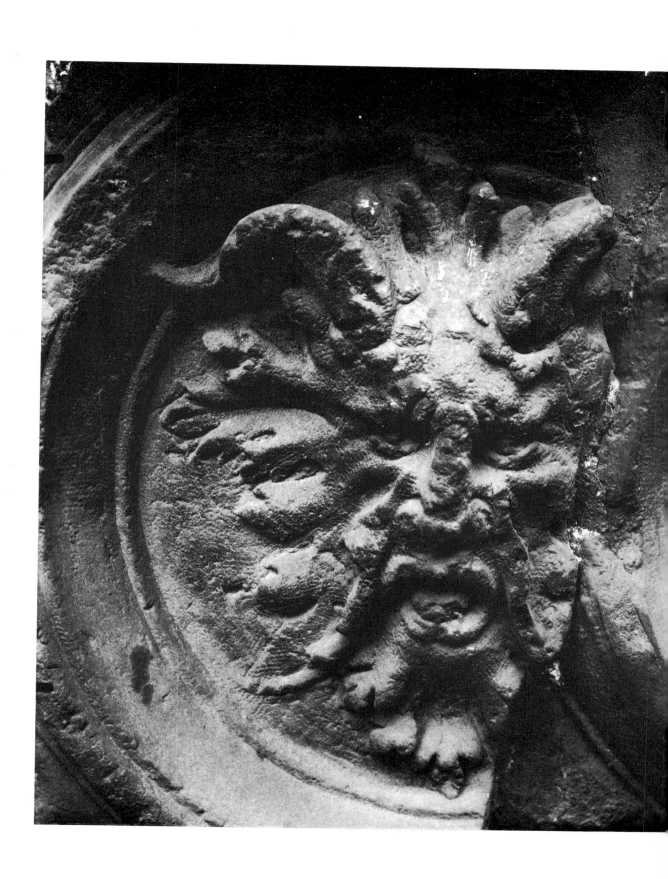

PLATE 72 / DETAIL. 16th CENTURY FAUN

PLATE 73 / RAG-PICKER

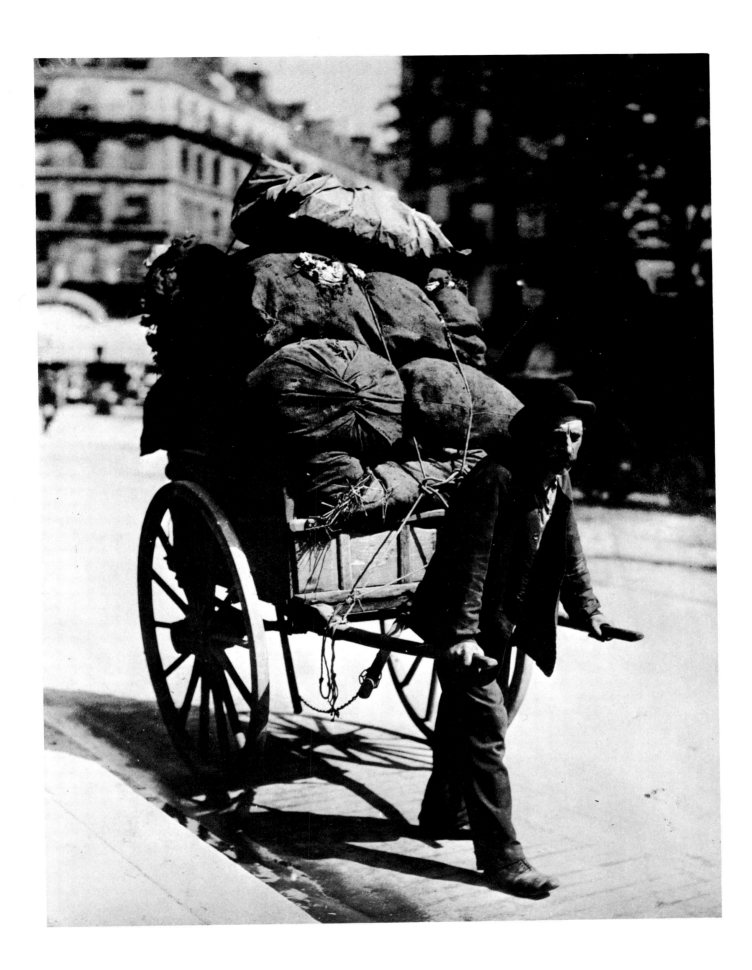

PLATE 74 / STREET SCENE

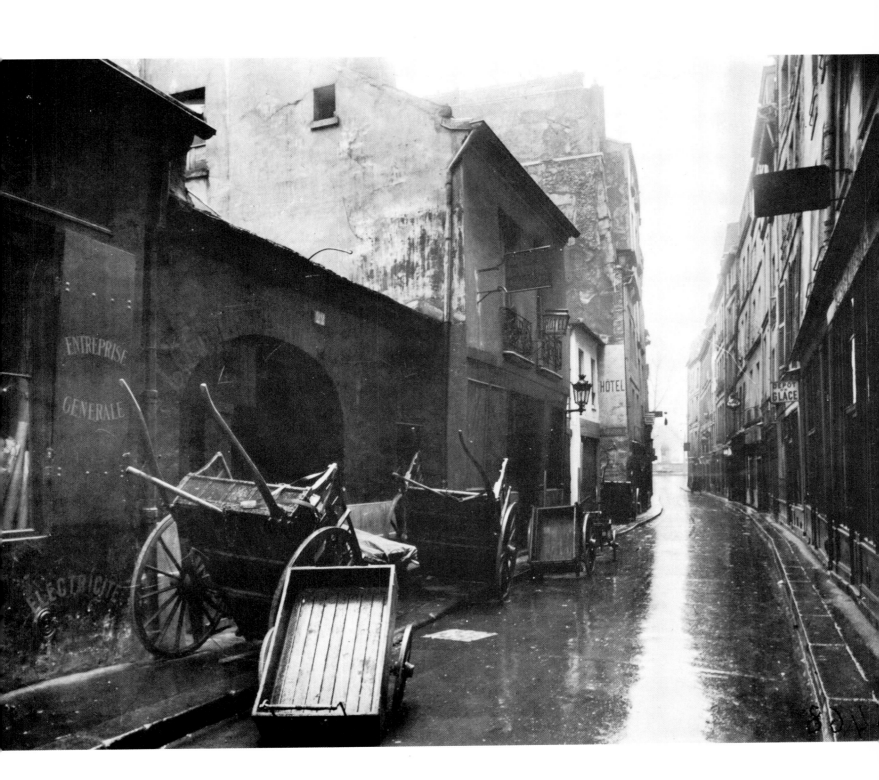

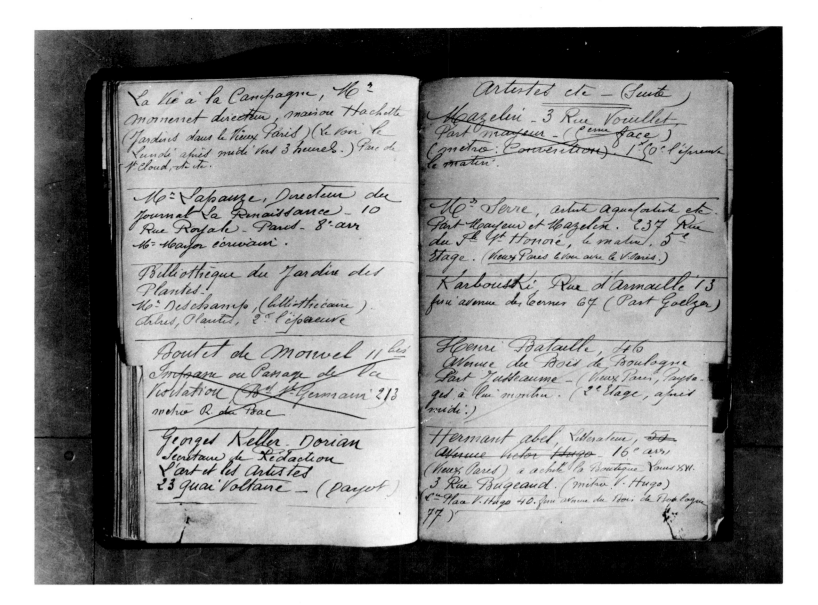

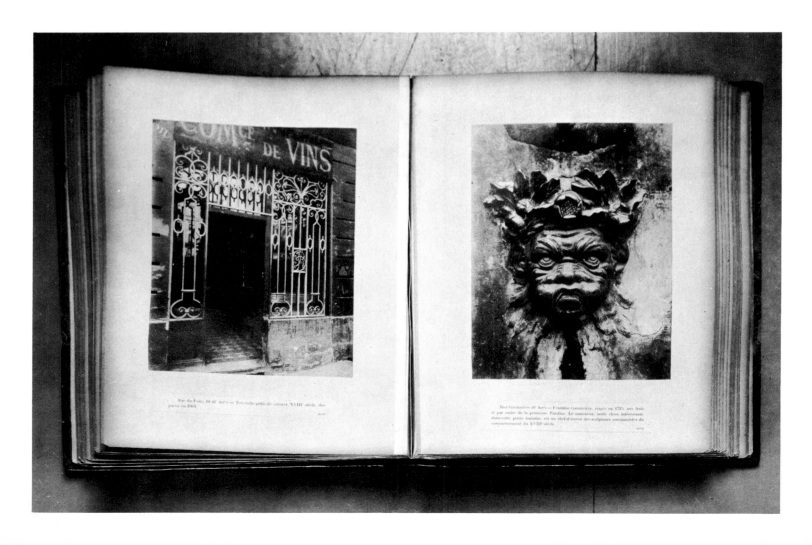

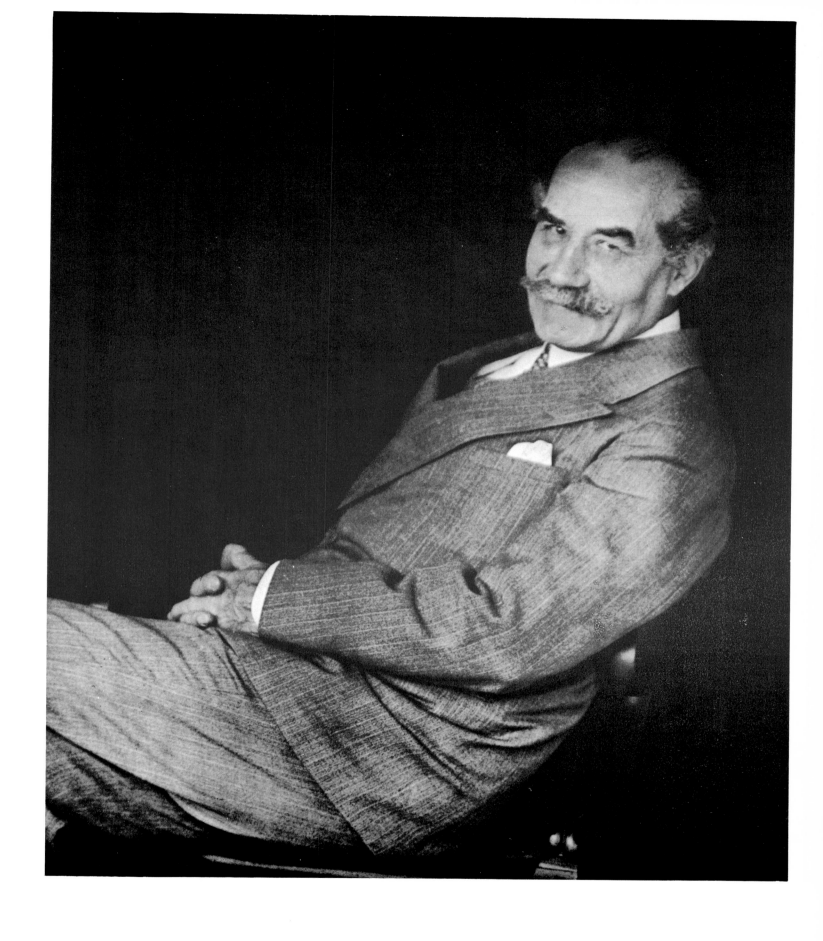

PLATE 77 / ANDRE CALMETTE

PHOTOGRAPHS BY BERENICE ABBOTT

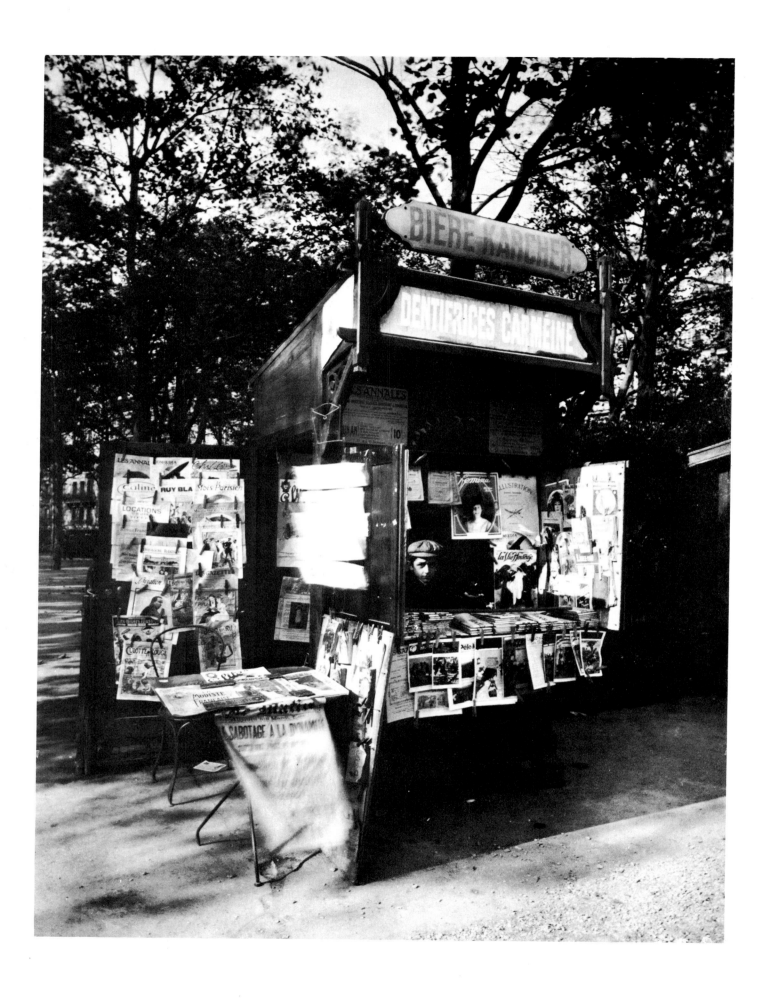

PLATE 78 / NEWSSTAND

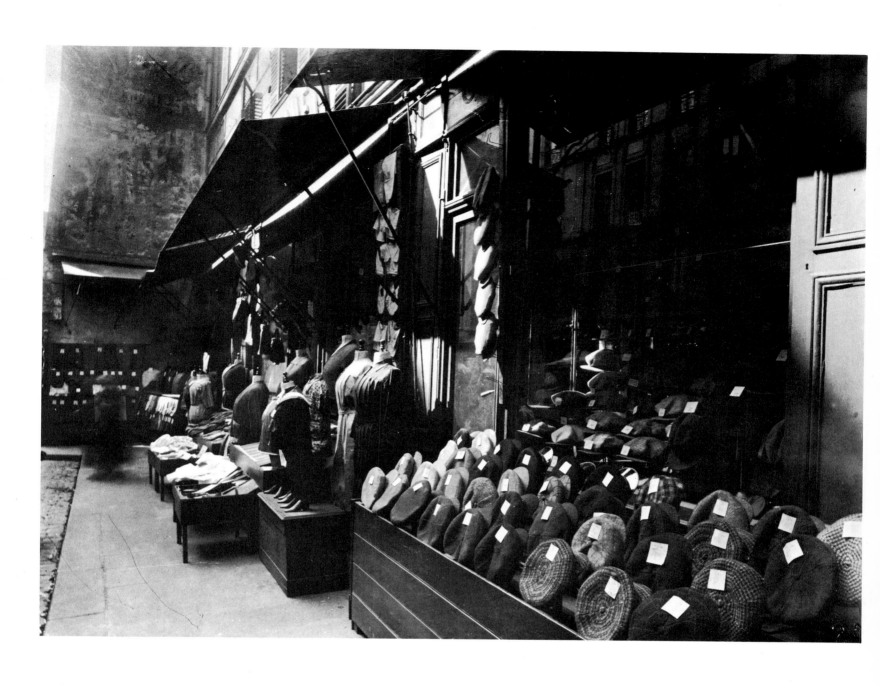

PLATE 79 / SHOPS

PLATE 80 / STORE

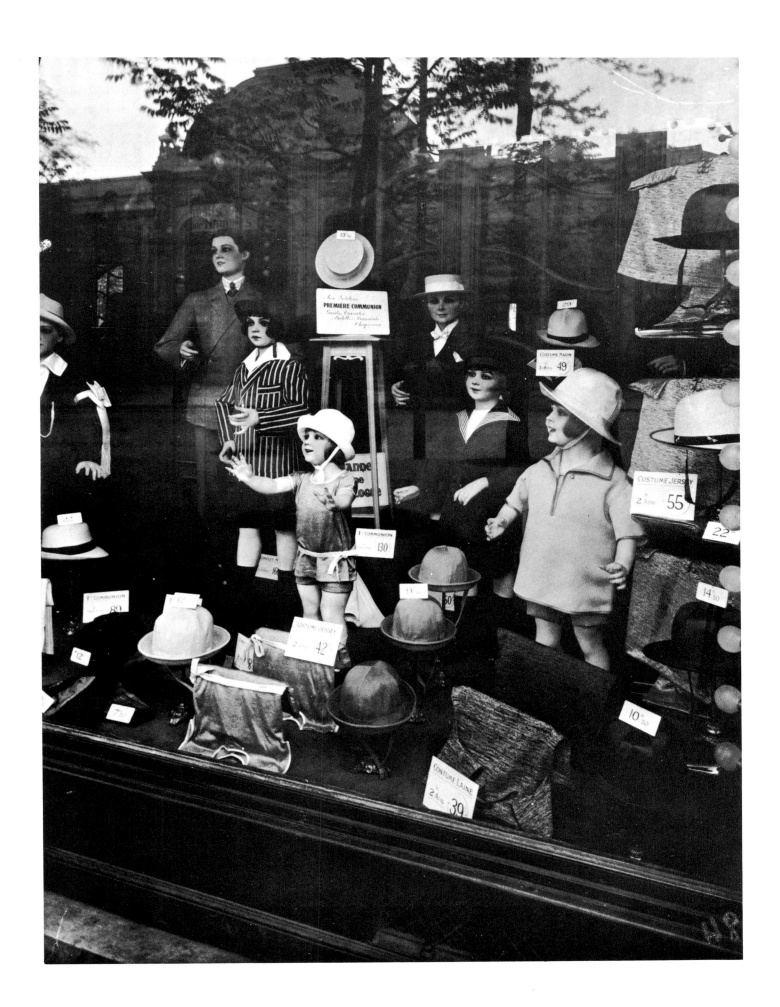

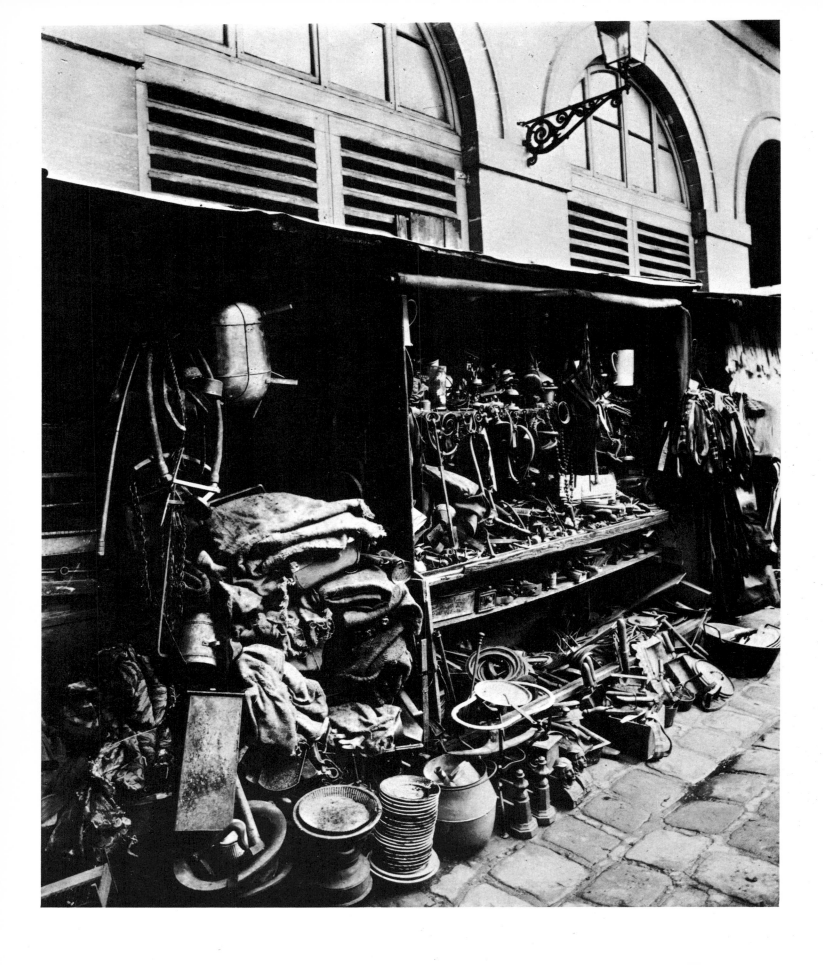

PLATE 81 / SECONDHAND STALLS

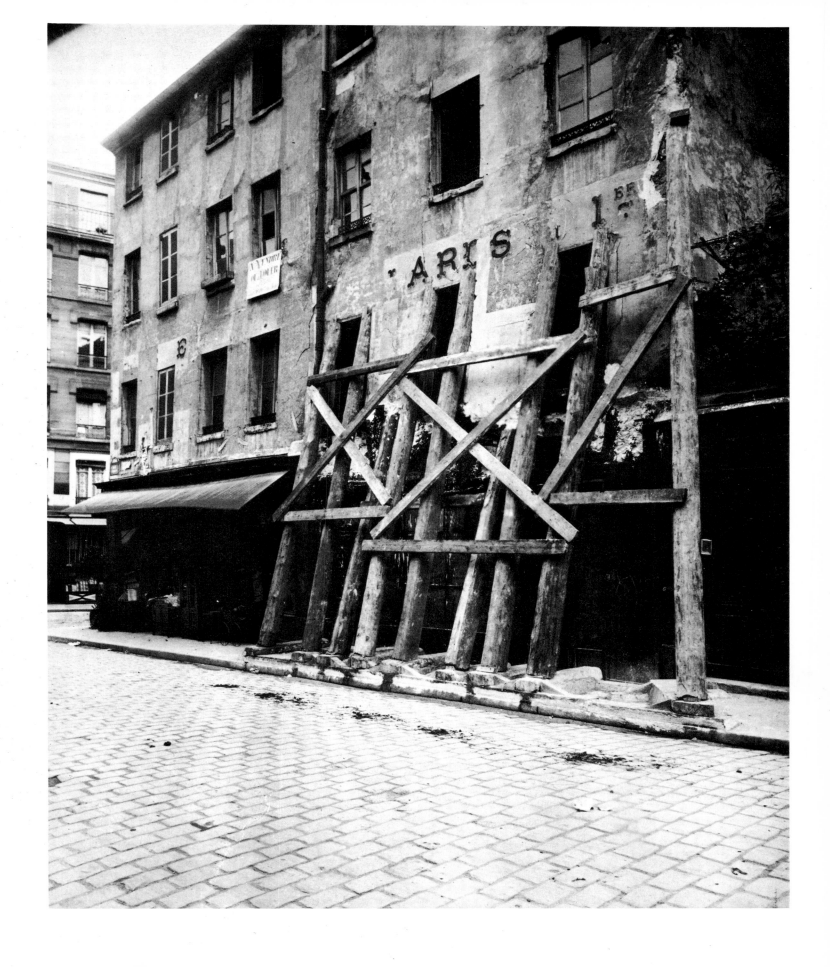

PLATE 82 / 5 RUE THOUIN

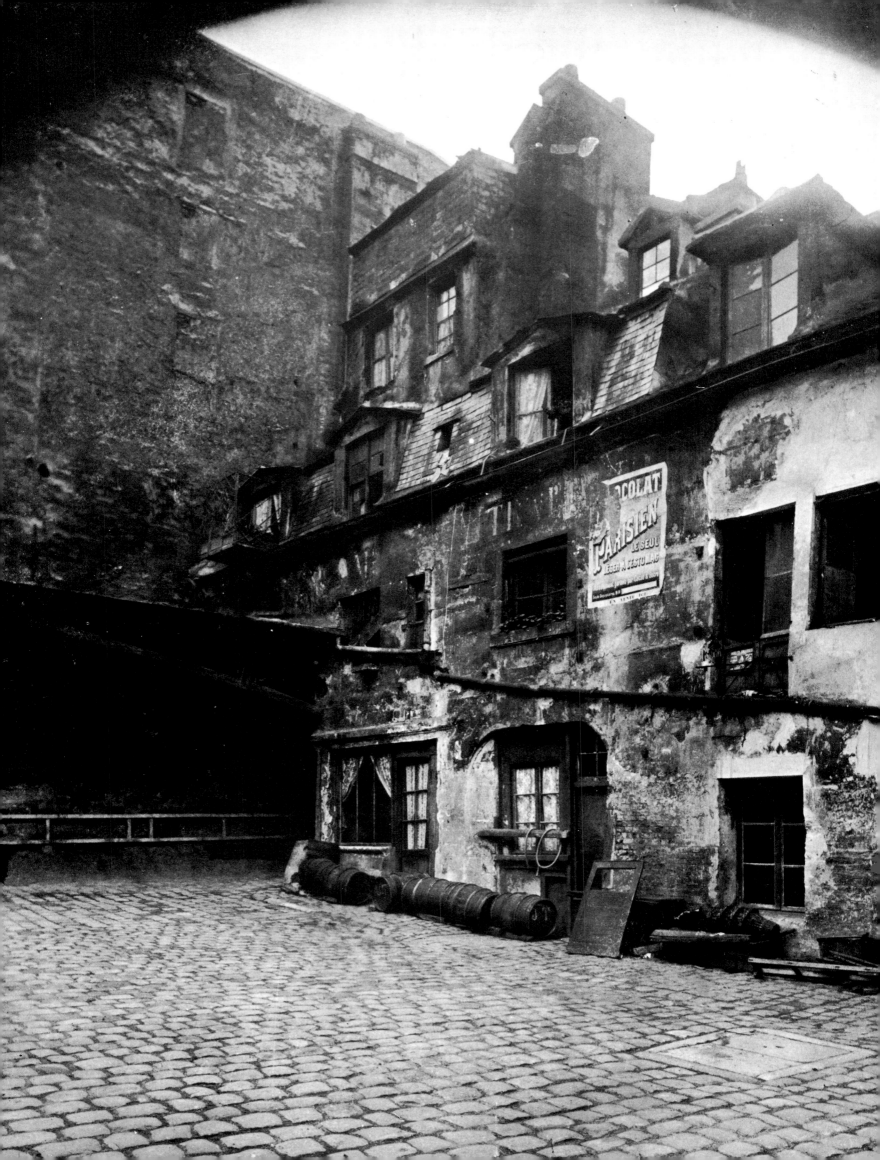

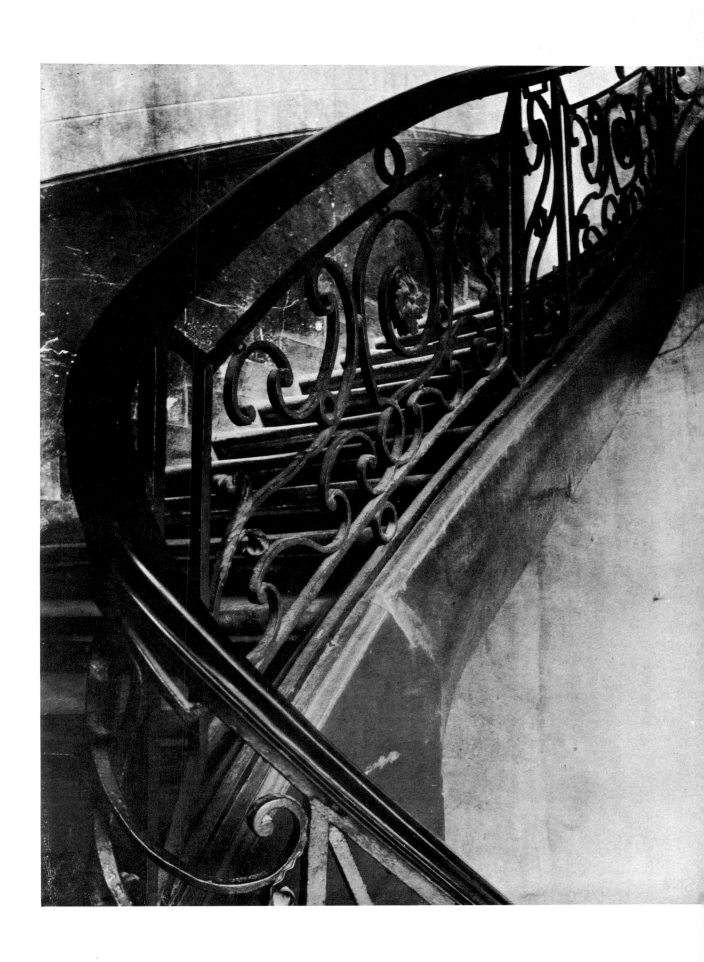

PLATE 83 / RUE MAZET

PLATE 84 / INTERIOR STAIRS. RUE ST. ANDRE DES ARTS

PLATE 85 / INTERIOR STAIRS

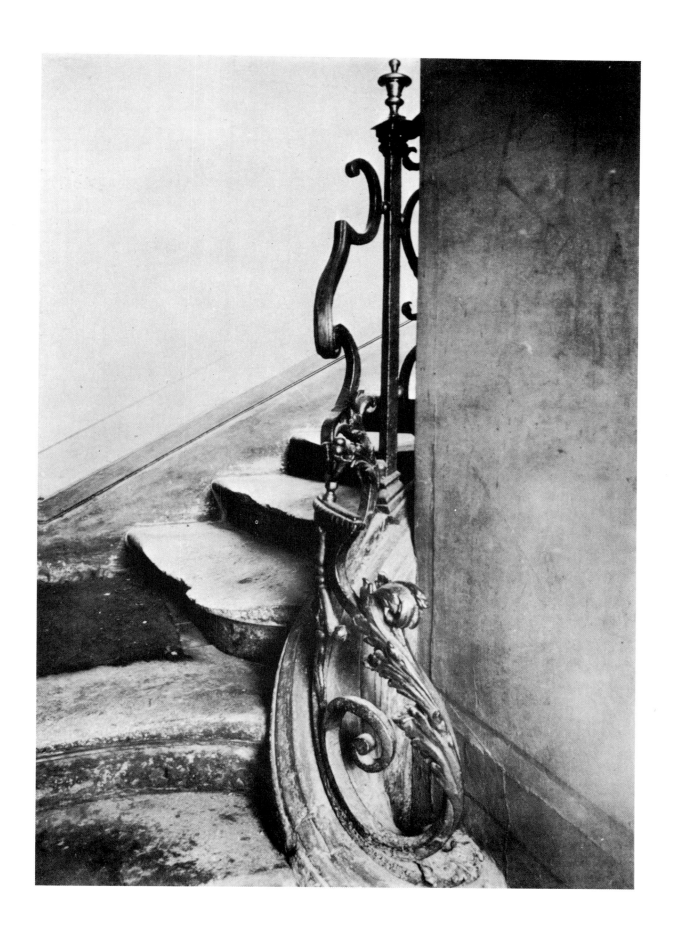

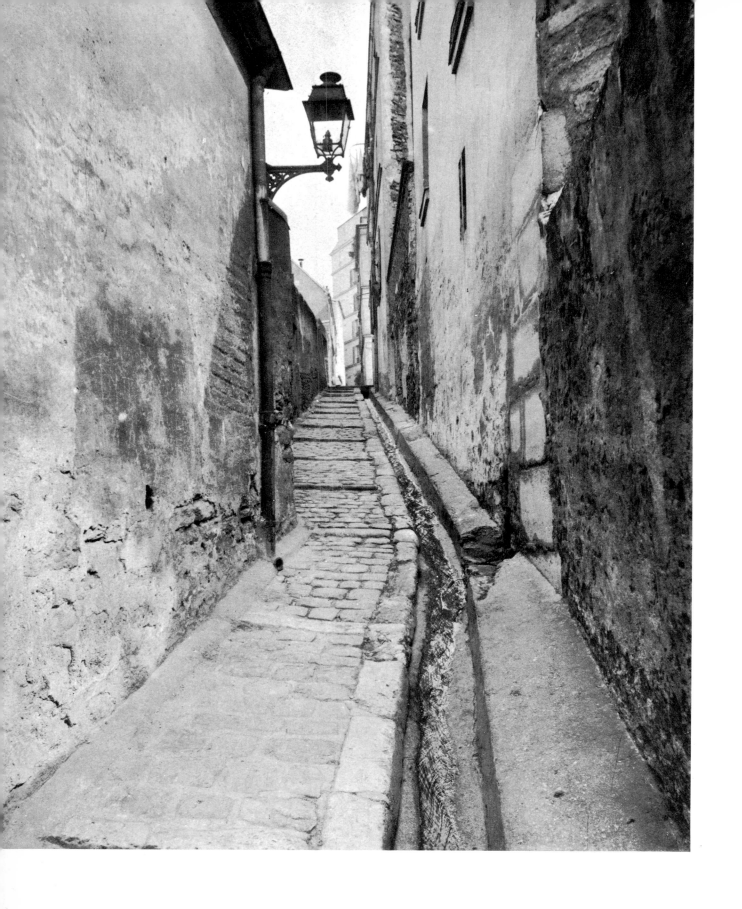

PLATE 86 / PASSAGE VAUDREZANNE. BUTTE AUX CAILLES

PLATE 87 / MONTMARTR

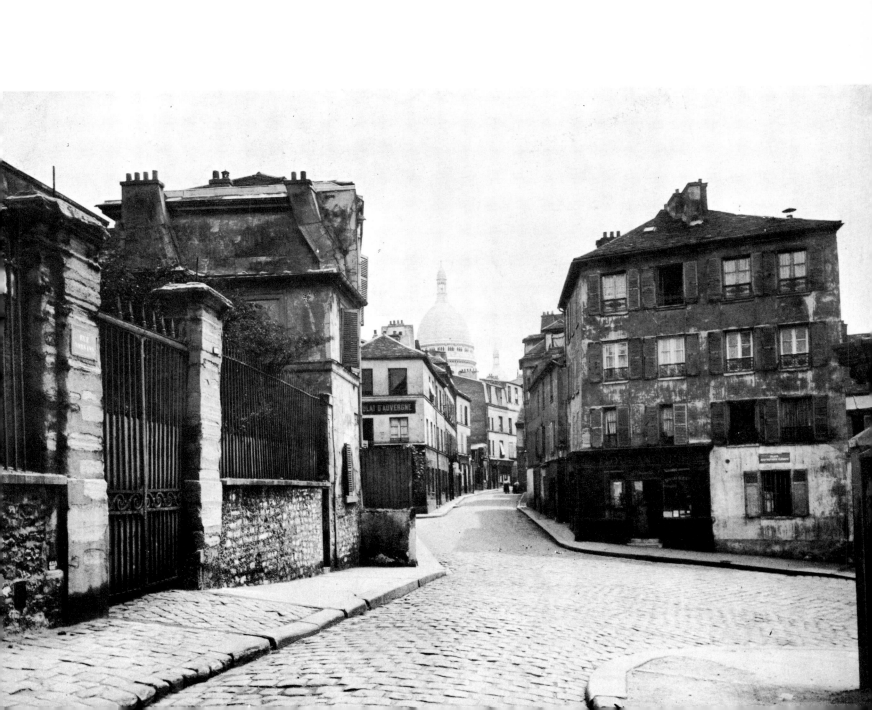

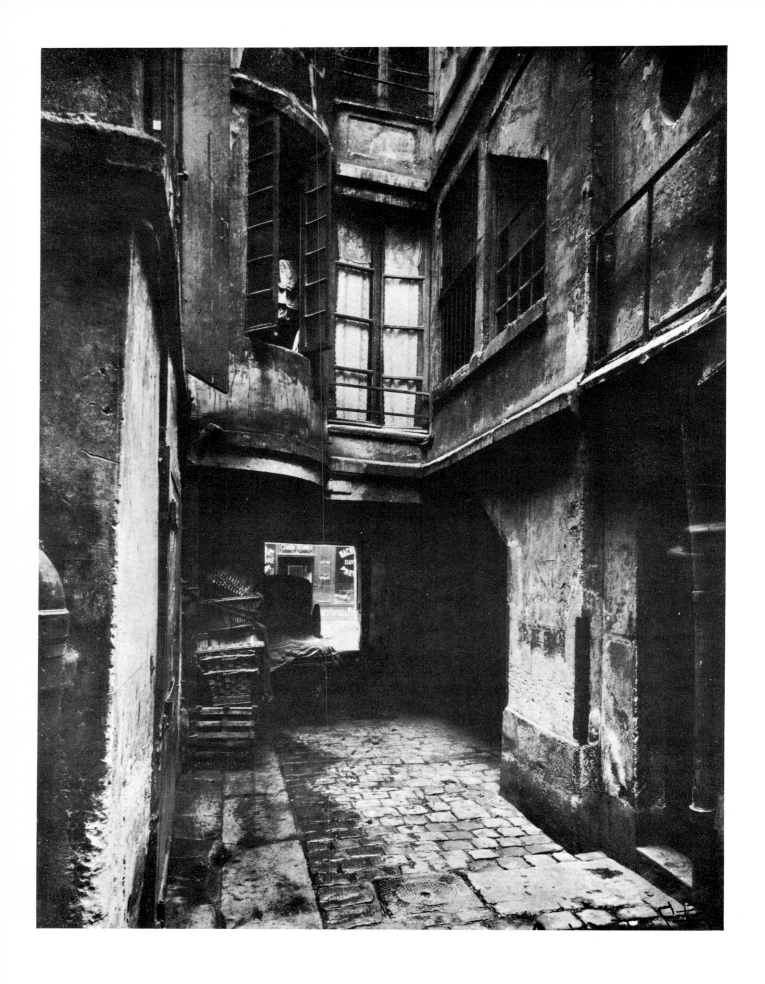

PLATE 88 / COURTYARD

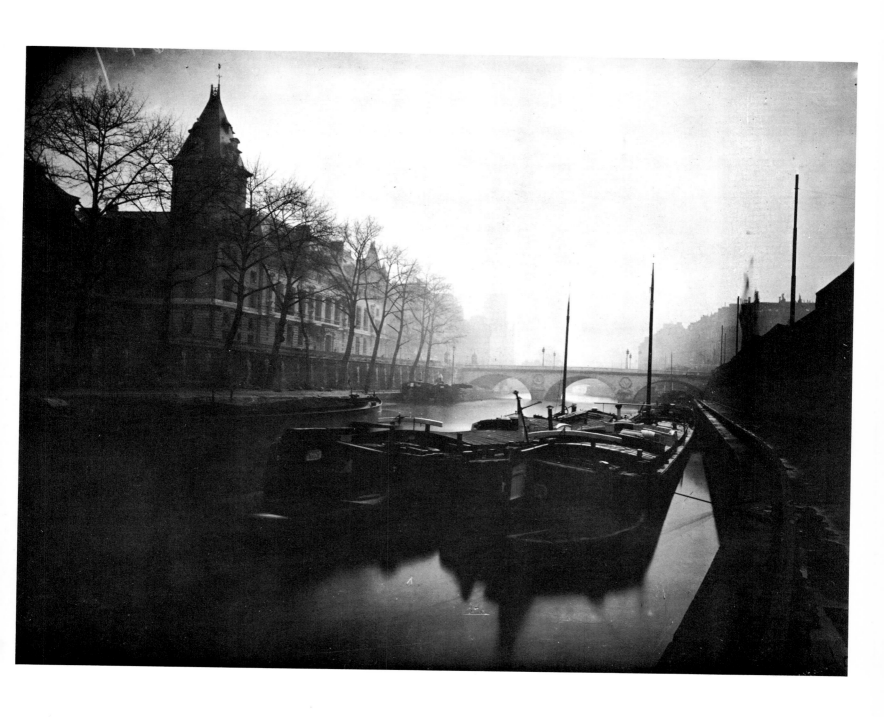

PLATE 89 / PONT ST. MICHEL

PLATE 90 / BUTCHER

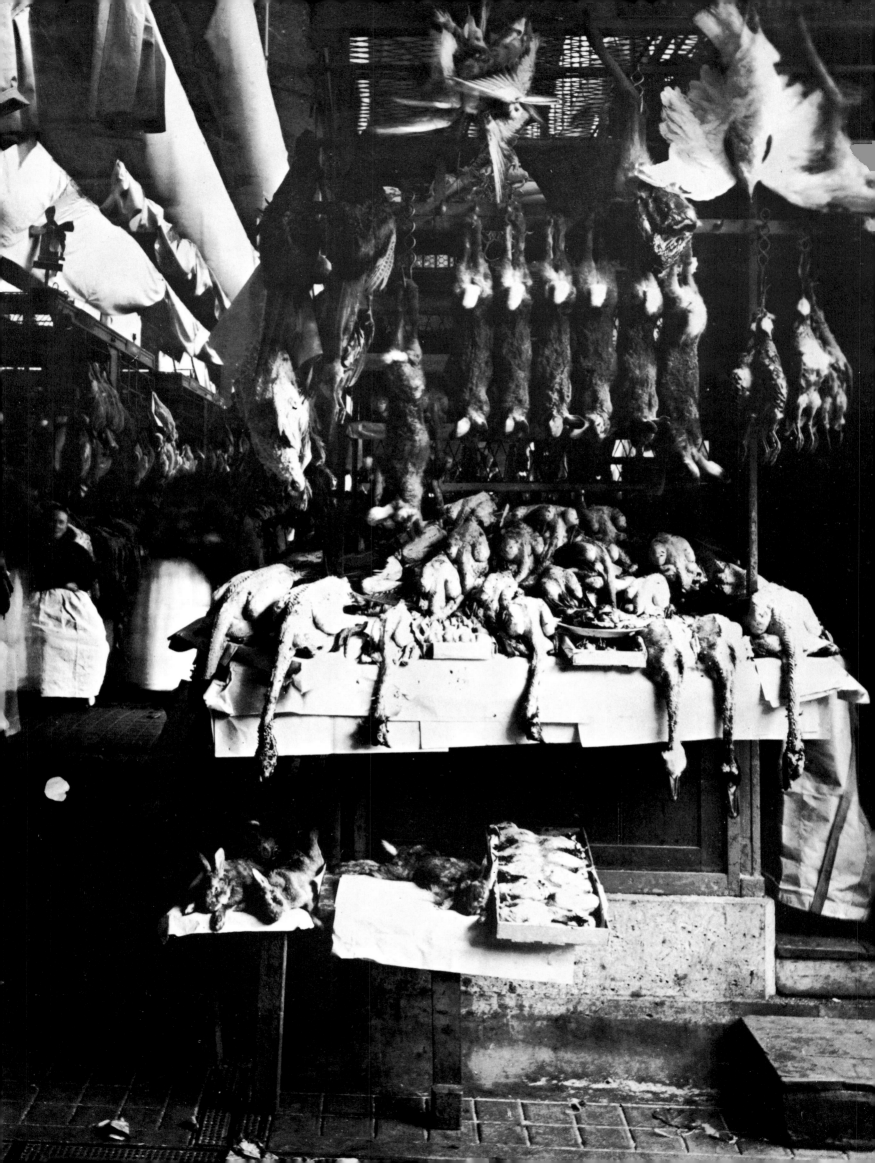

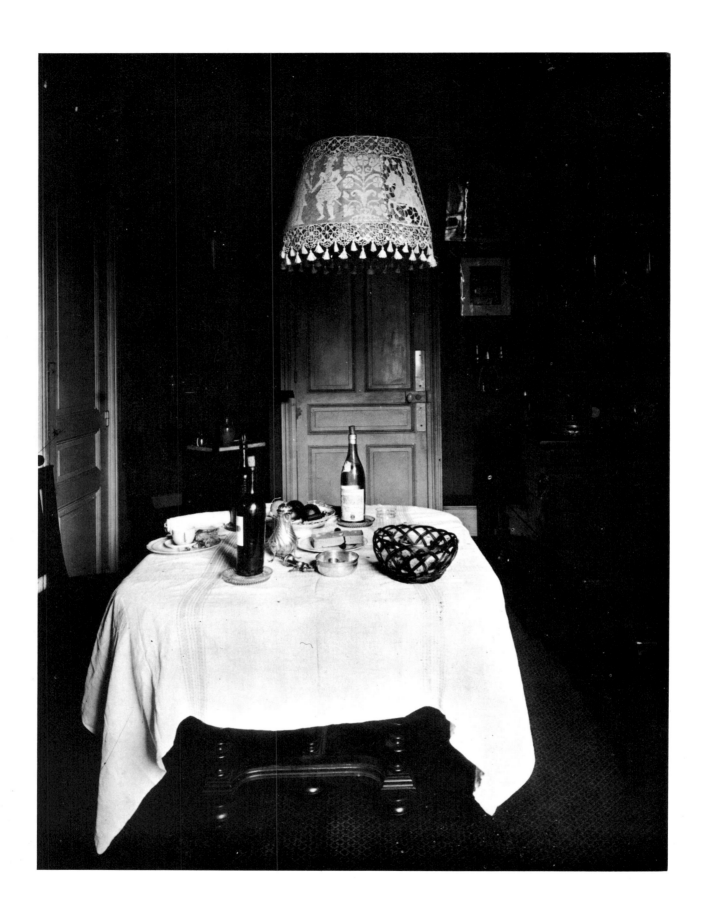

PLATE 91 / INTERIOR

PLATE 92 / WAREHOUSES. BERC

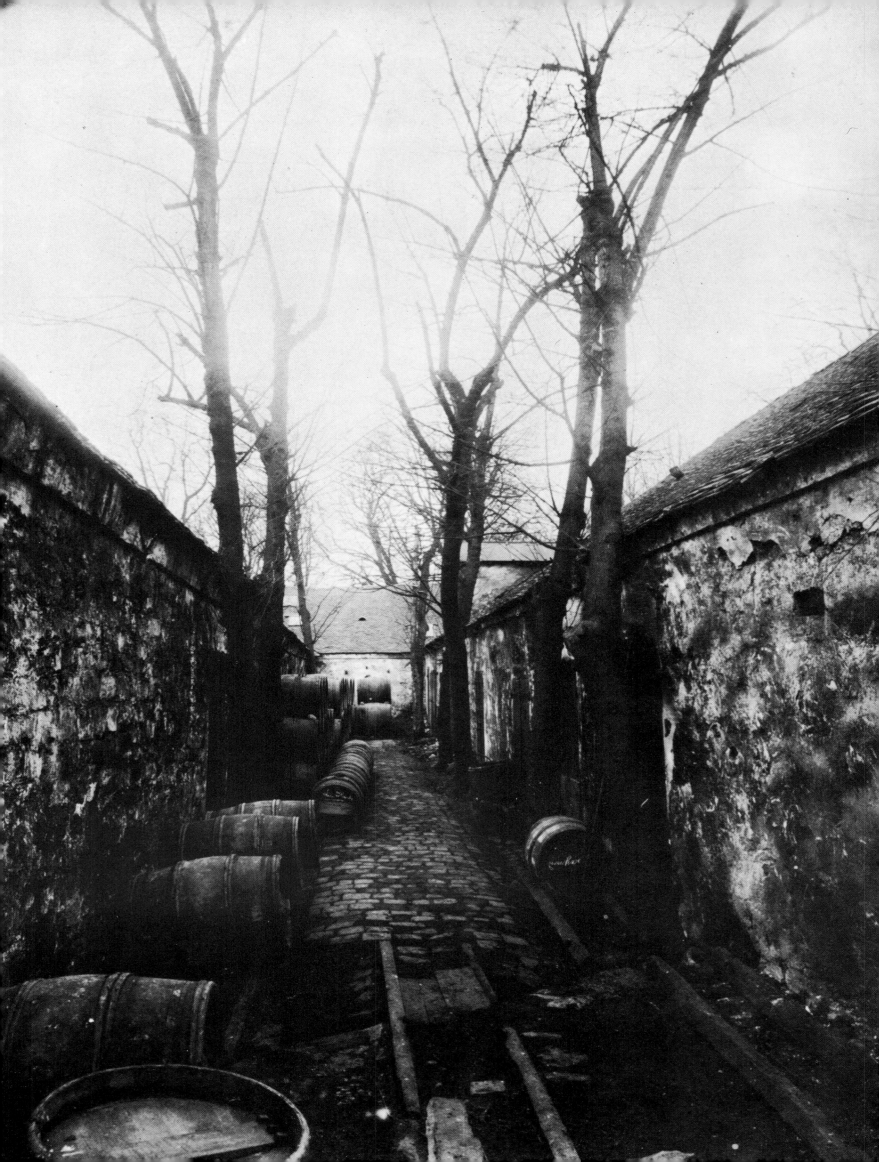

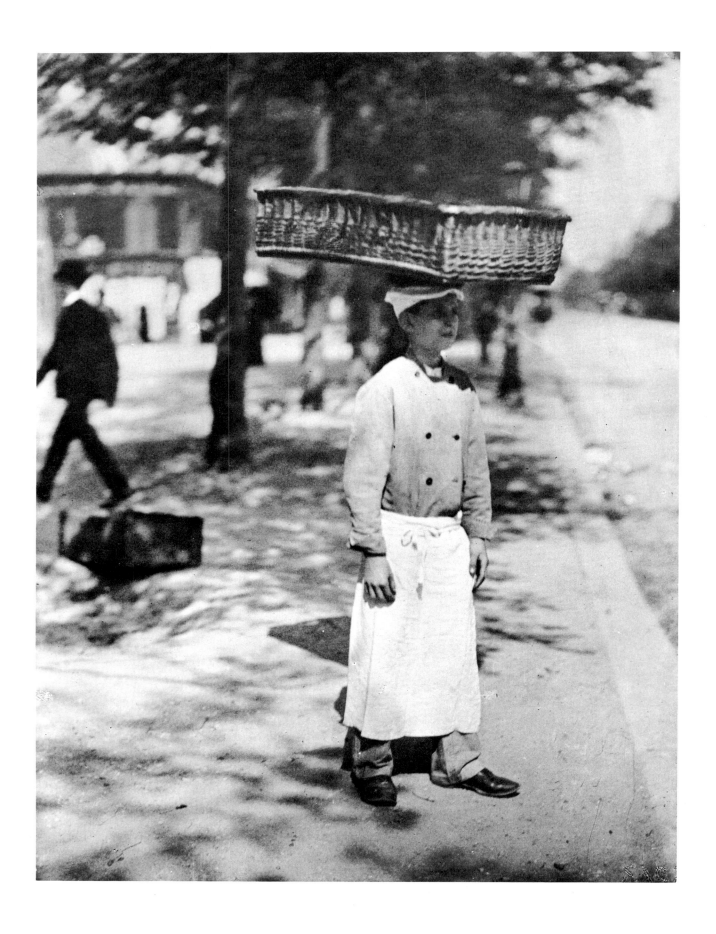

PLATE 93 / BREAD-BOY

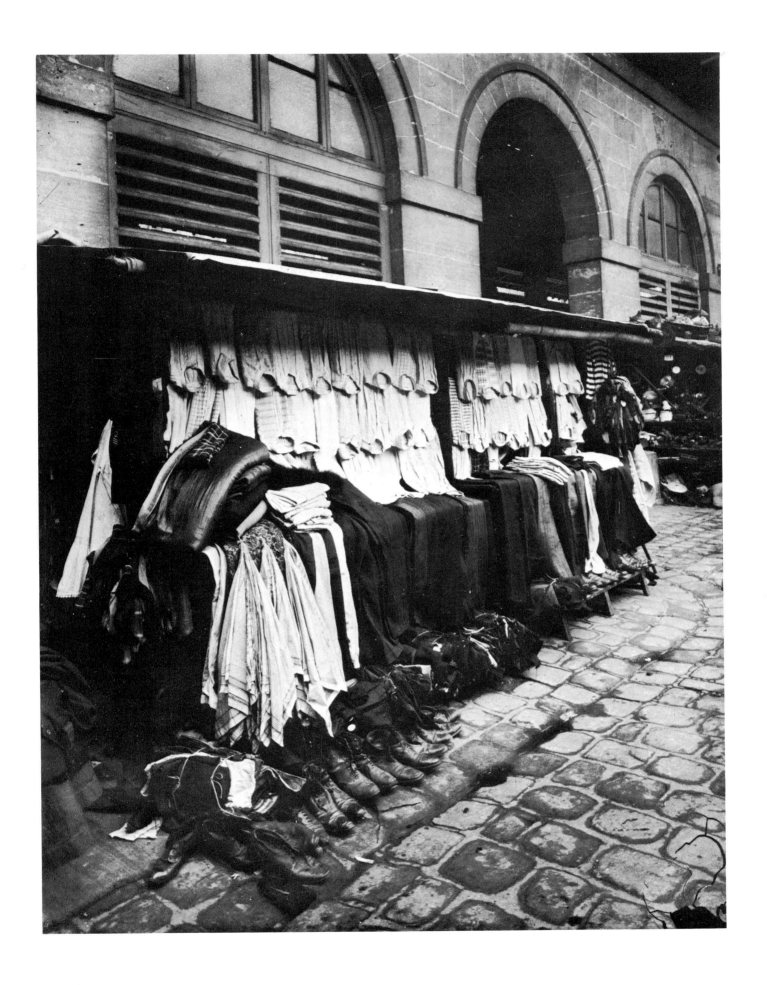

PLATE 94 / SECONDHAND STALLS

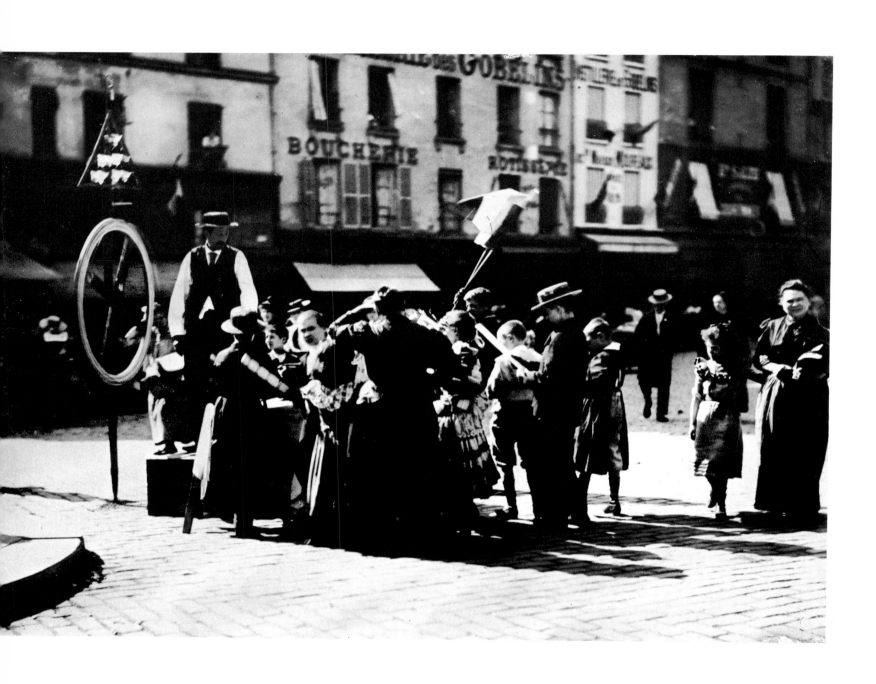

PLATE 95 / STREET SCENE

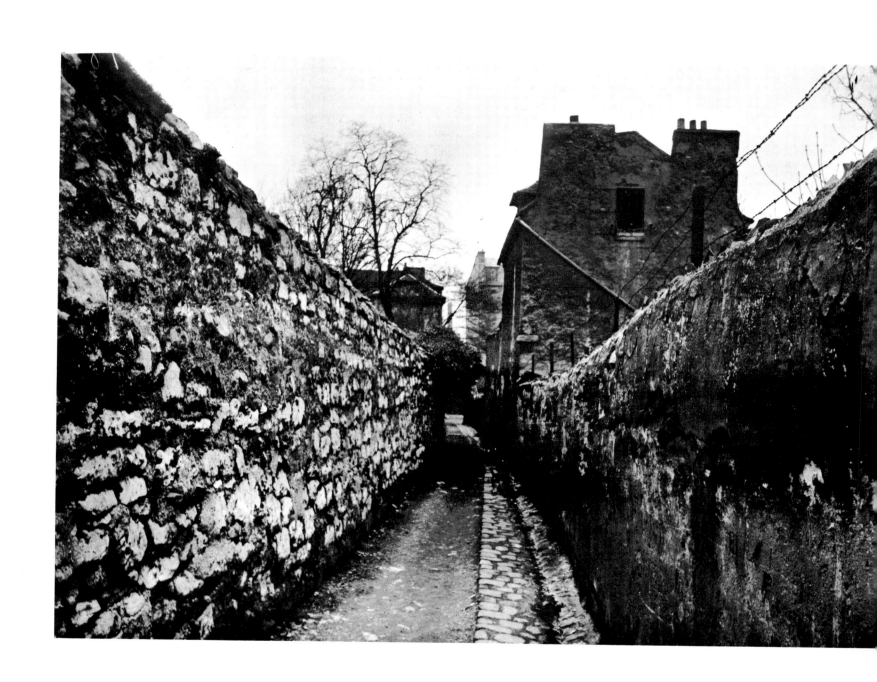

PLATE 96 / PASSAGE

PLATE 97 / STREET-WORKERS

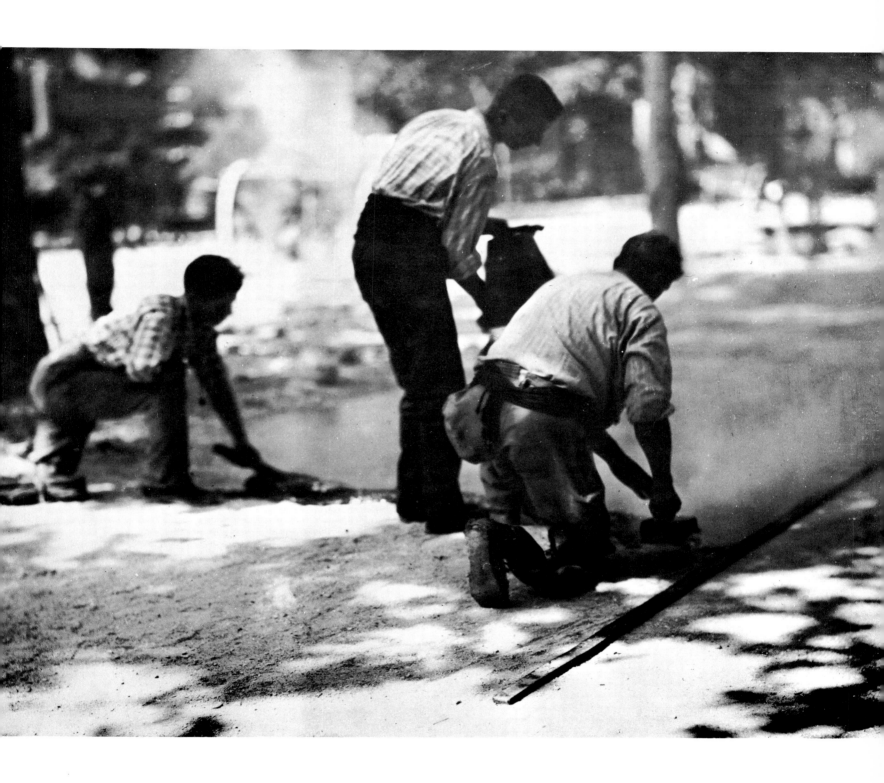

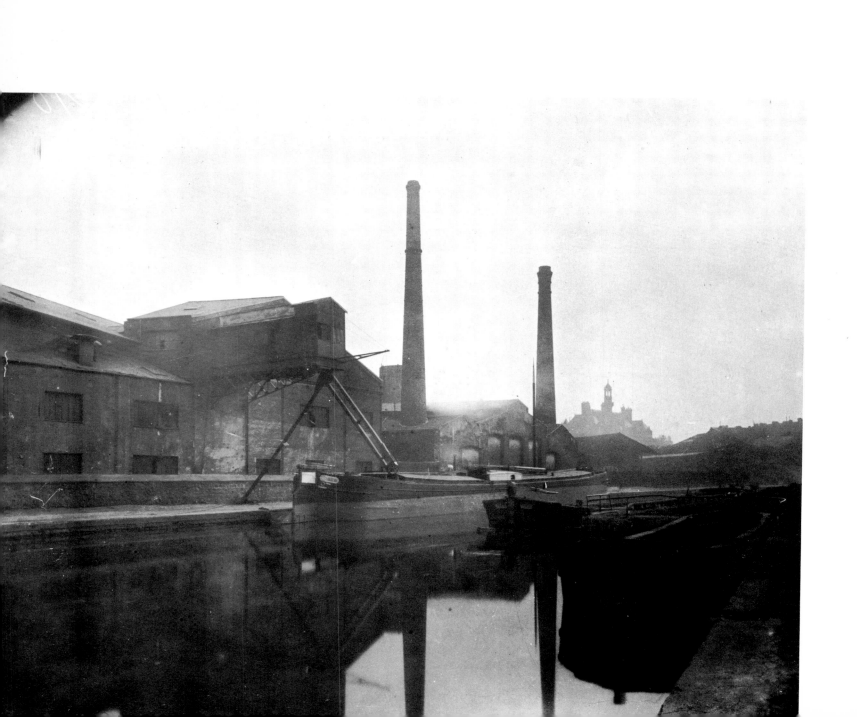

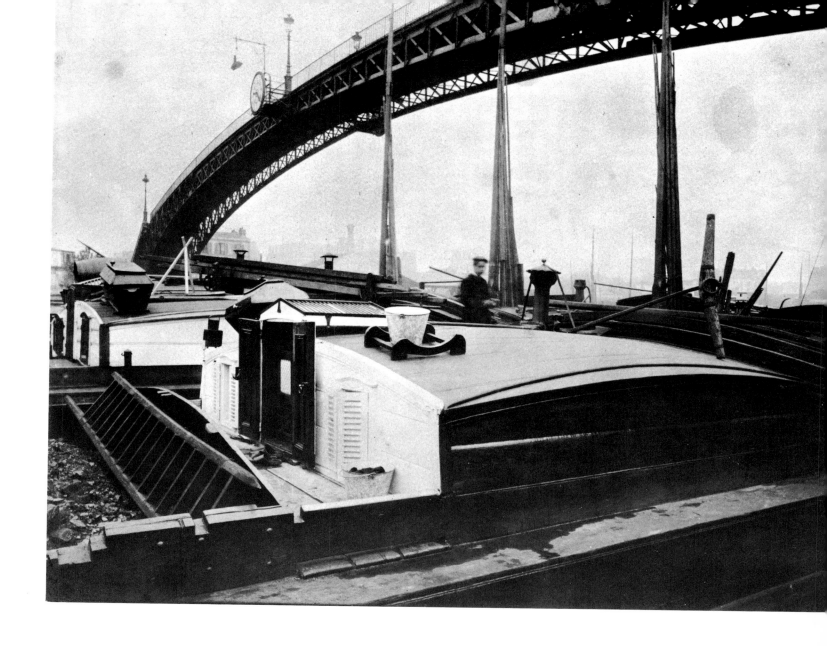

PLATE 99 / BARGES. LA VILLETTE

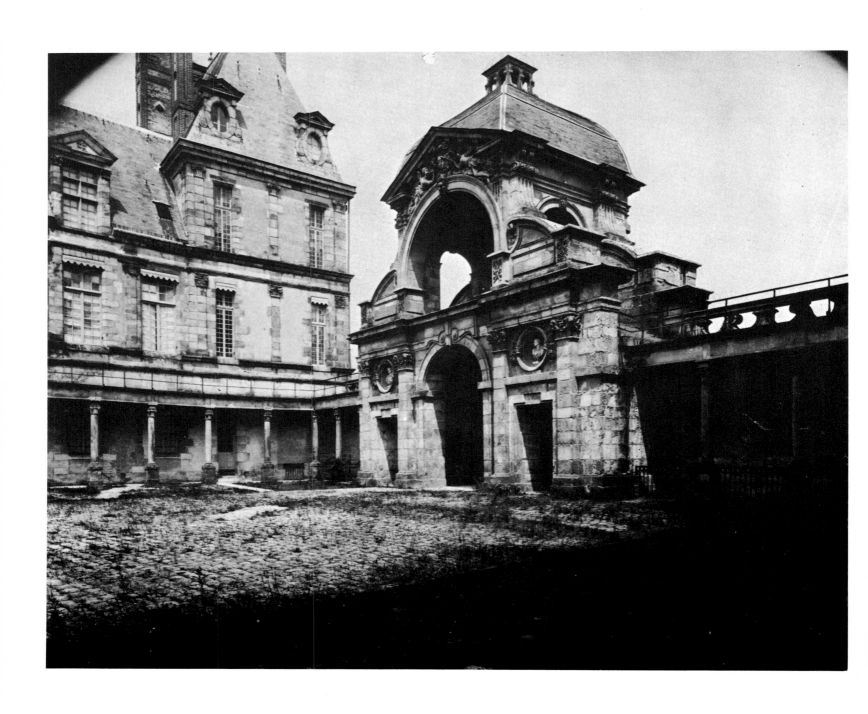

PLATE 100 / CHATEAU. FONTAINEBLEAU

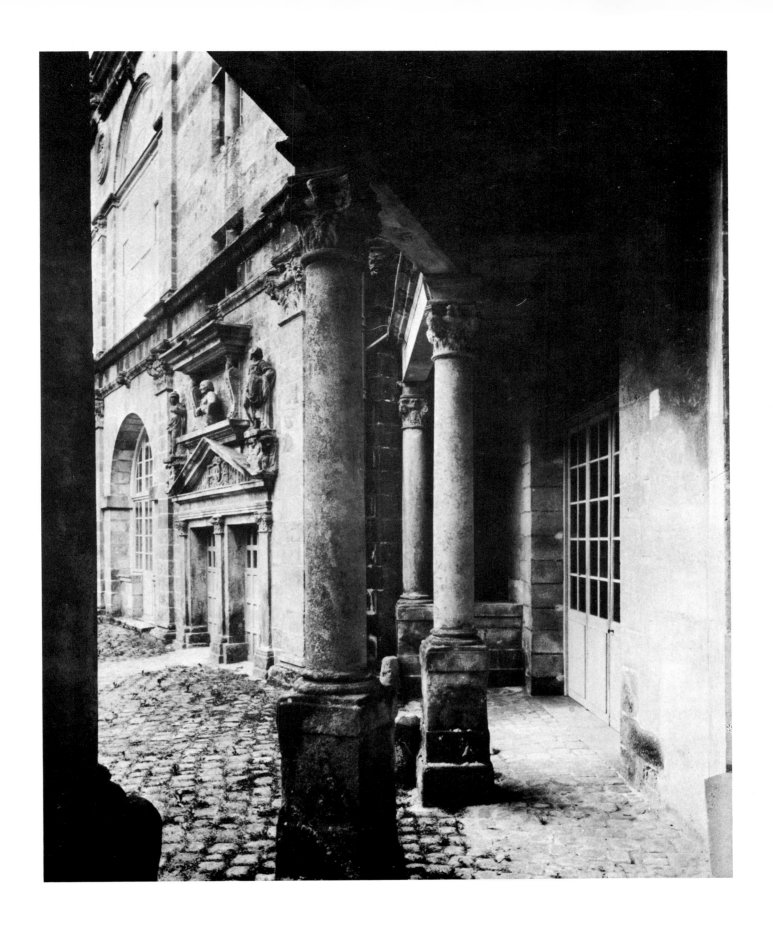

PLATE 101 / OVAL COURT. FONTAINEBLEAU

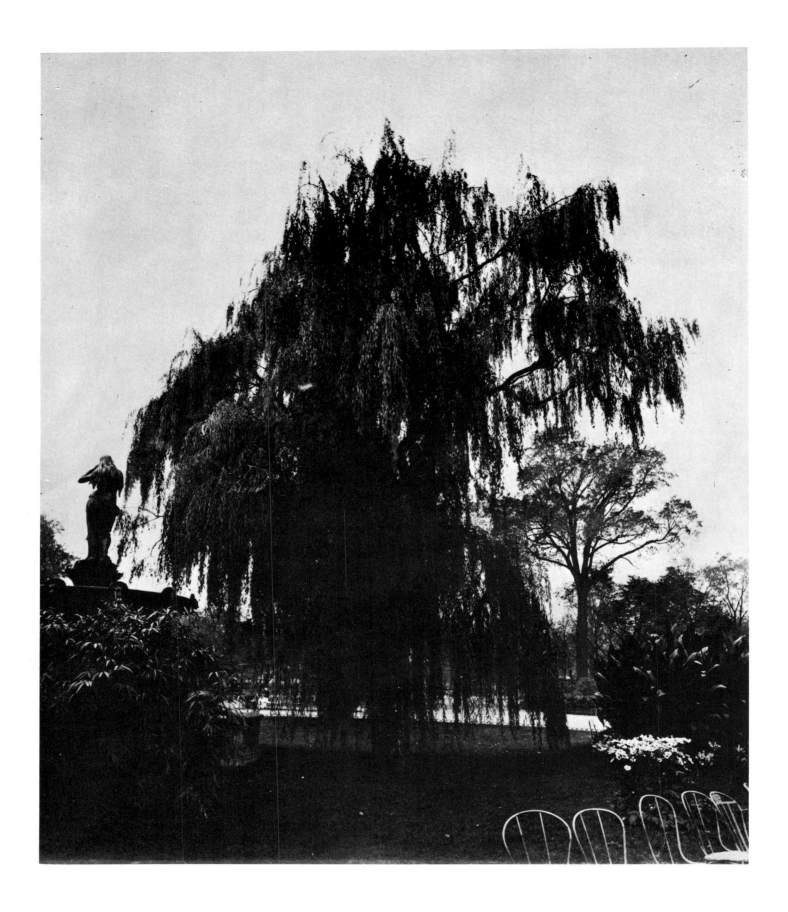

PLATE 102 / WILLOW

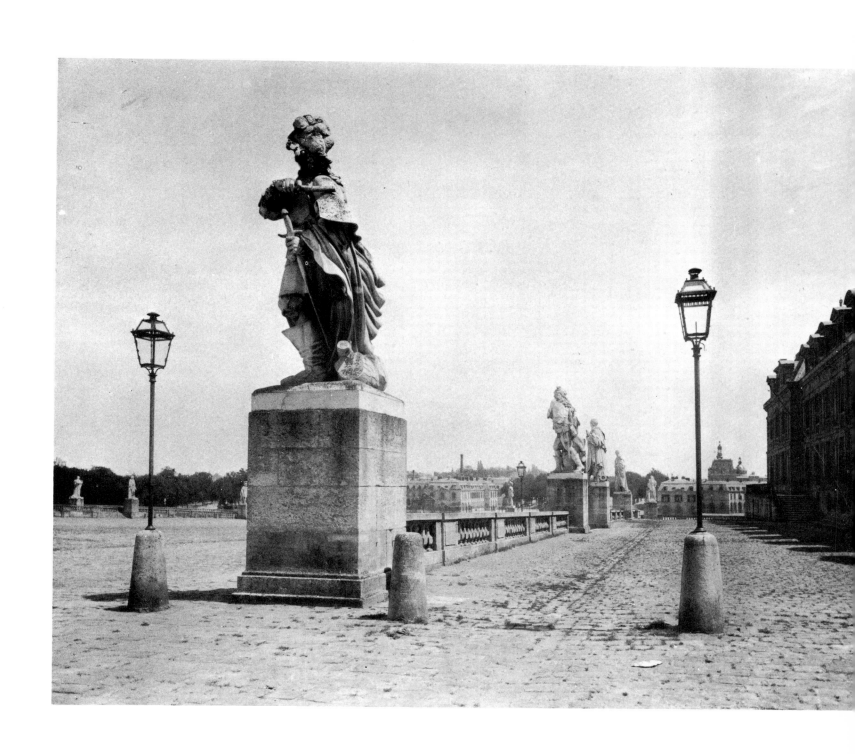

PLATE 103 / VERSAILLES

PLATE 104 / NASTURTIUMS

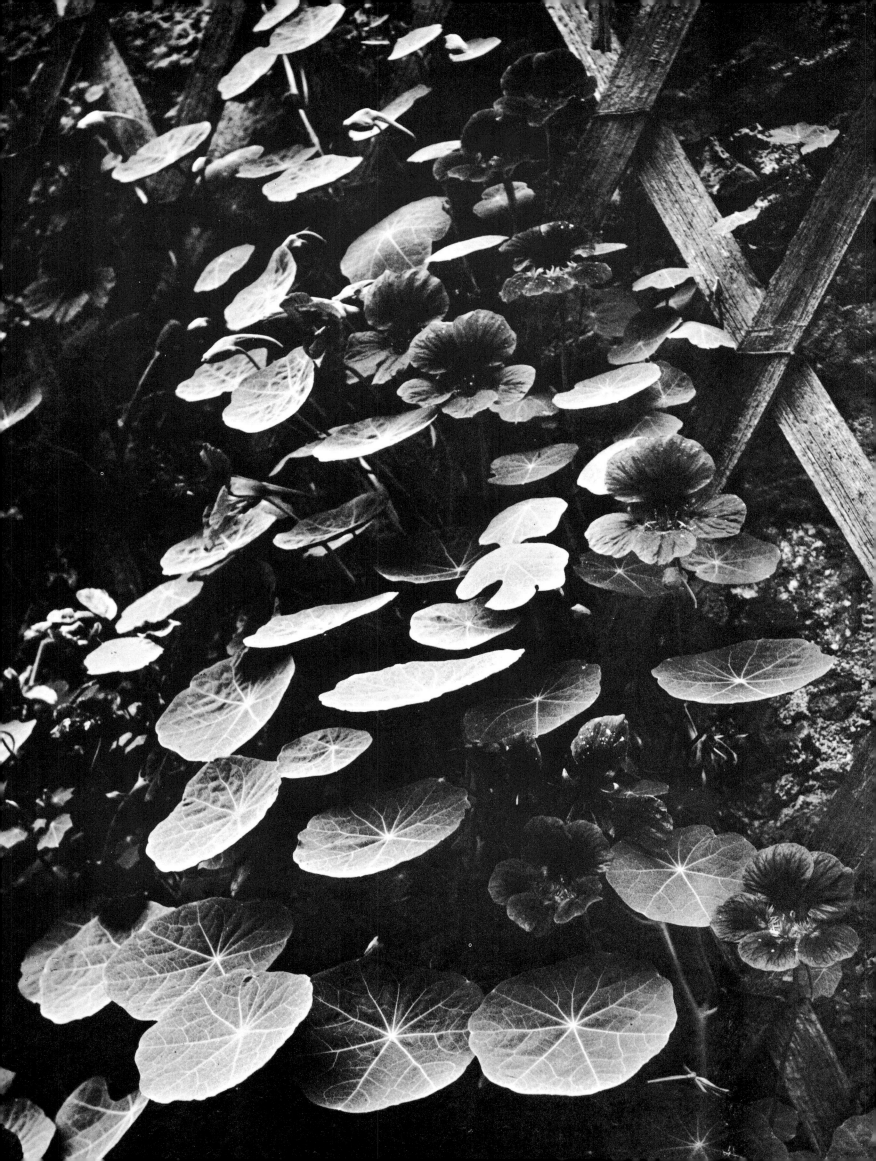

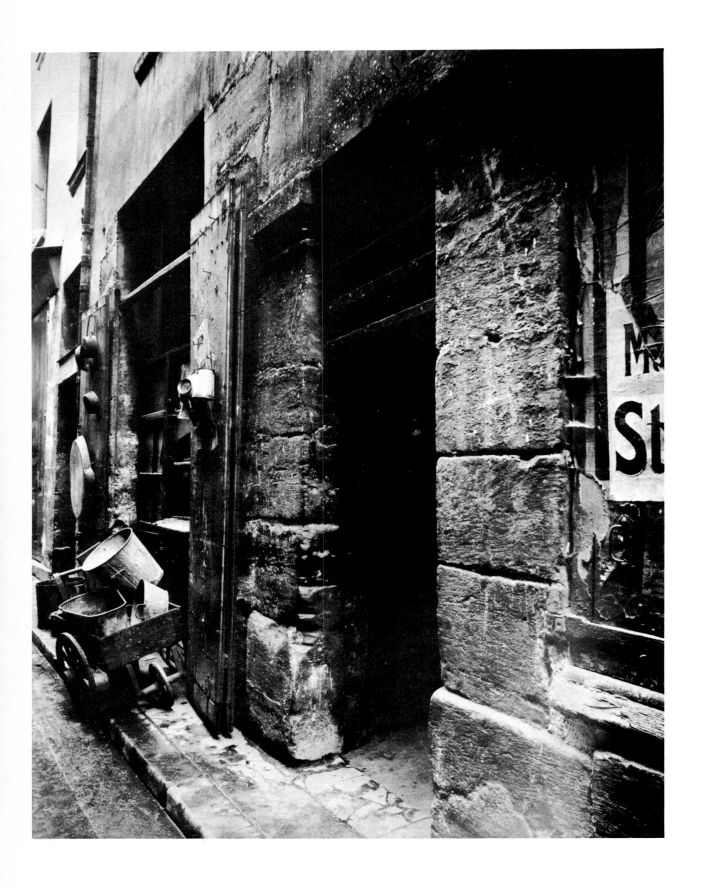

PLATE 105 / STREET SCENE

PLATE 106 / HOLLYHOC

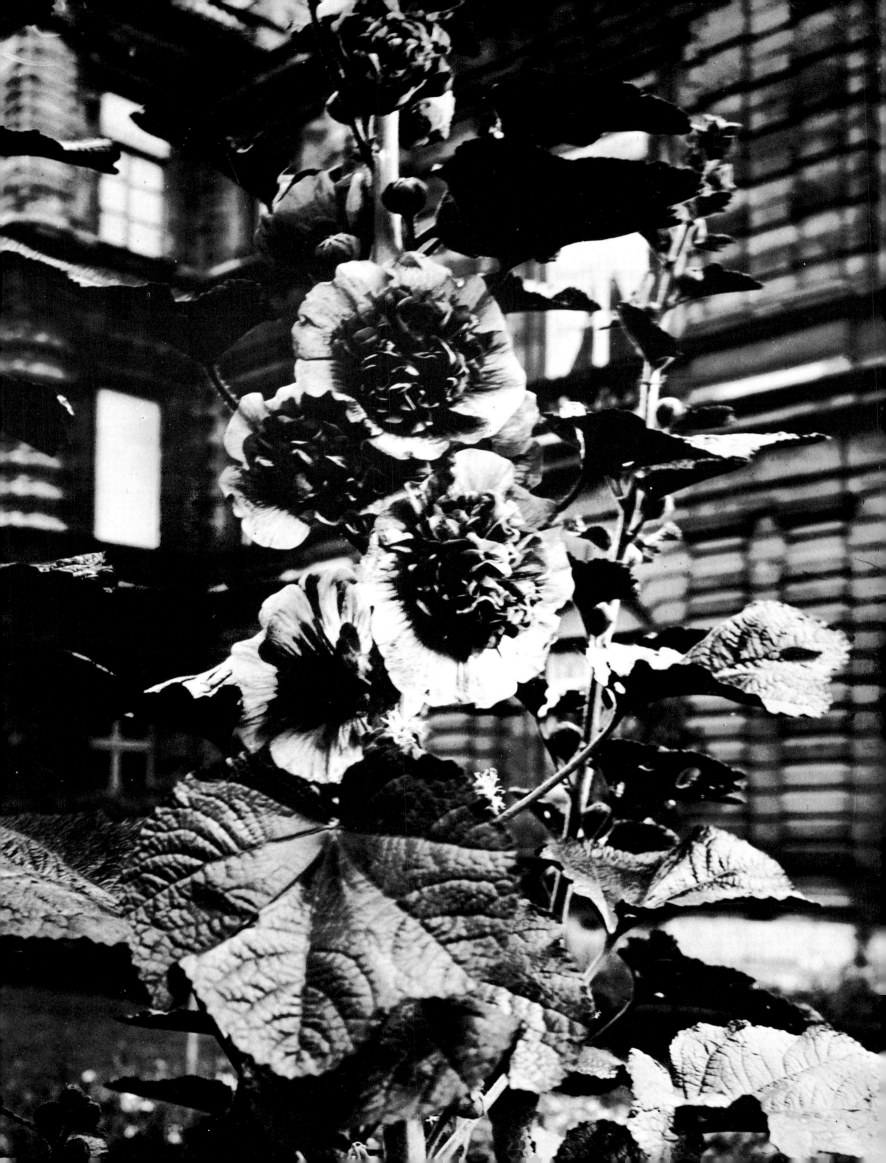

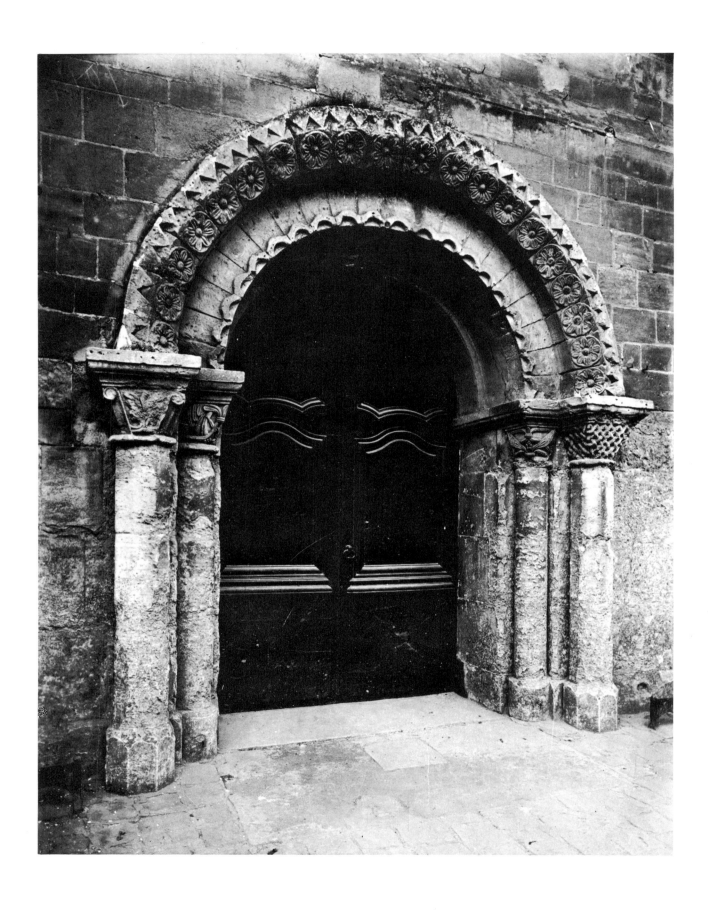

PLATE 107 / PORTAL. ST. OUEN-L'AUMONE

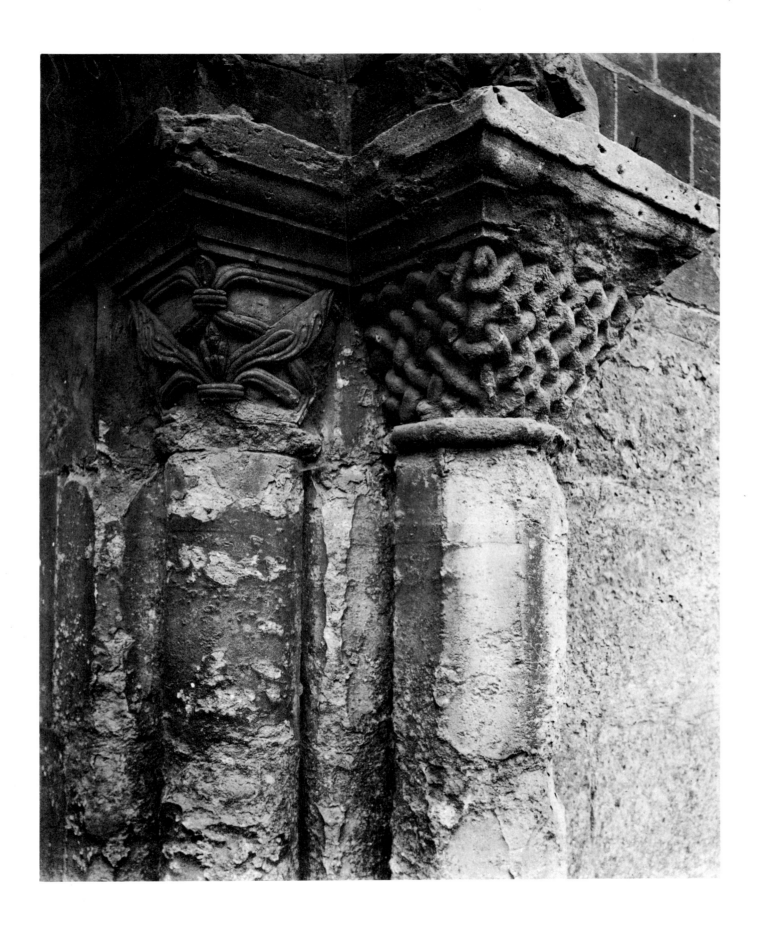

PLATE 108 / DETAIL

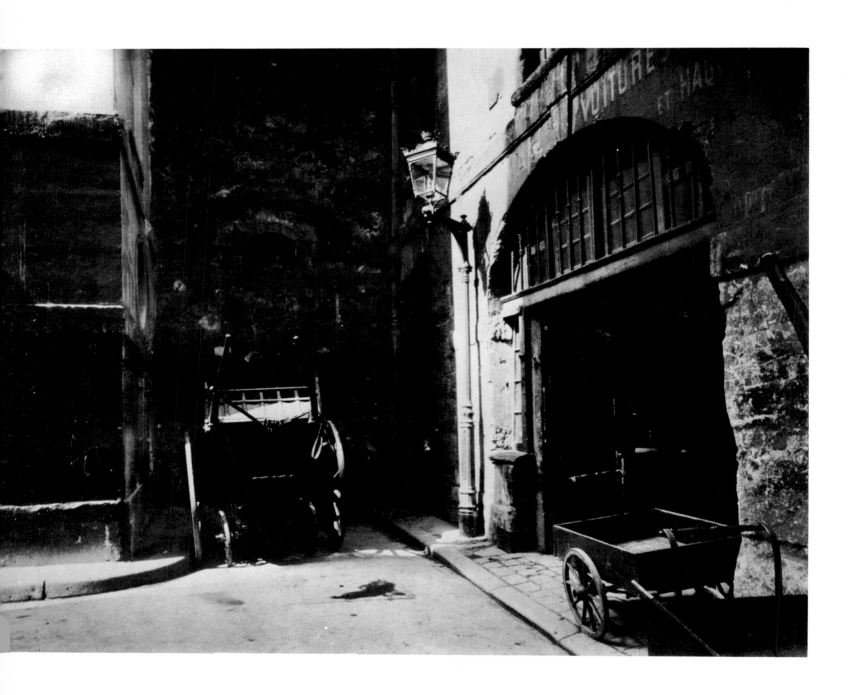

PLATE 109 / COURTYARD

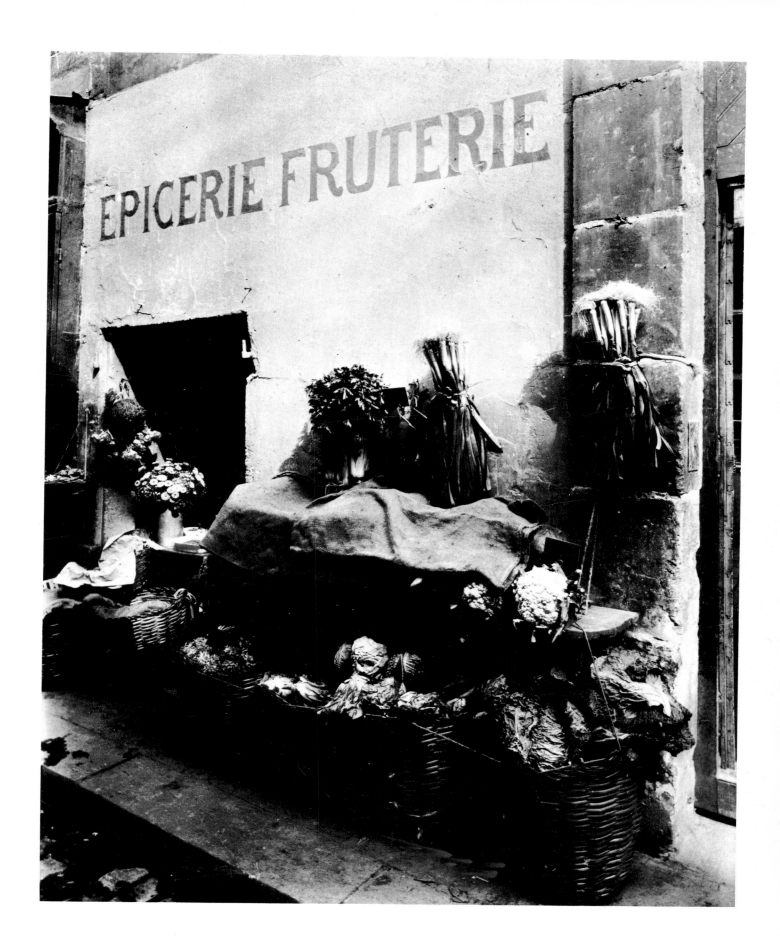

PLATE 110 / GROCERY

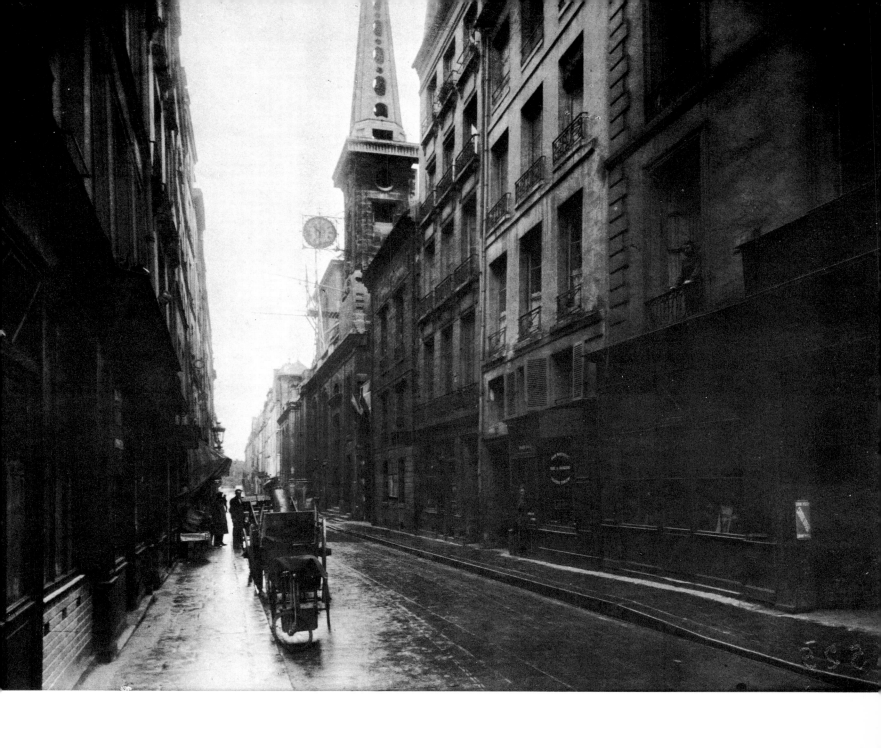

PLATE 113 / STREET SCENE

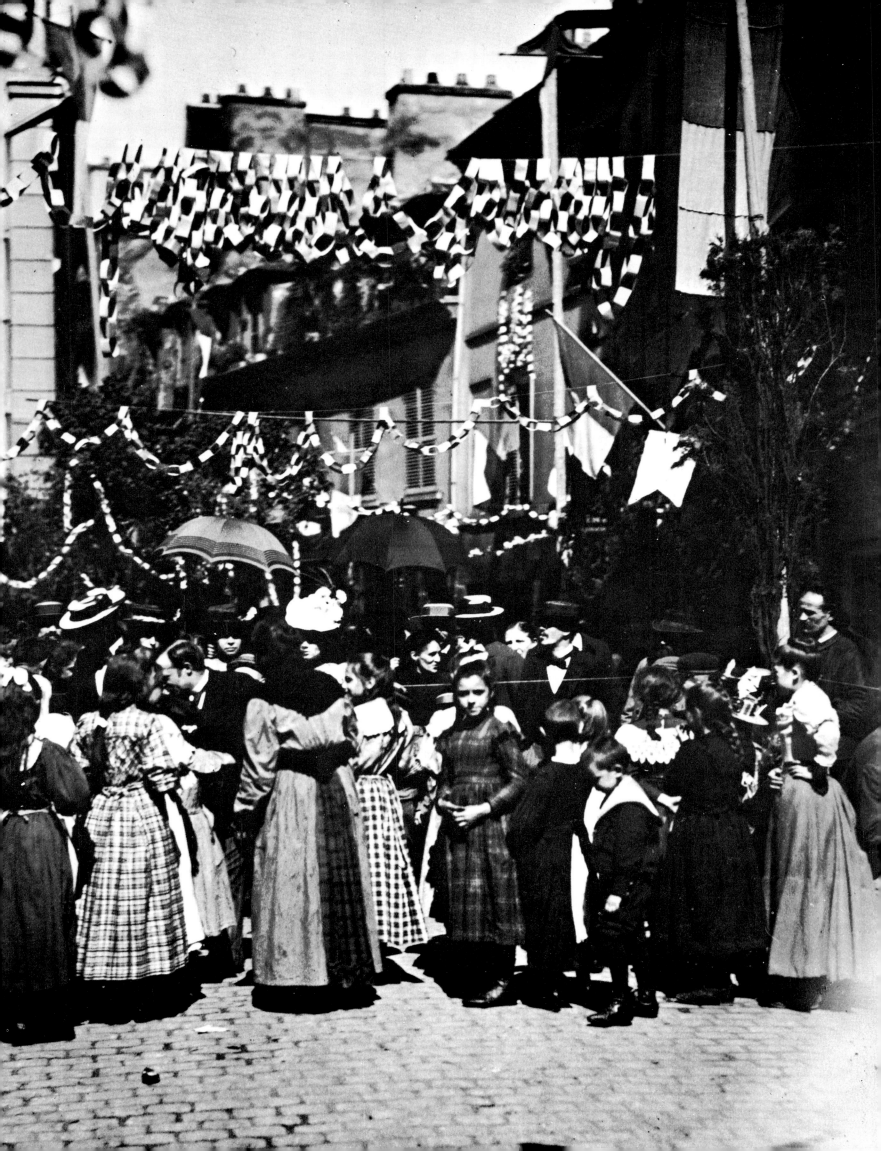

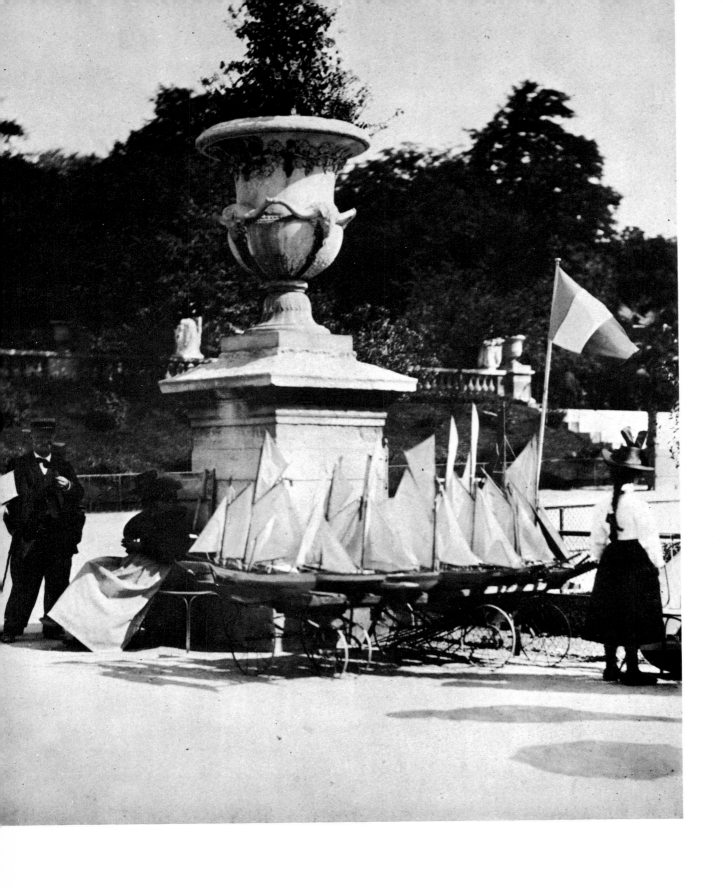

PLATE 114 / TOY BOATS

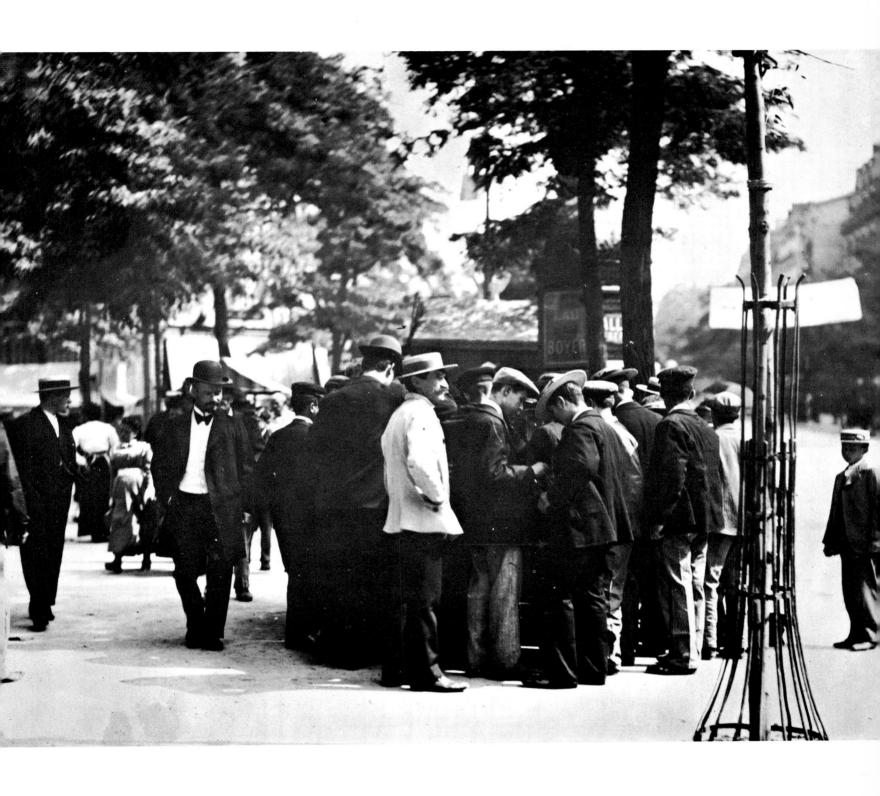

PLATE 115 / STREET SCENE

PLATE 116 / FLOWER-BOY

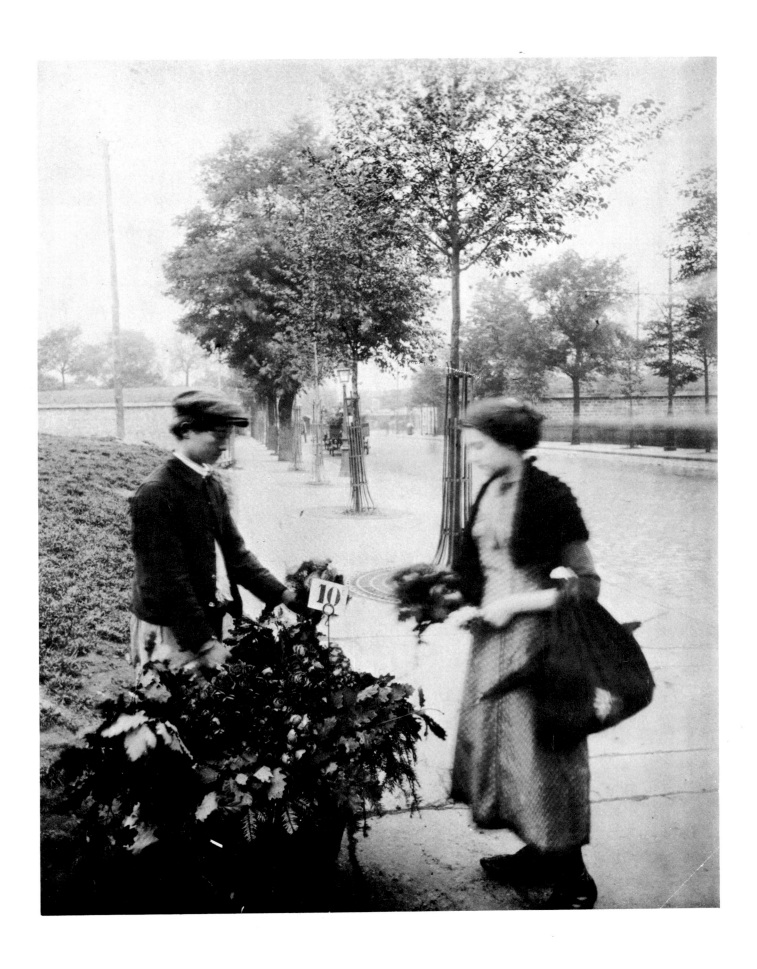

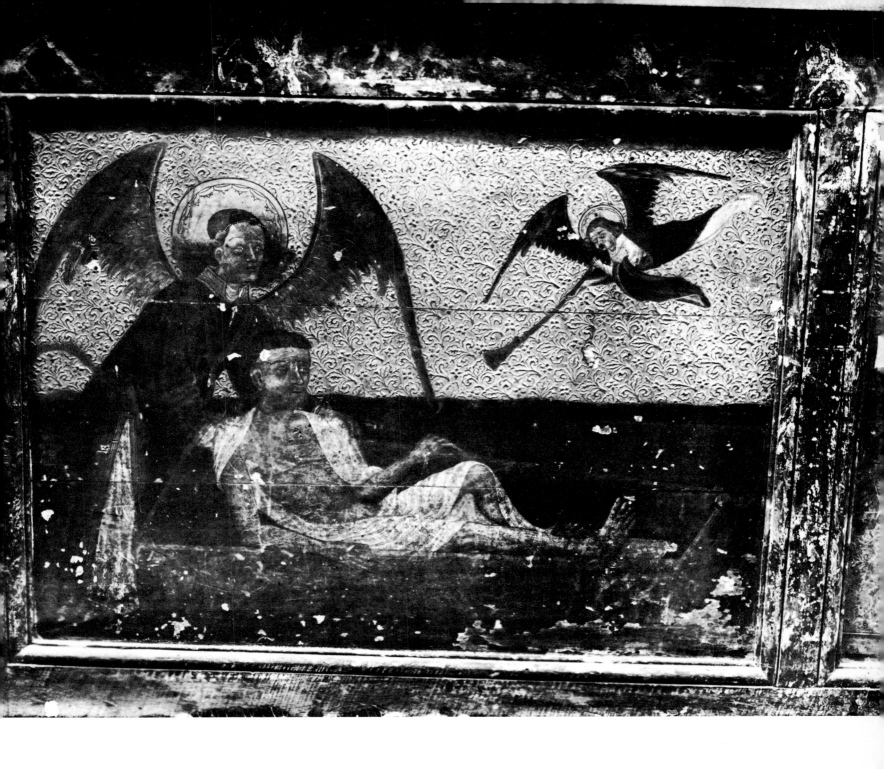

PLATE 118 / ART DETAIL. ST. VULFRAN. ABBEVILLE

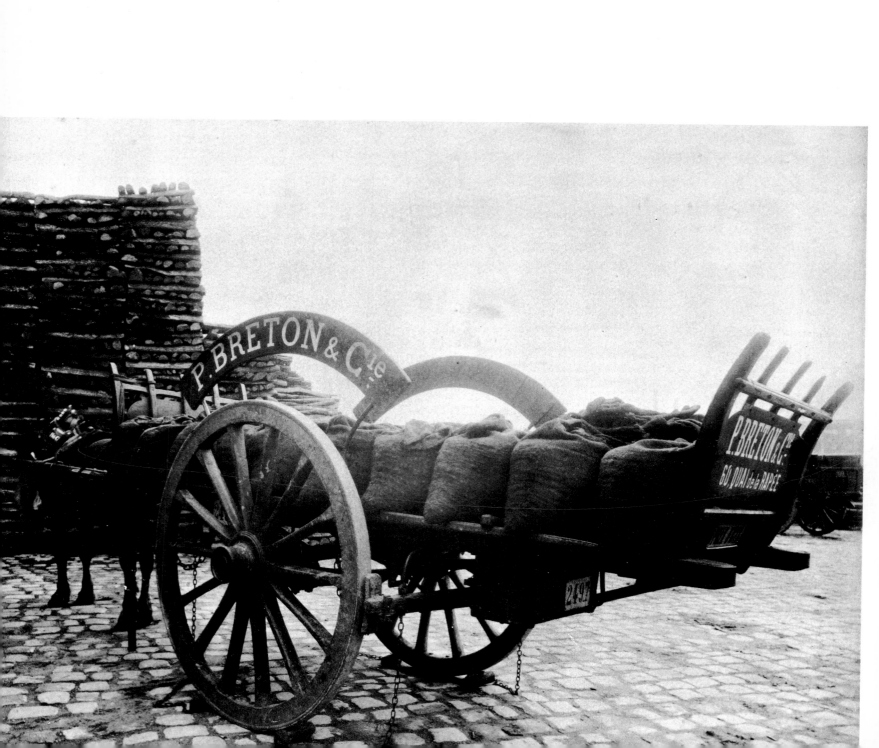

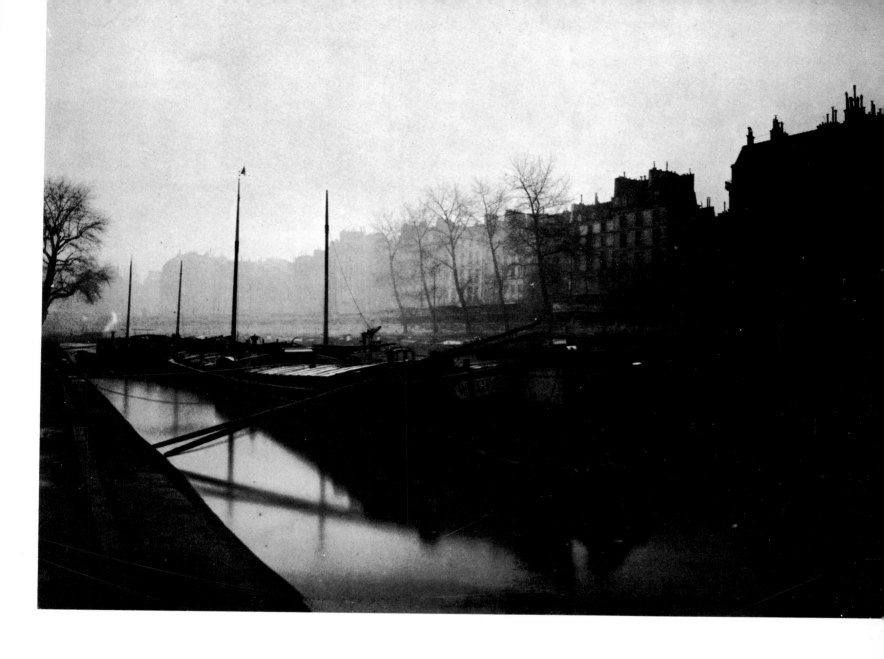

PLATE 119 / COAL WAGON

PLATE 120 / PONT NEUF

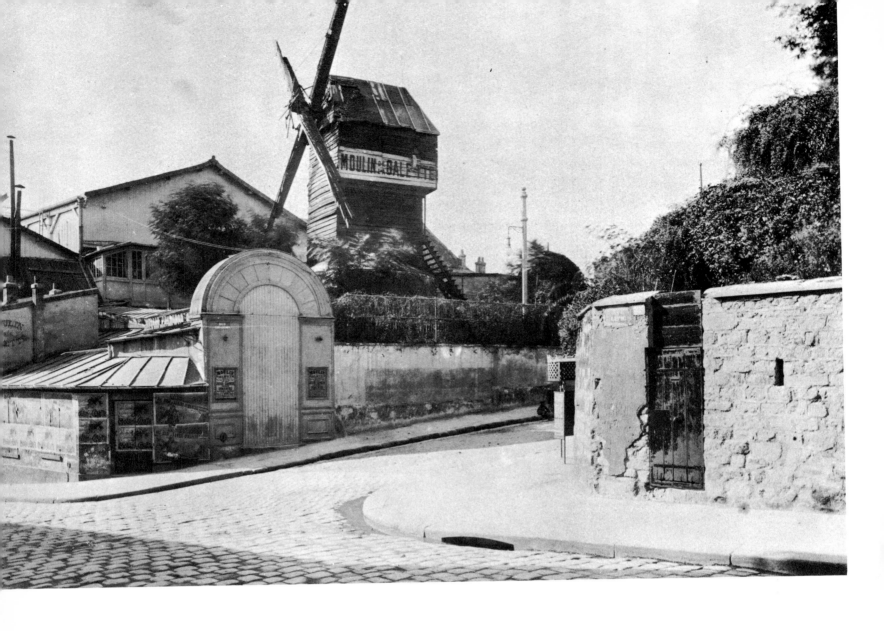

PLATE 121 / MOULIN DE LA GALETTE. MONTMARTRE

PLATE 122 / STREET SCEN

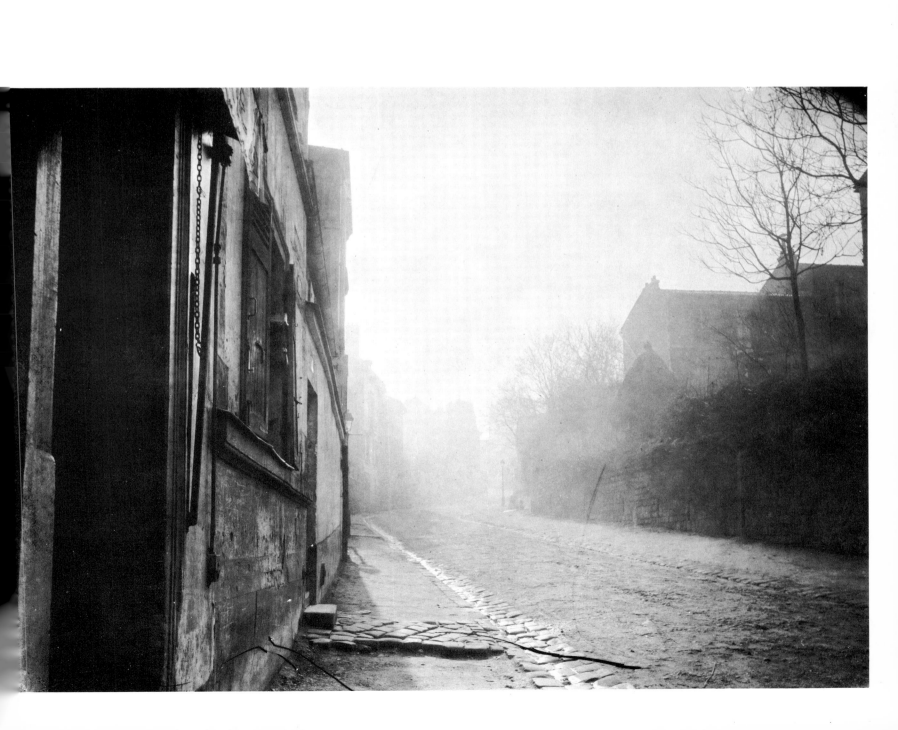

PLATE 123 / CABARET

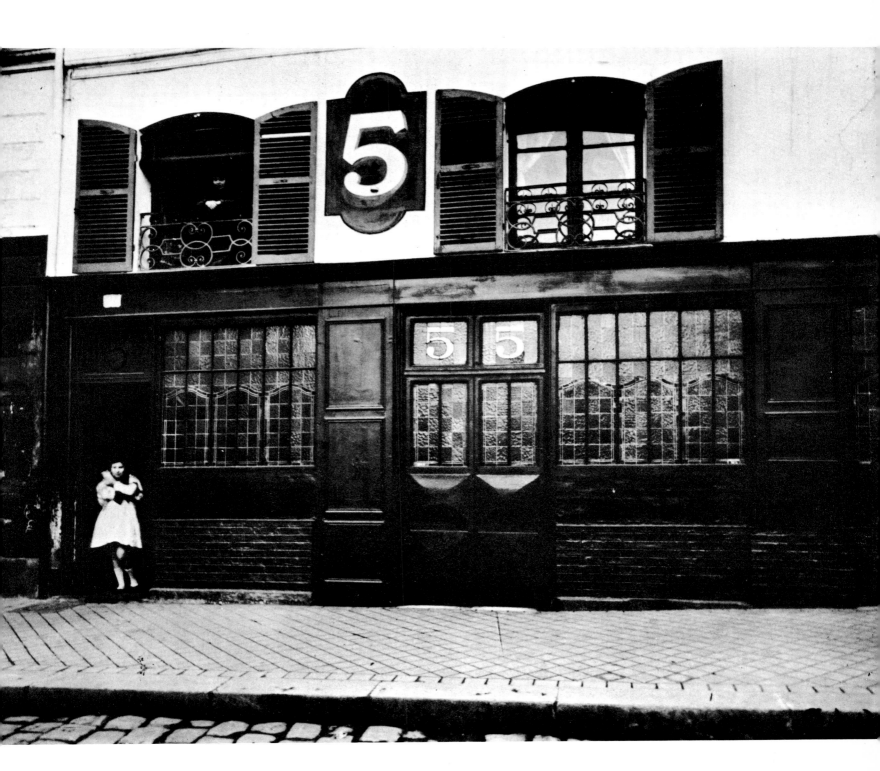

PLATE 124 / PROSTITUTE

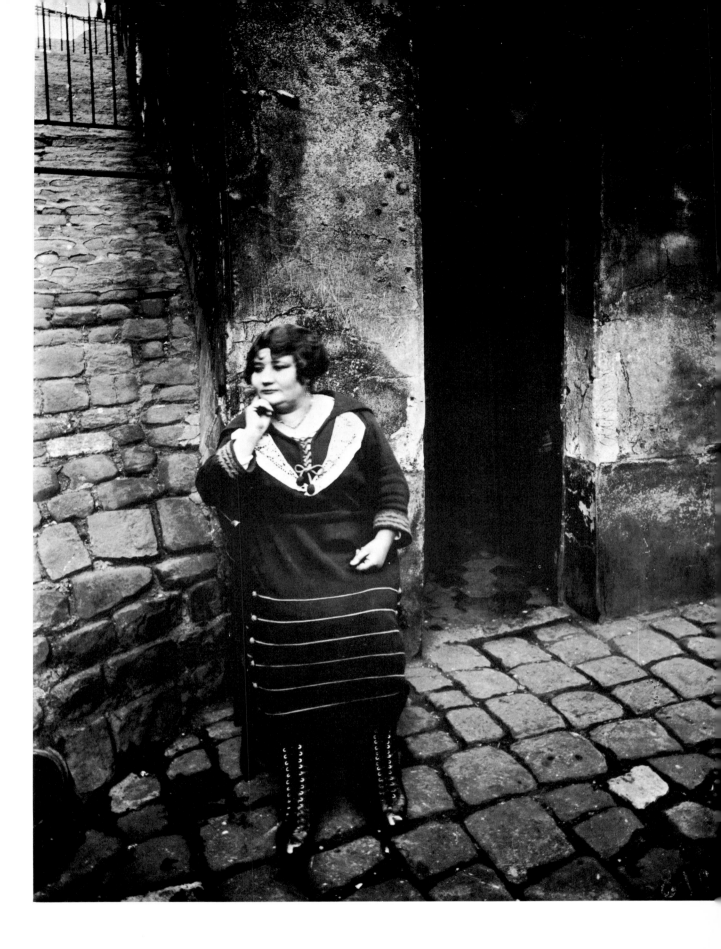

PLATE 125 / FLOWER-MAN

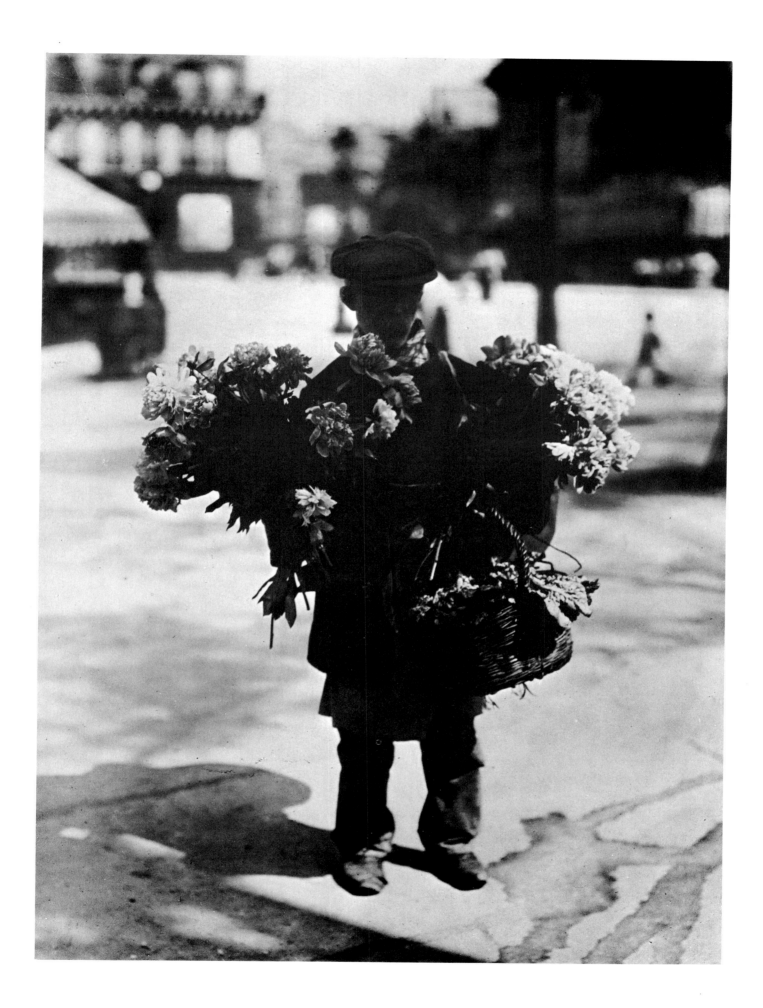

PLATE 126 / ANIMALS

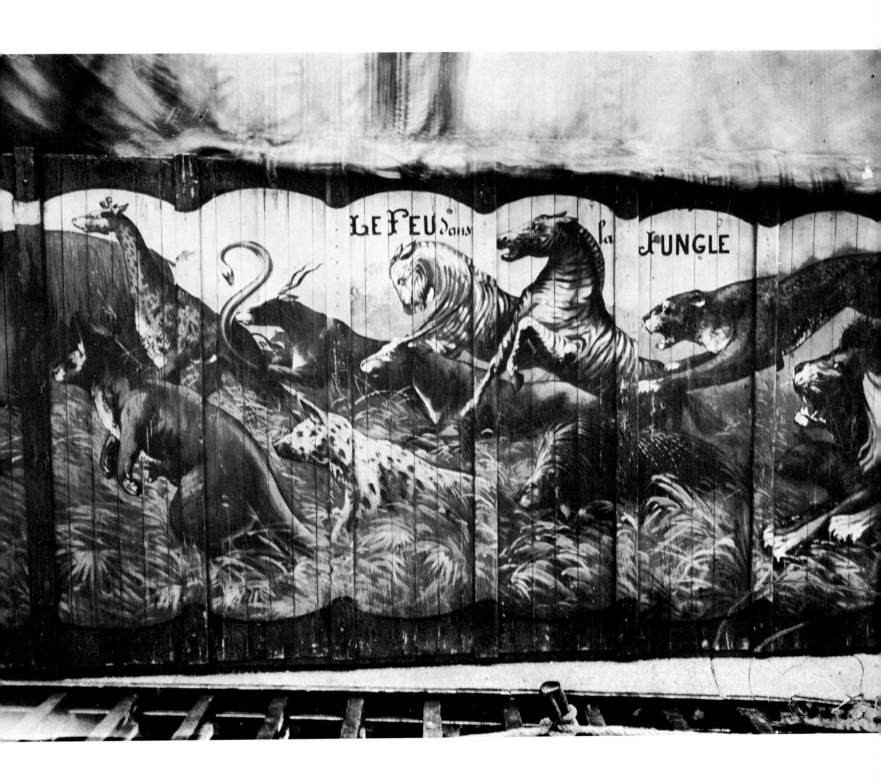

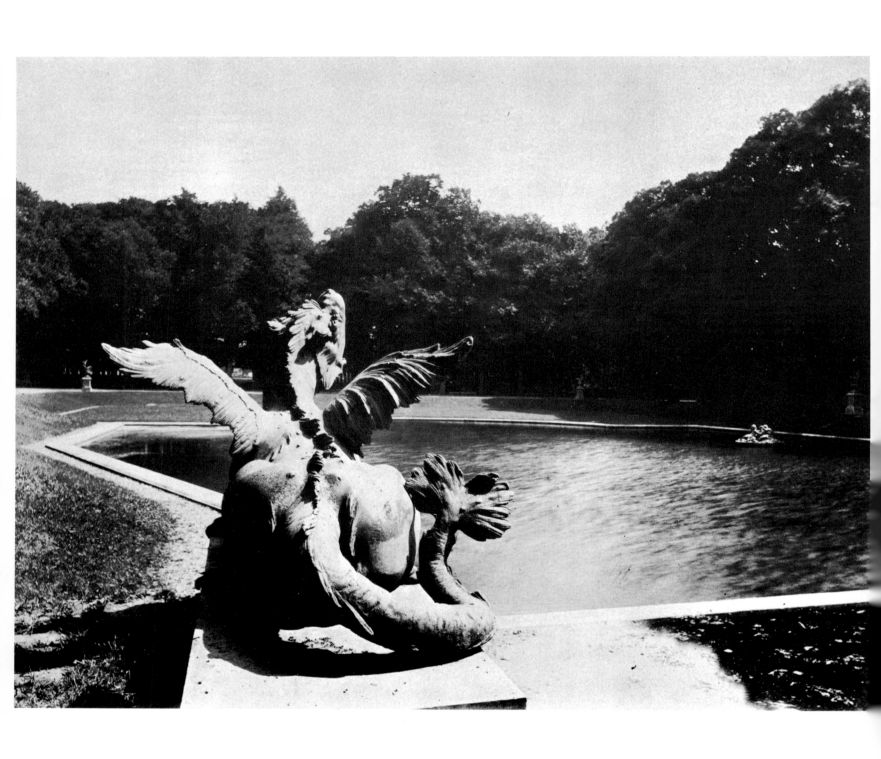

PLATE 127 / DRAGON BY HARDY. GRAND TRIANON

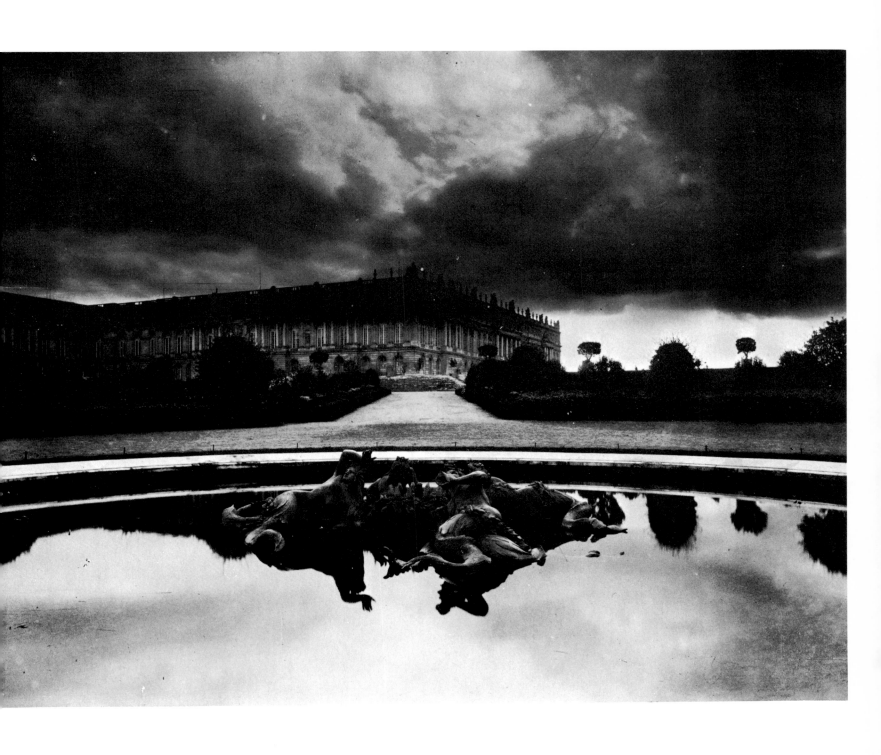

PLATE 128 / VERSAILLES

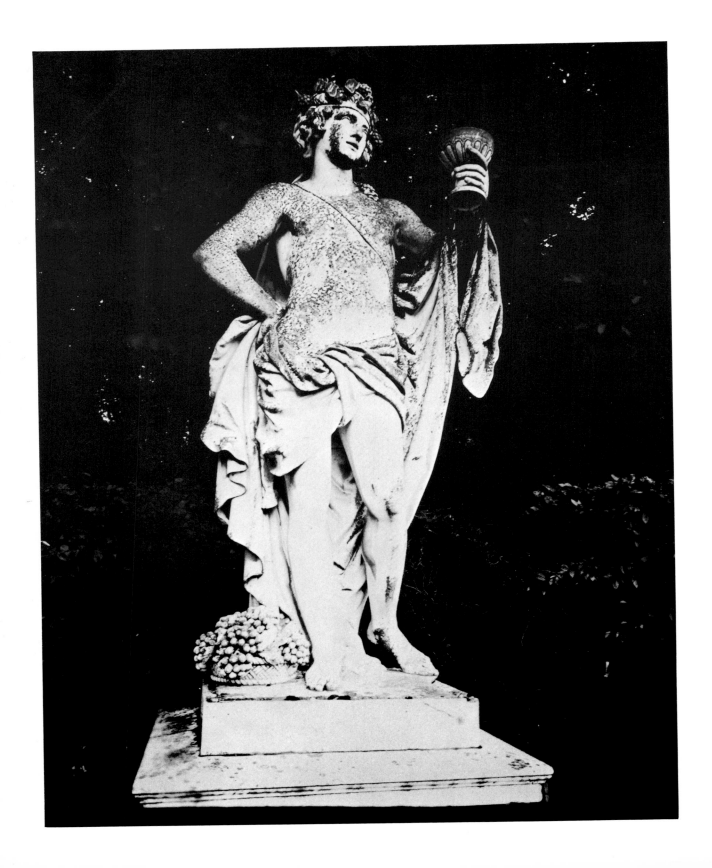

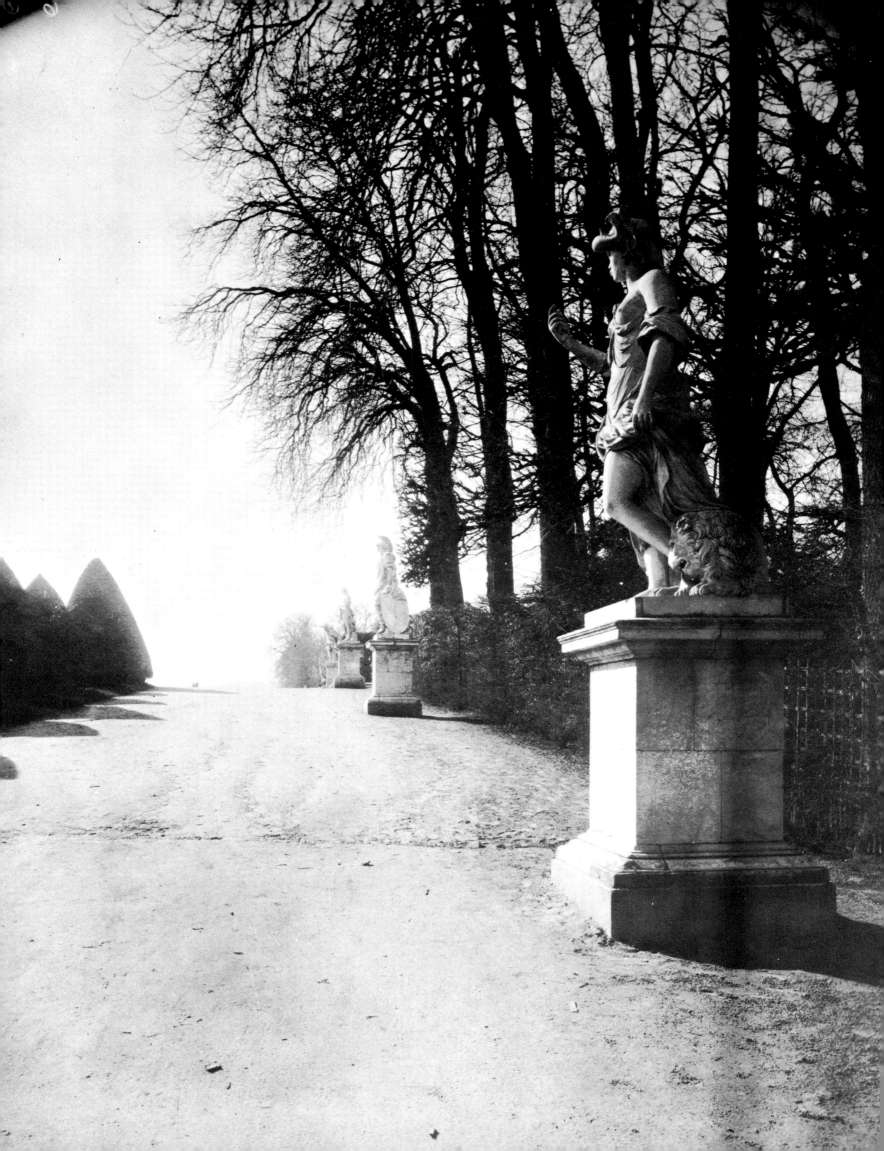

PLATE 131 / BANK OF THE MARNE. LA VARENNE

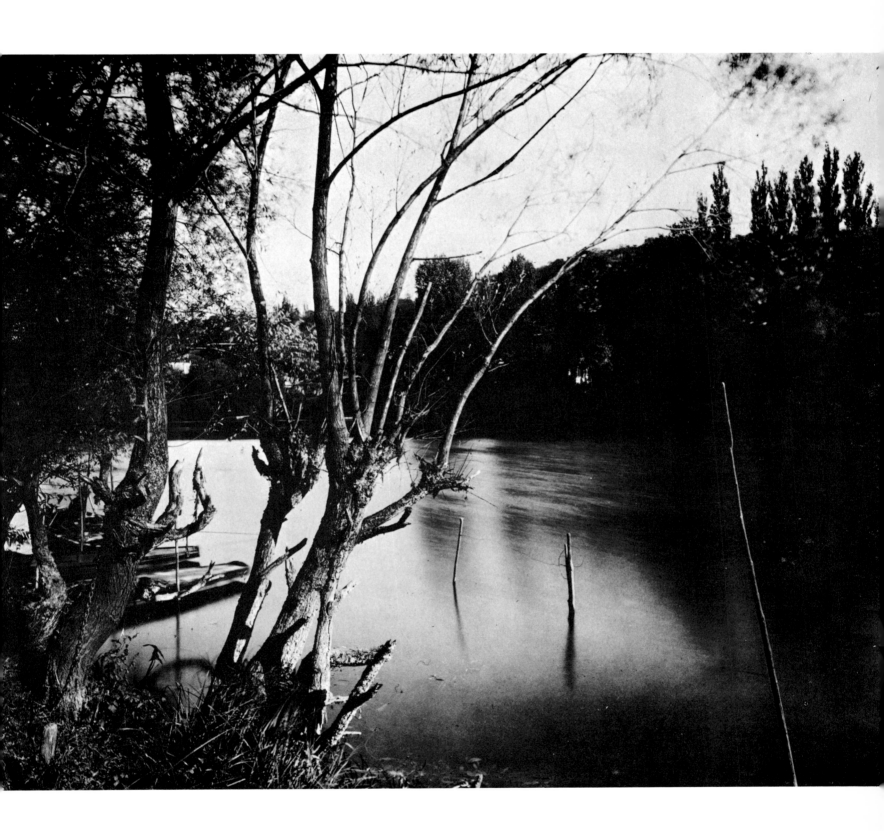

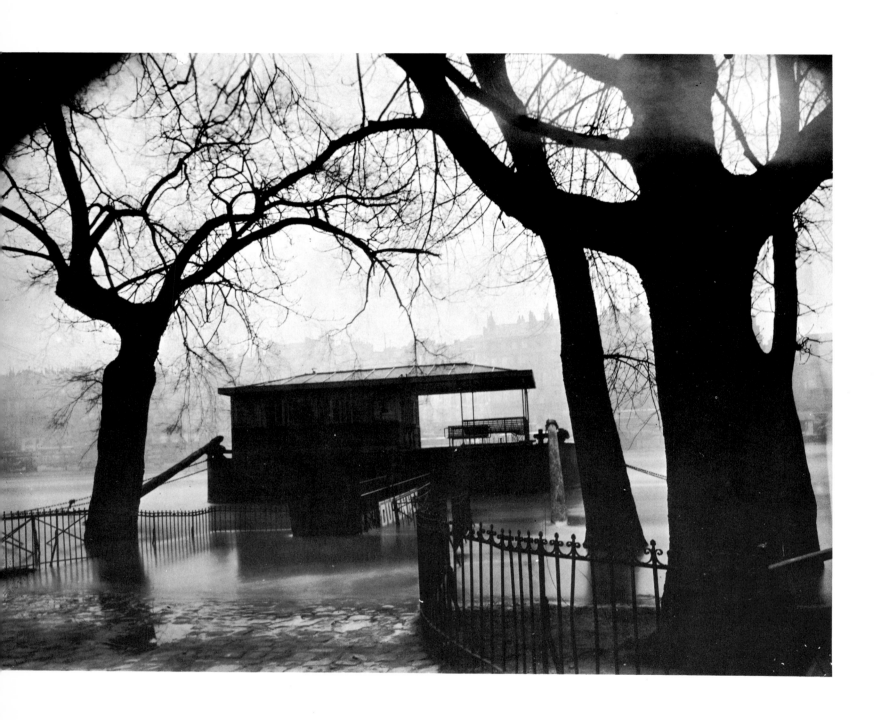

PLATE 132 / PORT DES TUILERIES

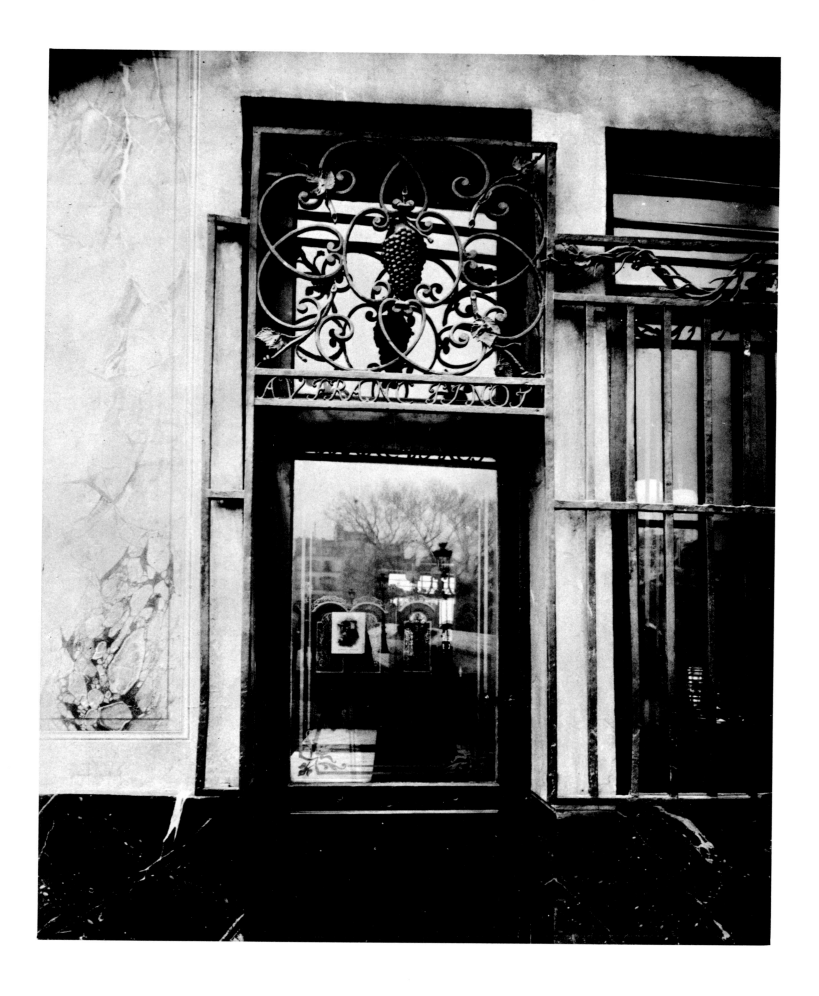

PLATE 133 / DOOR WITH ATGET'S REFLECTION

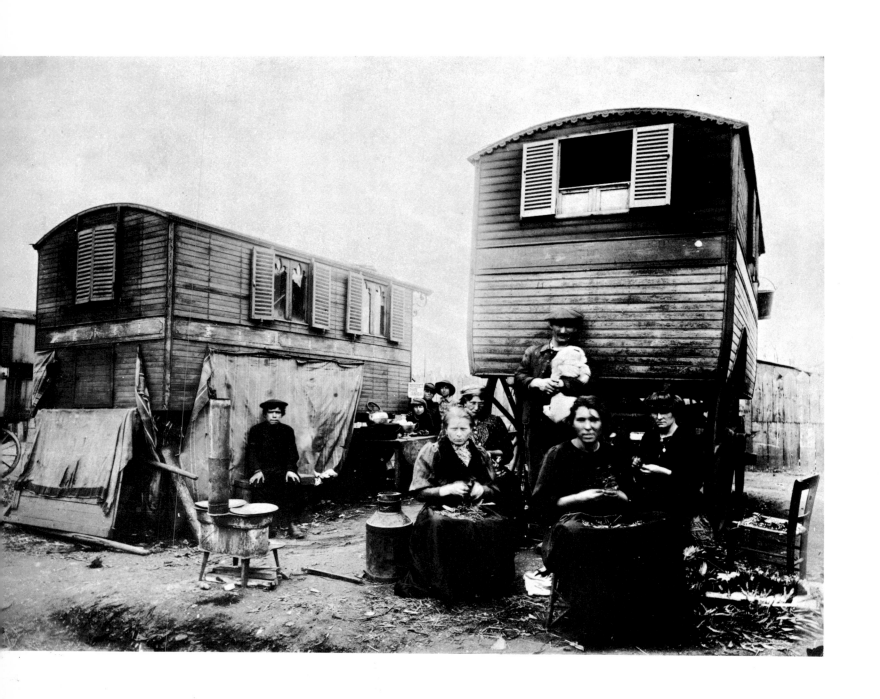

PLATE 134 / RAG-PICKERS. PORTE DE CHOISY

PLATE 135 / RAG-PICKERS' HU

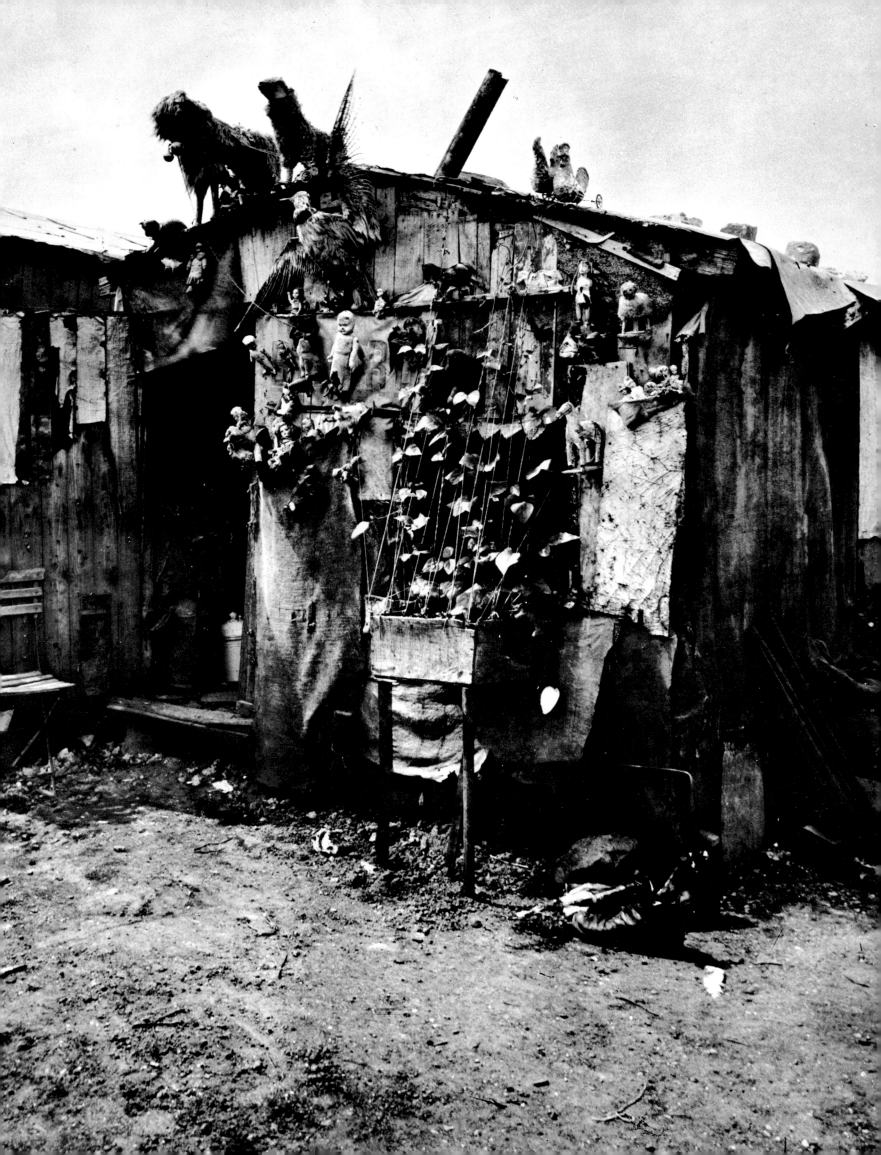

PLATE 136 / RAG-PICKERS

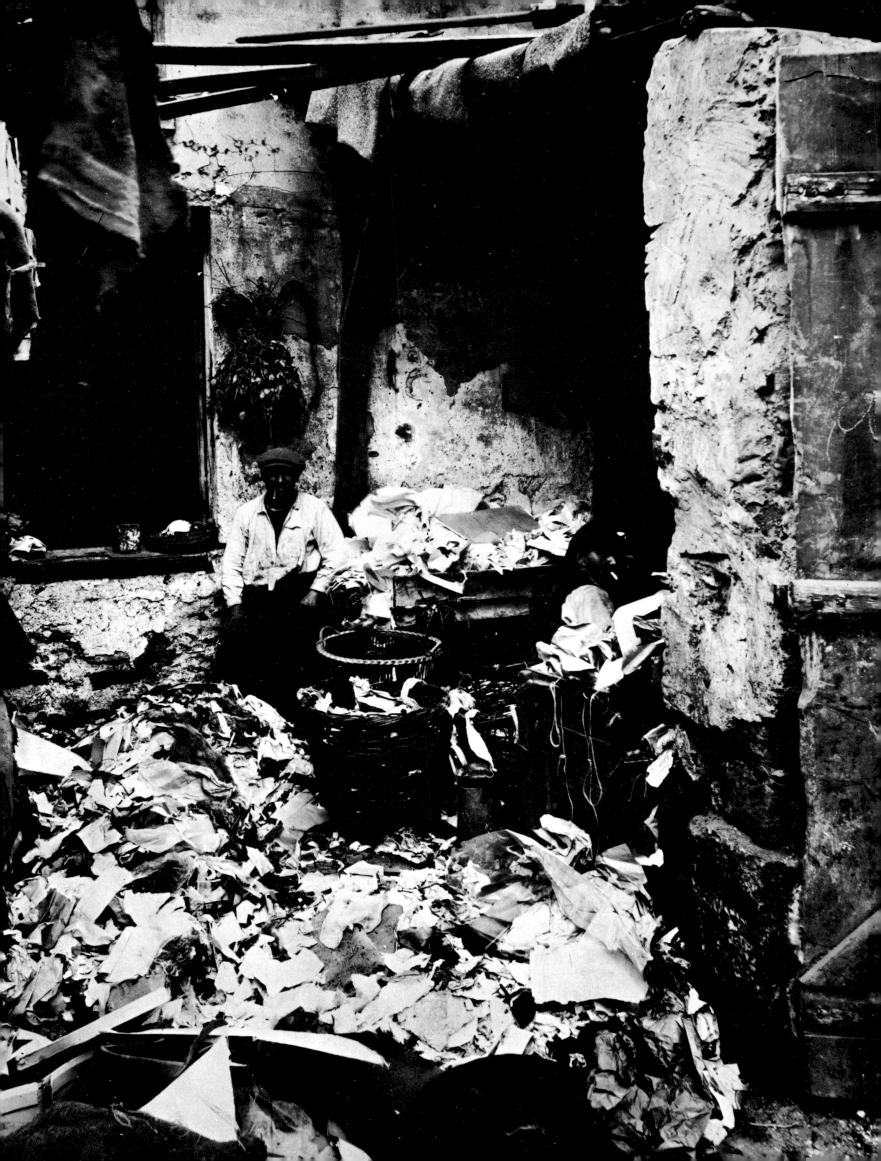

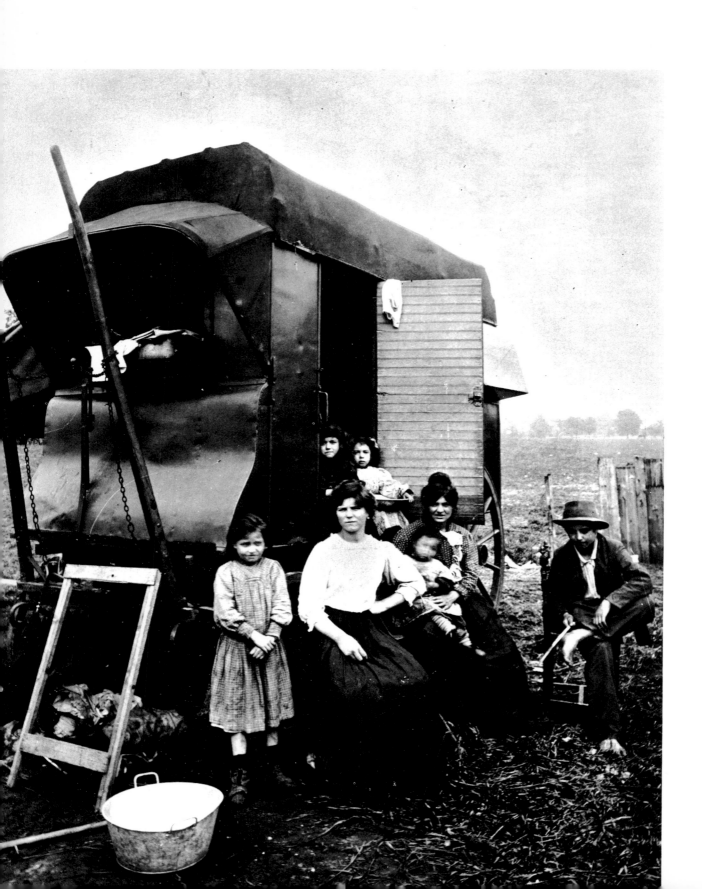

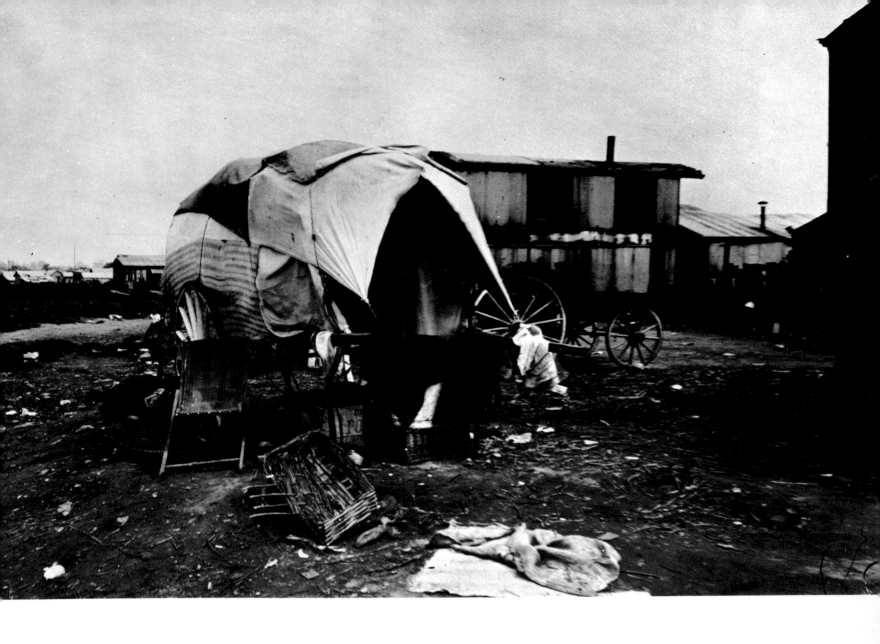

PLATE 138 / RAG-PICKERS' WAGONS

PLATE 139 / DETAIL. GARANCIERE FOUNTAIN

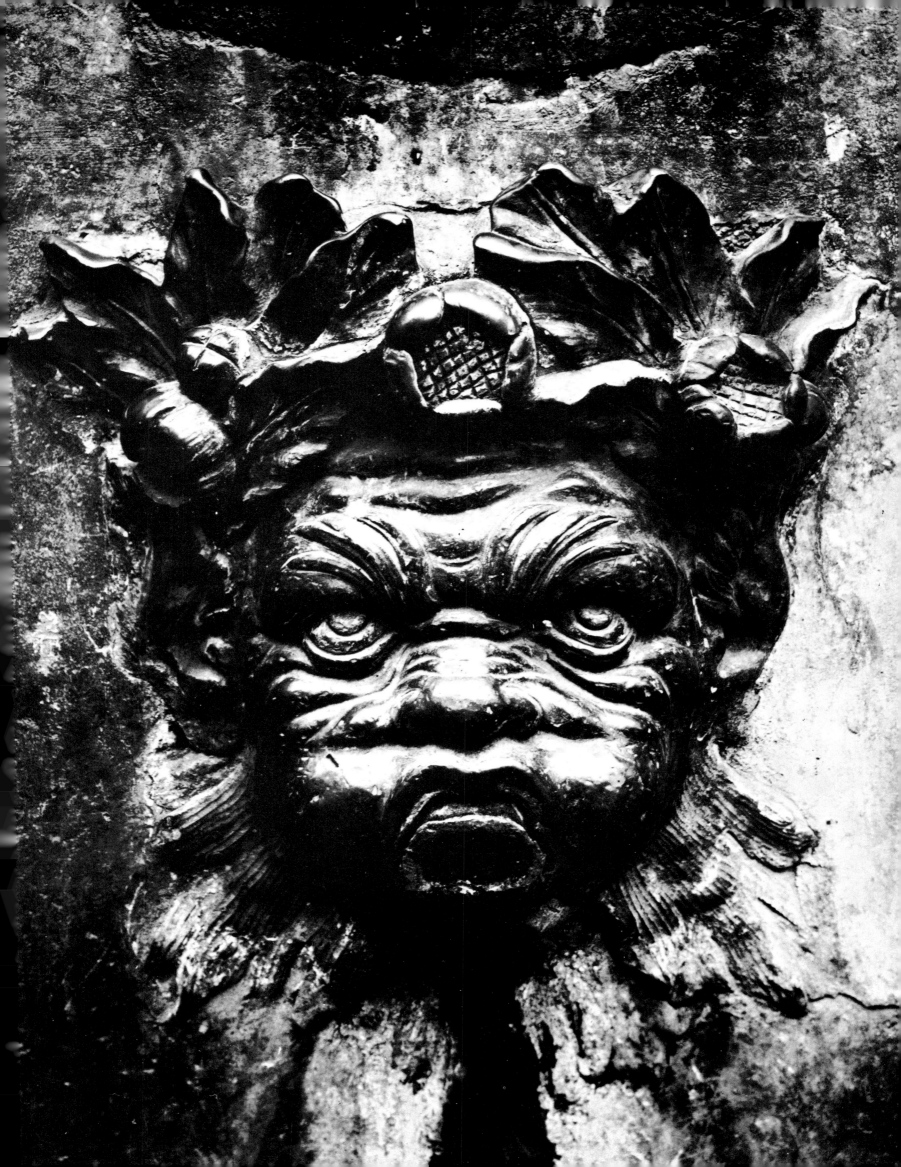

PLATE 140 / FOUNTAIN

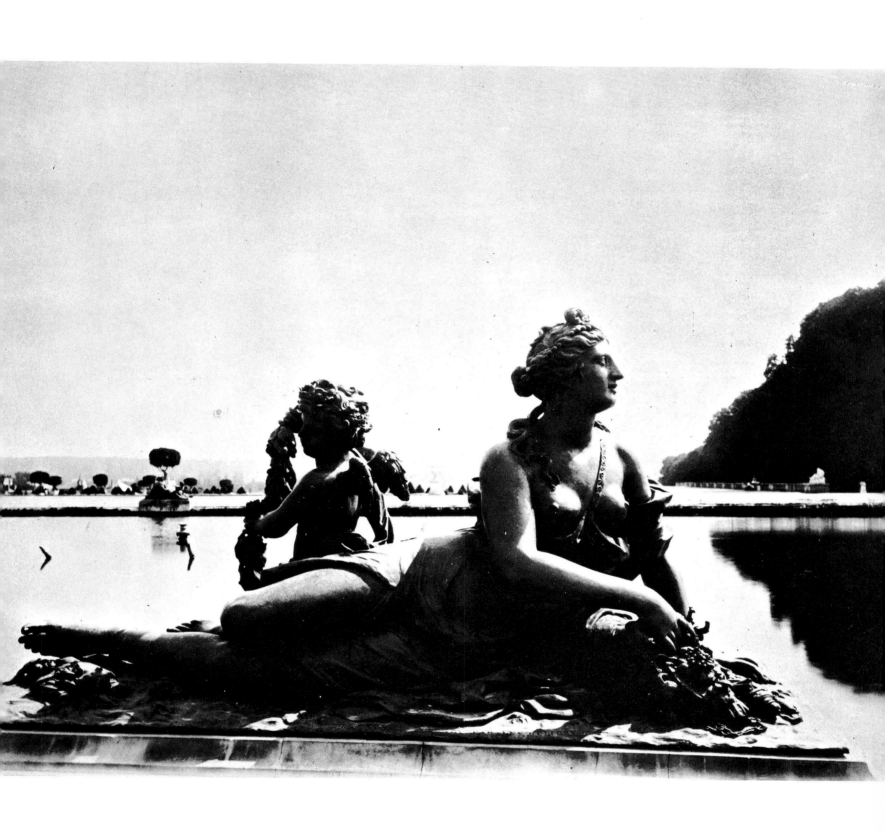

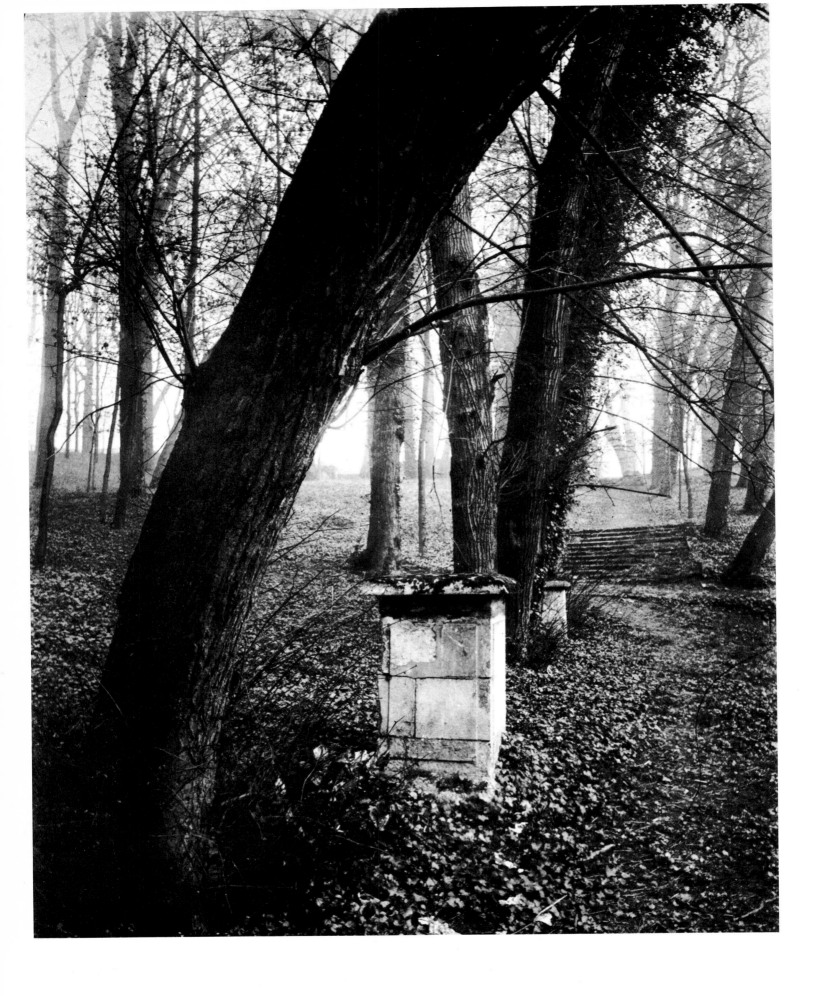

PLATE 141 / WOODS. ST. CLOUD

PLATE 142 / ROOT

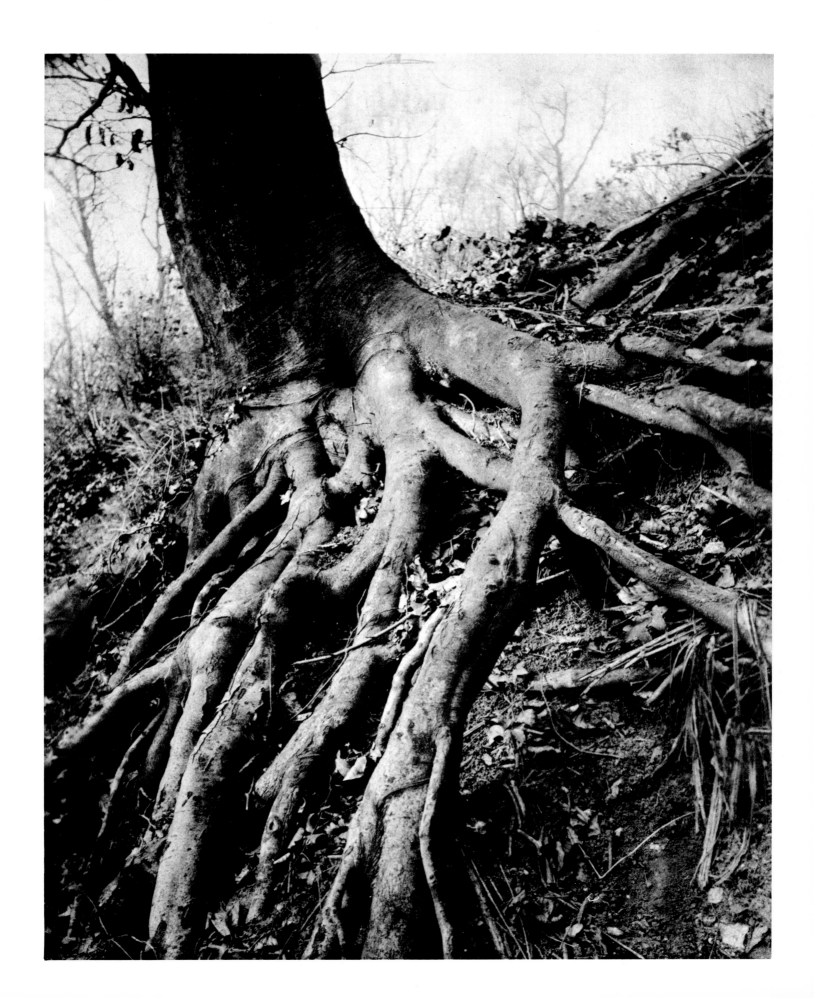

PLATE 143 / TREES. TRIANON

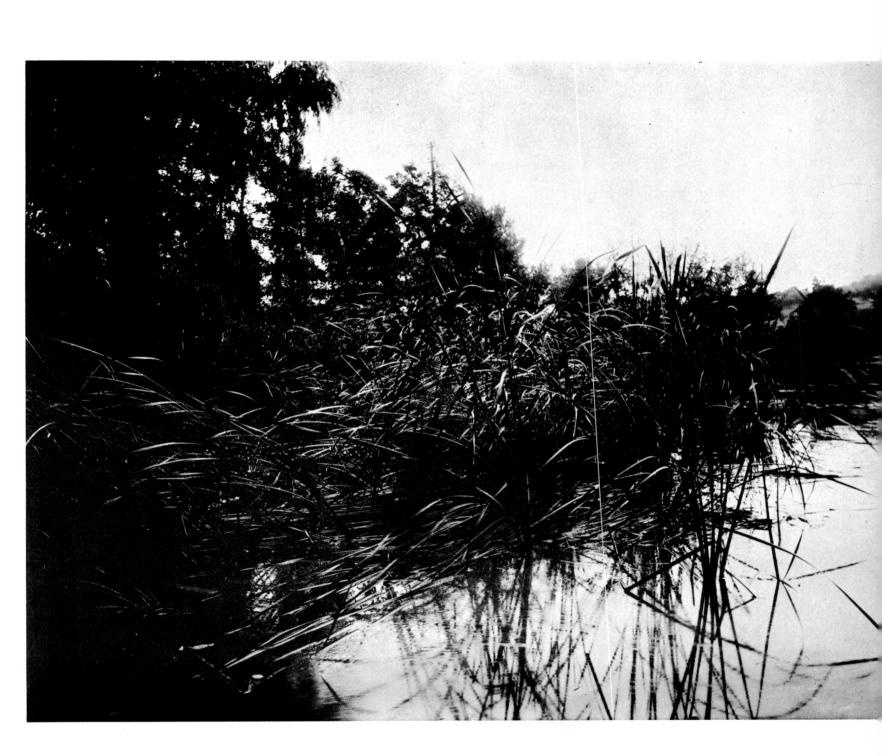

PLATE 145 / ROSES

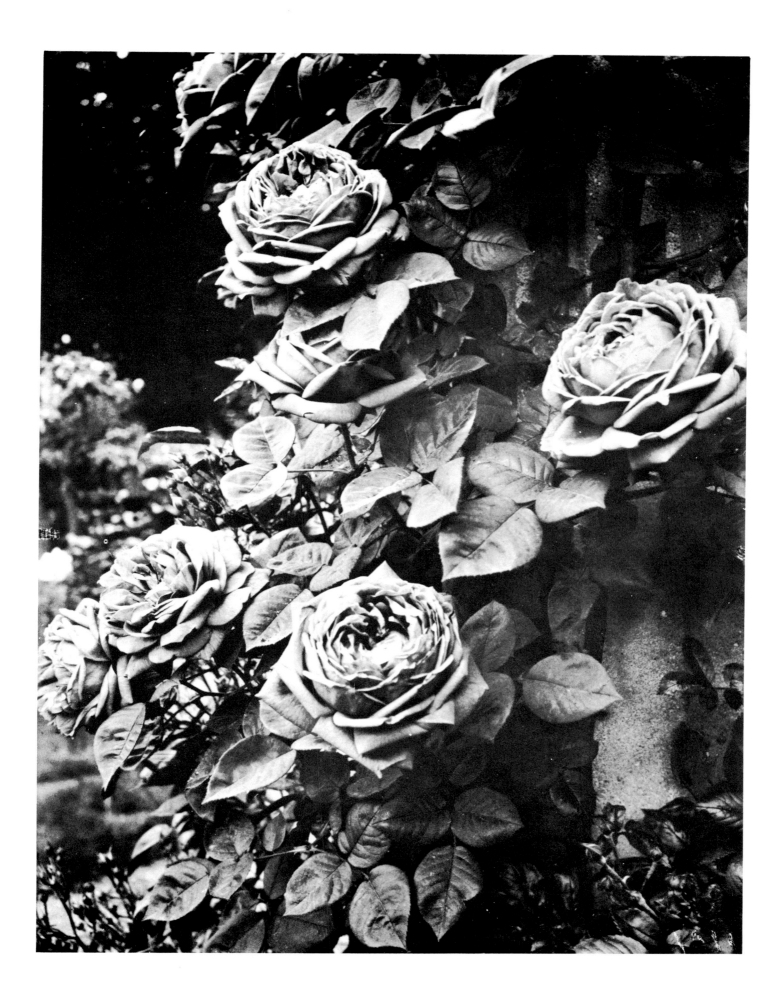

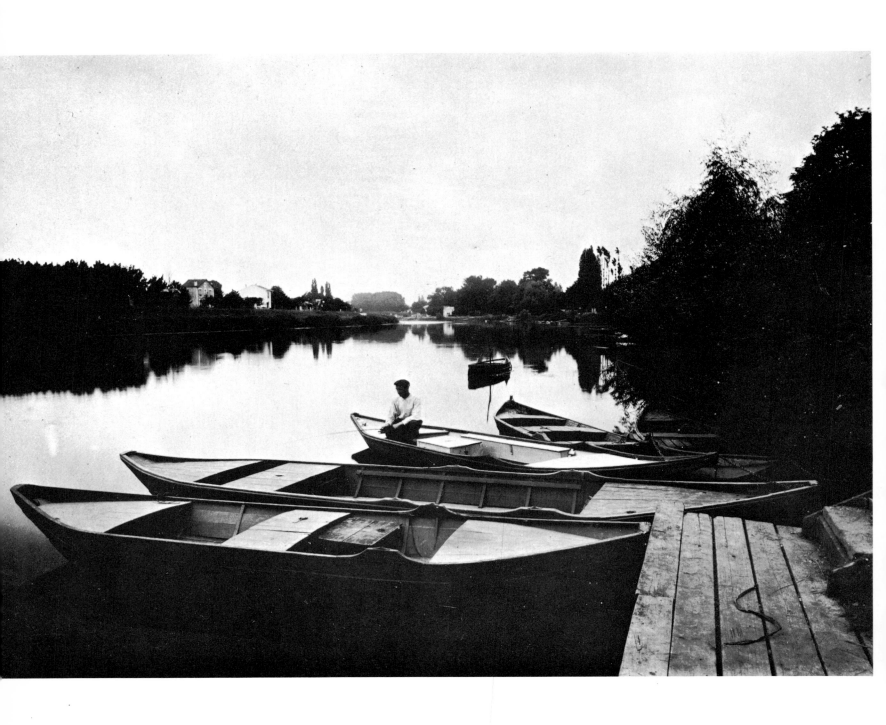

PLATE 146 / THE MARNE

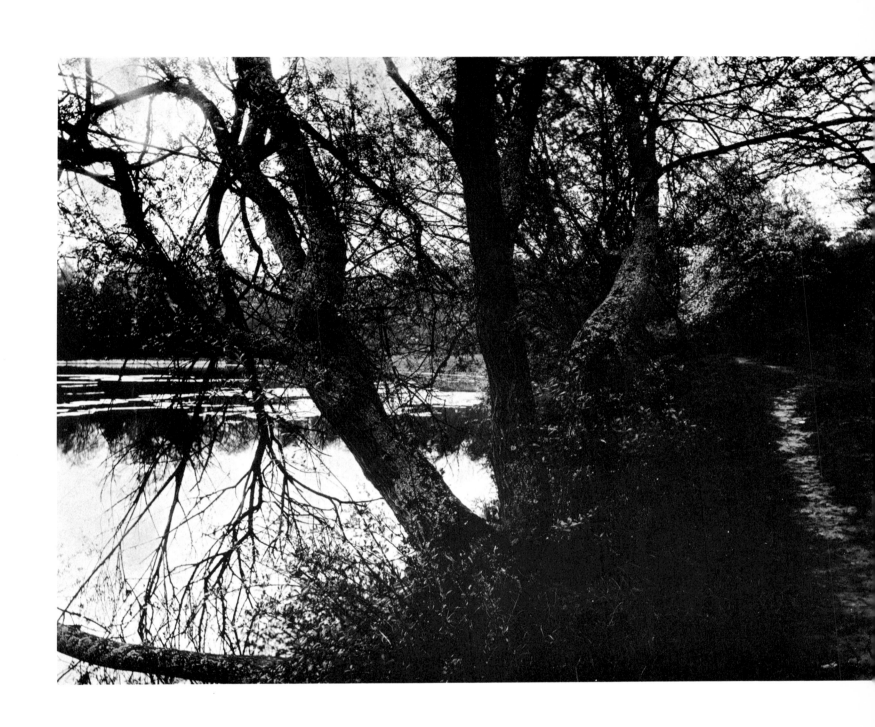

PLATE 147 / VILLE D'AVRAY

PLATE 148 / STEAM HOIST

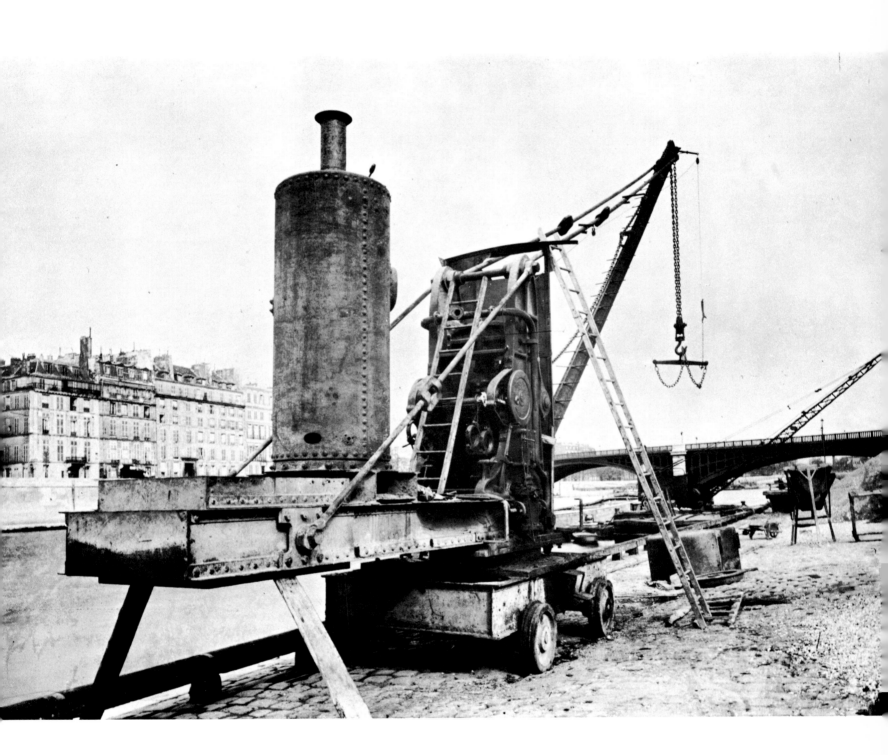

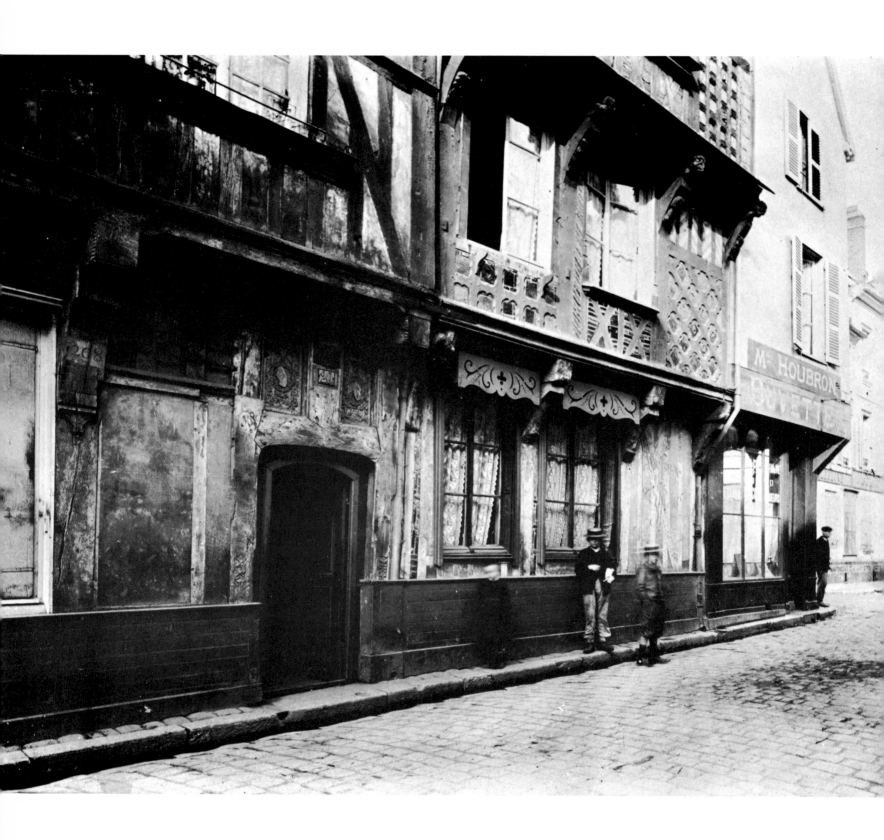

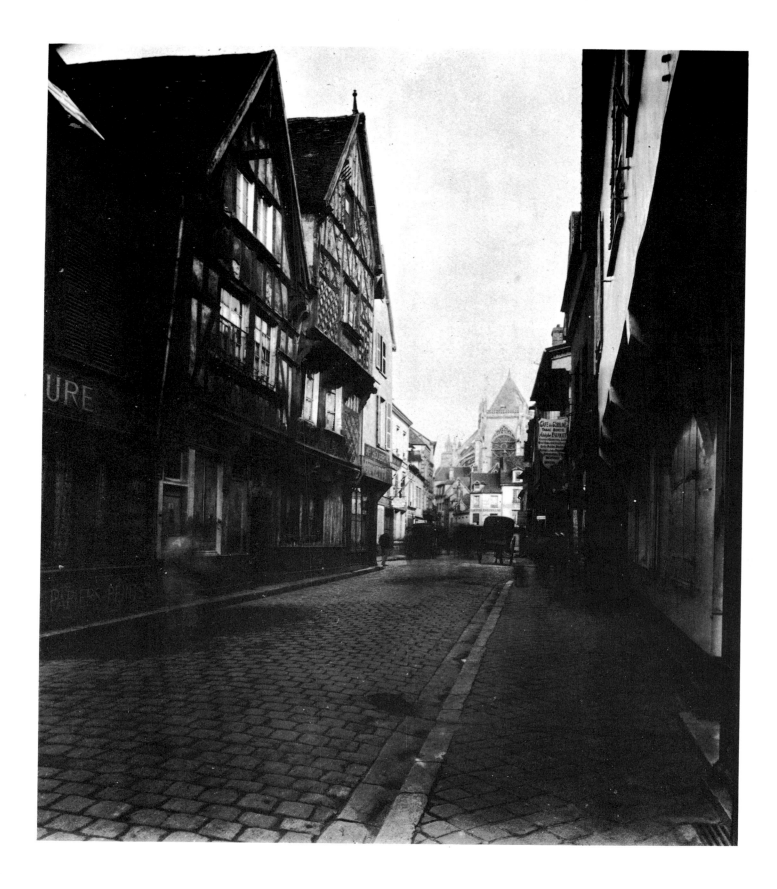

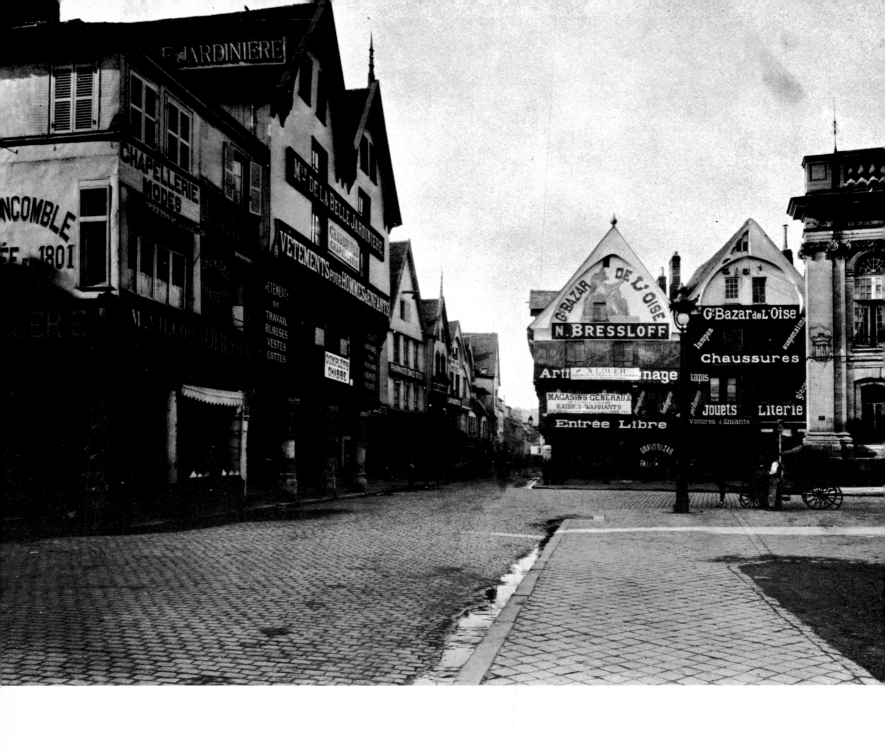

PLATE 151 / PLACE HOTEL DE VILLE. BEAUVAIS

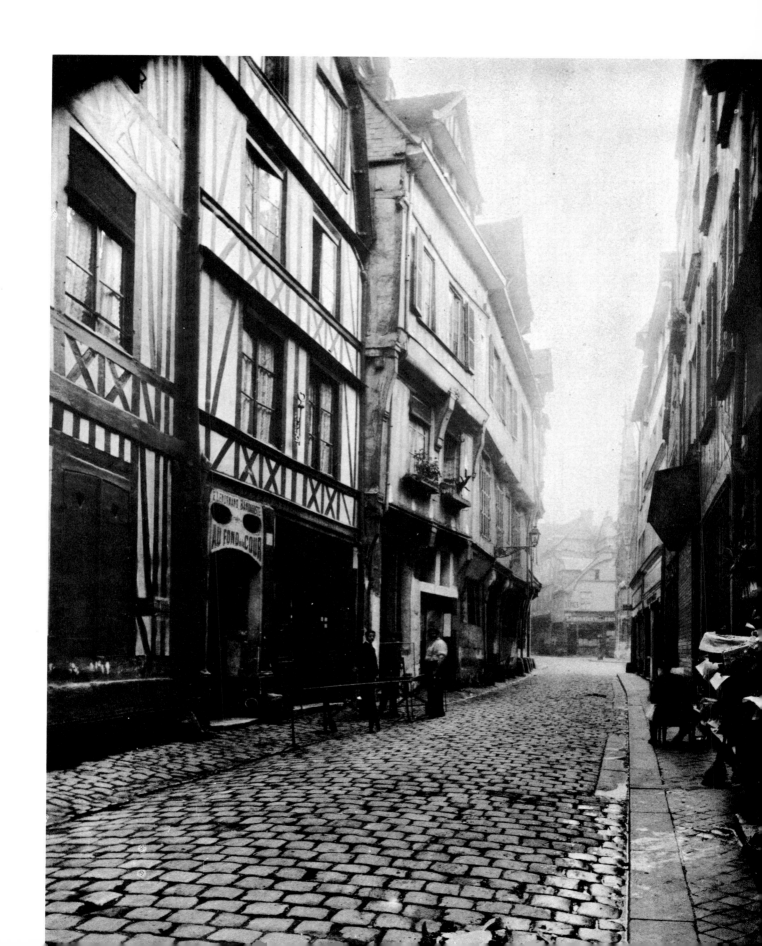

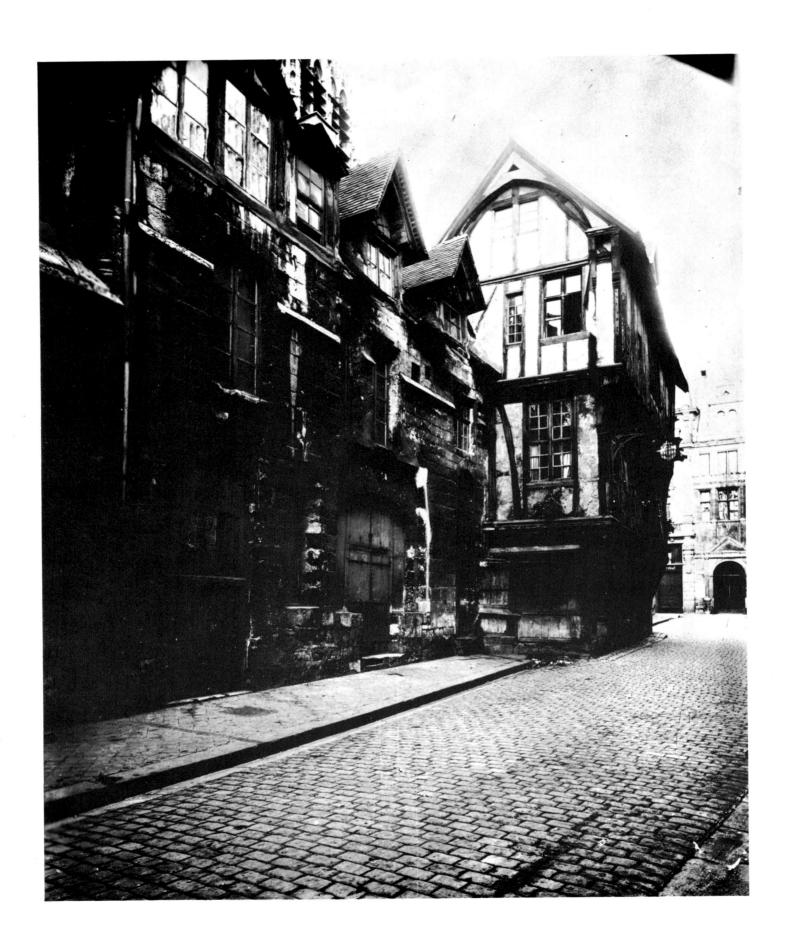

PLATE 153 / RUE ST. ROMAIN. ROUEN

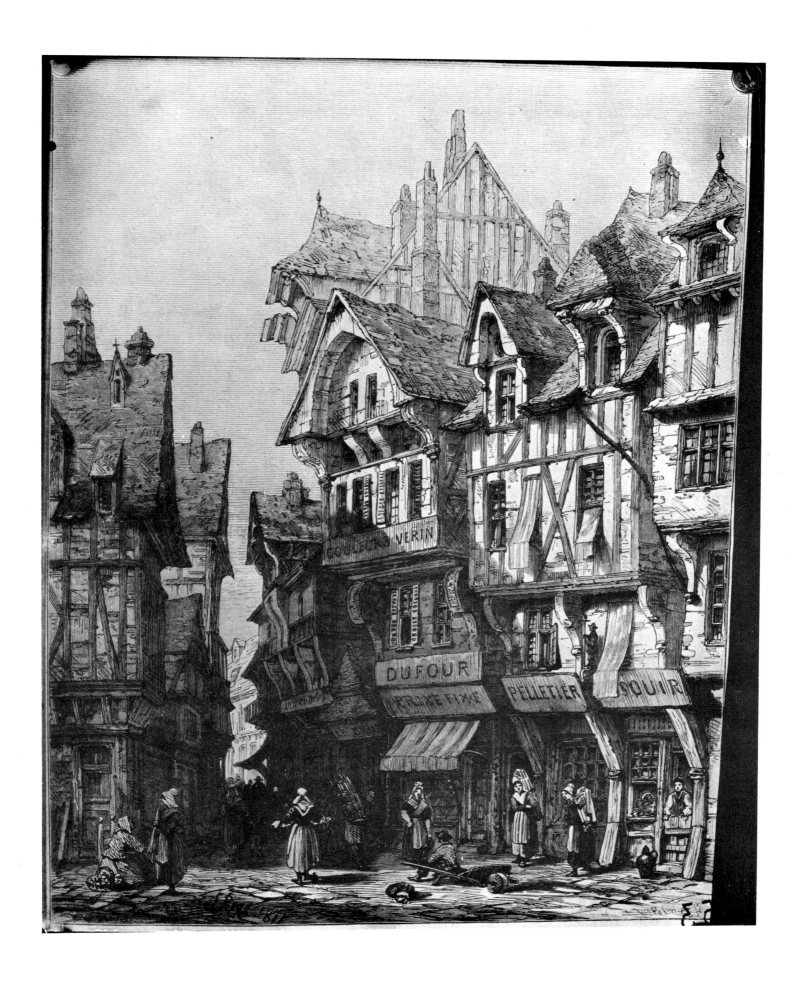

PLATE 154 / PHOTOGRAPH OF PRINT. ROUEN IN 1820

PLATE 155 / CAROUSEL

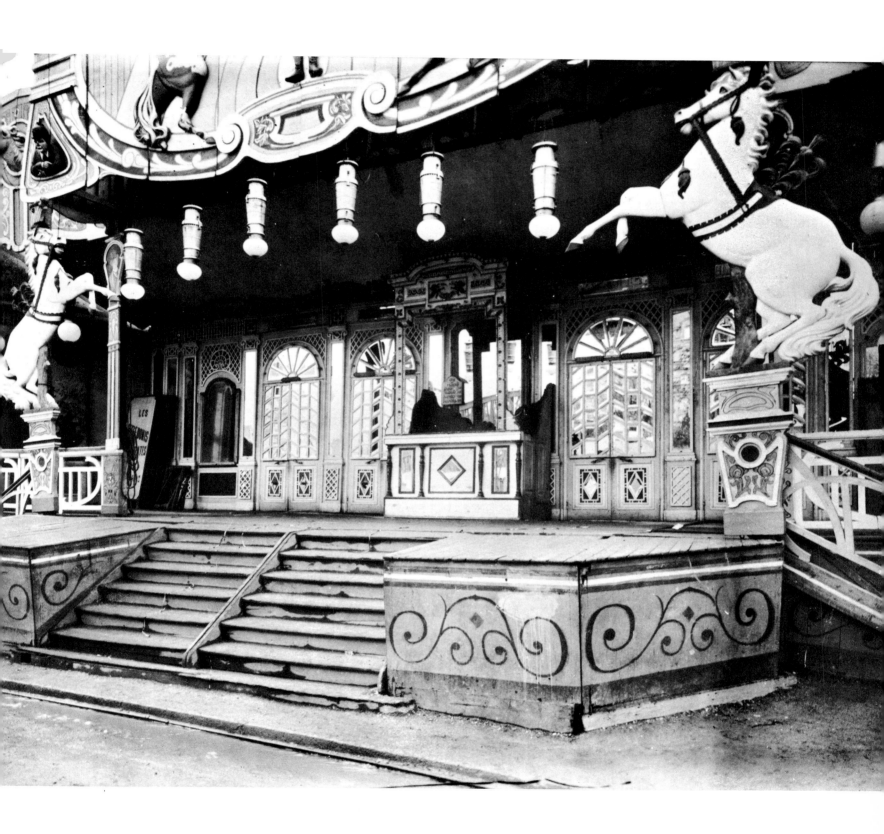

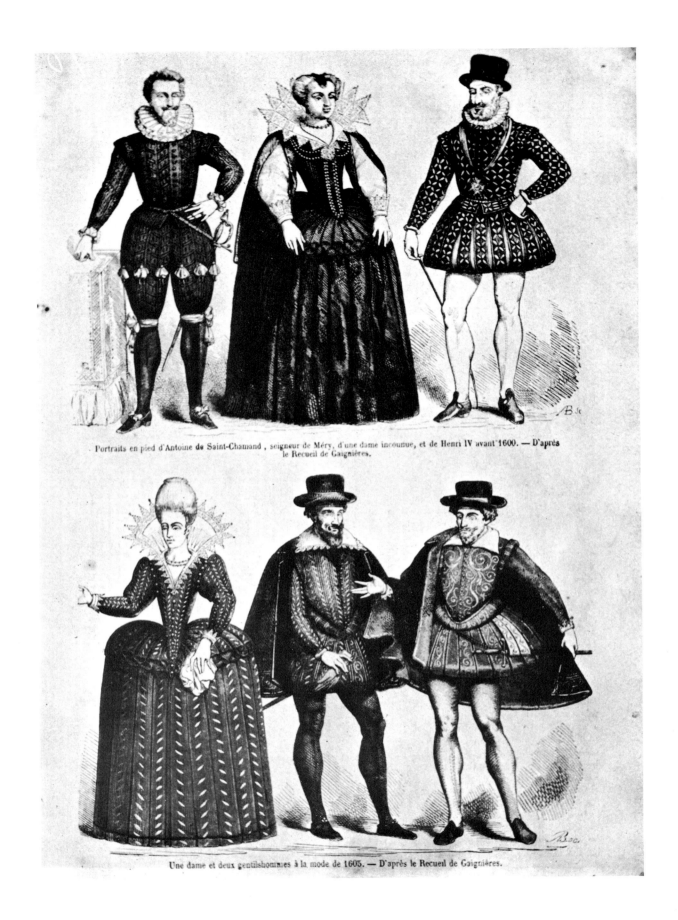

Portraits en pied d'Antoine de Saint-Chamand, seigneur de Méry, d'une dame inconnue, et de Henri IV avant 1600. — D'après le Recueil de Gaignières.

Une dame et deux gentilshommes à la mode de 1605. — D'après le Recueil de Gaignières.

PLATE 156 / PHOTOGRAPH OF PRINT. COSTUMES CA. 1600

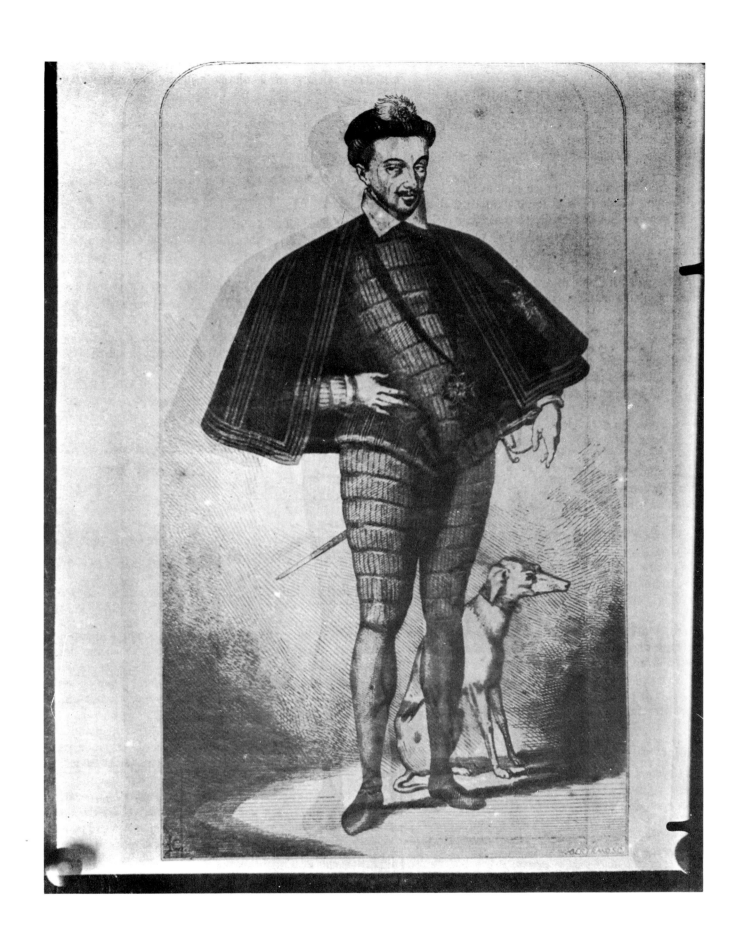

PLATE 157 / PHOTOGRAPH OF PRINT. HENRY III

PLATE 158 / GARGOYLE

PLATE 159 / SCULPTOR'S STUDIO. RUE DES LOMBARDS. COMPIEGNE

PLATE 160 / RUE ST. RUSTIQUE. MONTMARTR

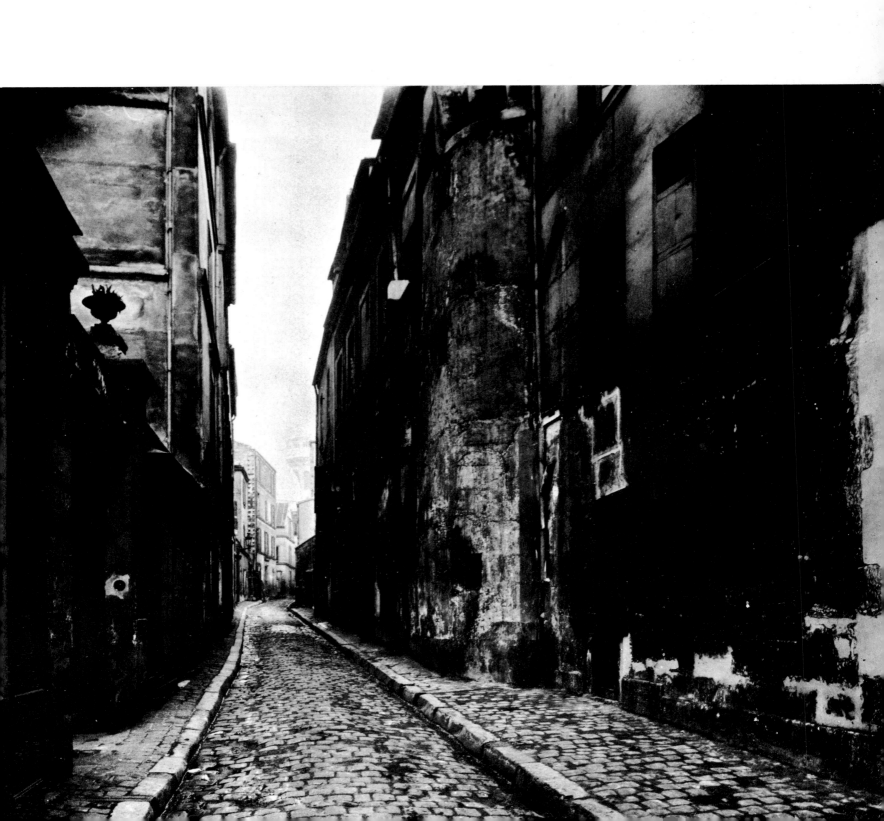

PLATE 161 / NOTRE DAME

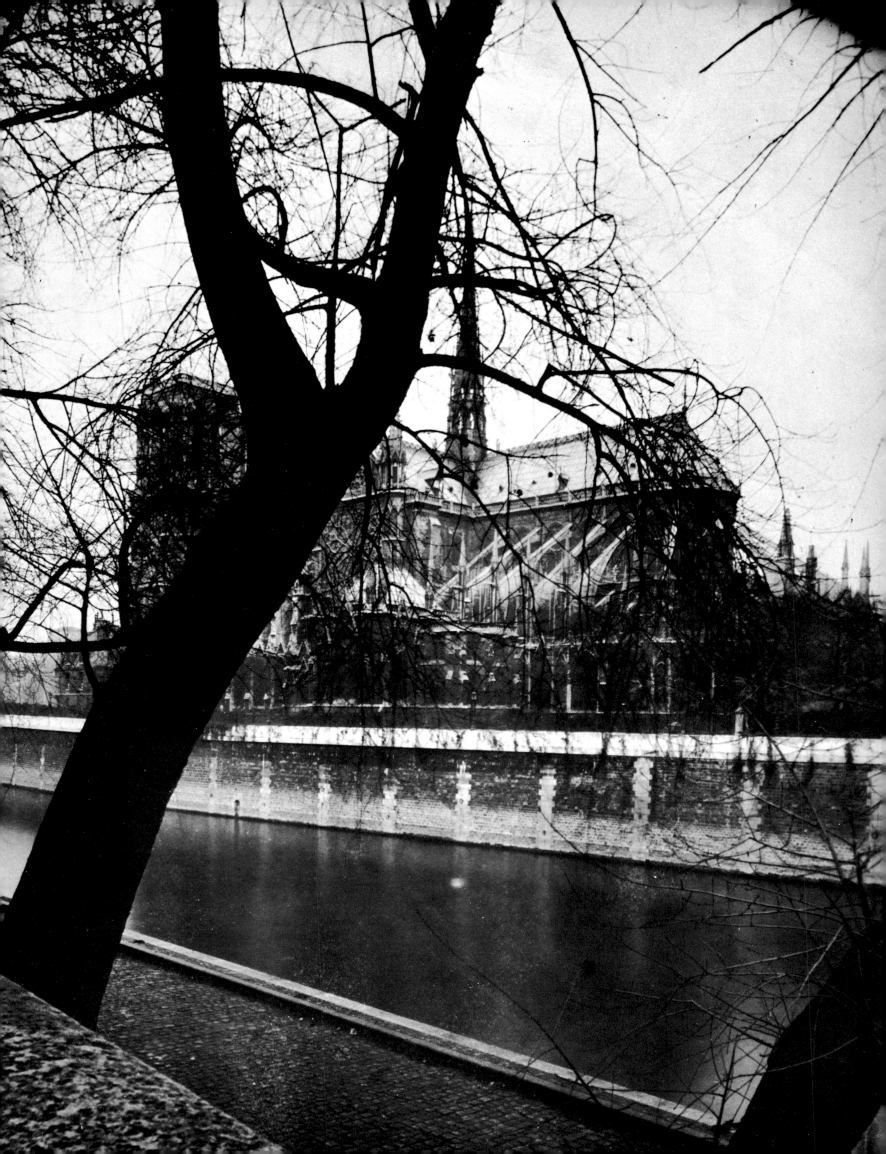

PLATE 162 / DETAIL. NOTRE DAME

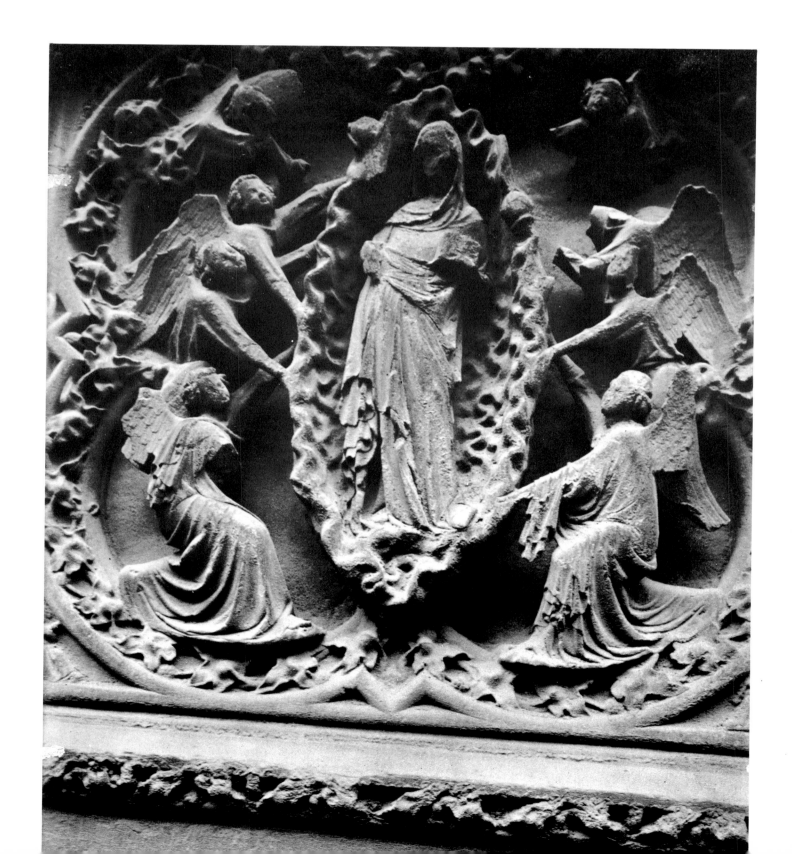

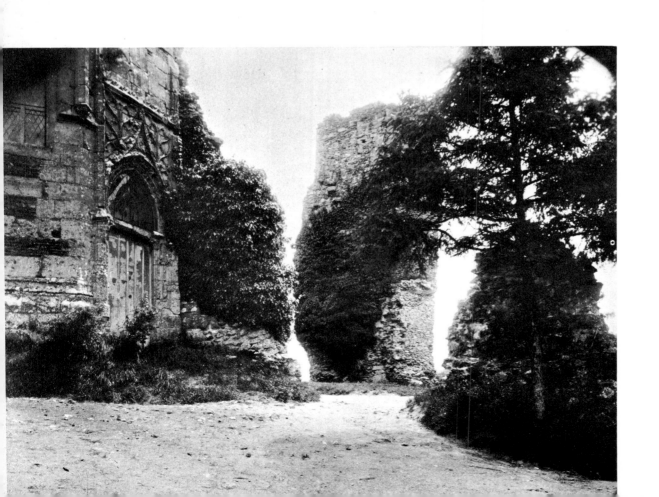

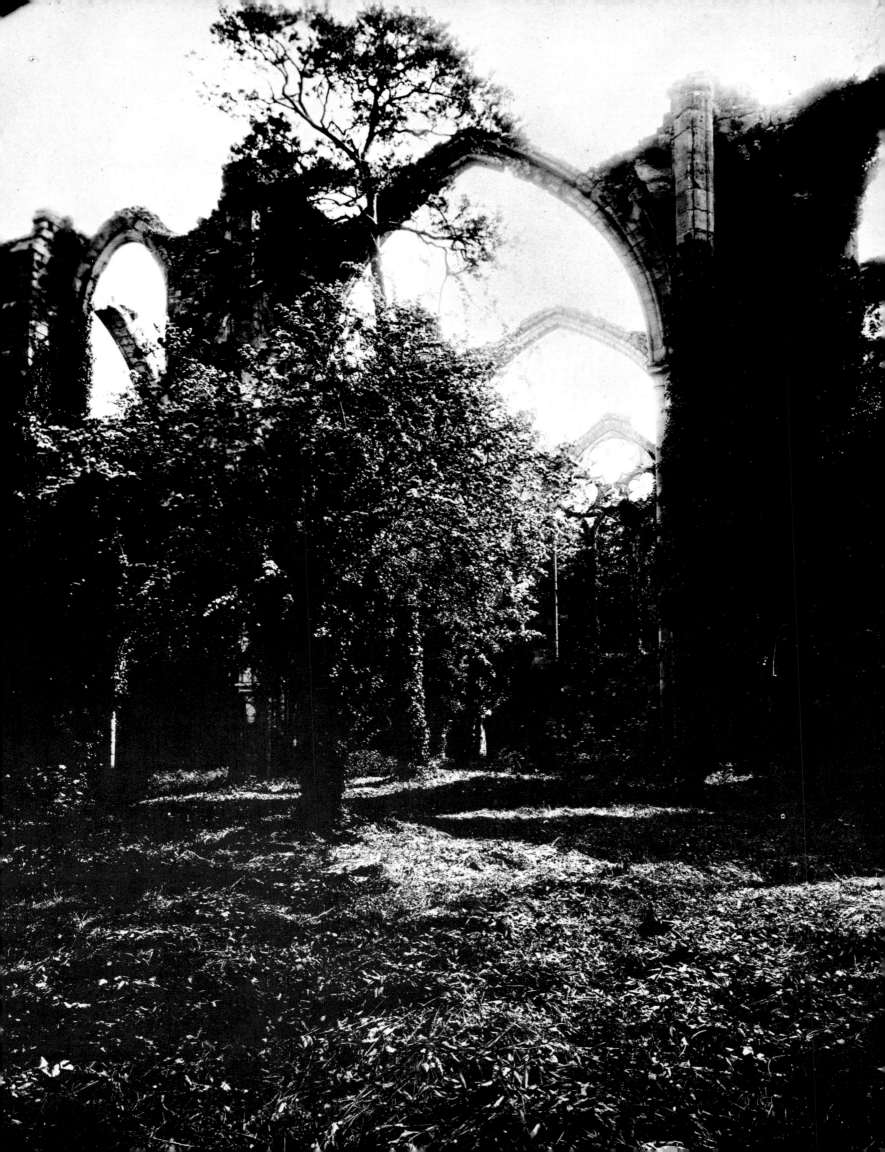

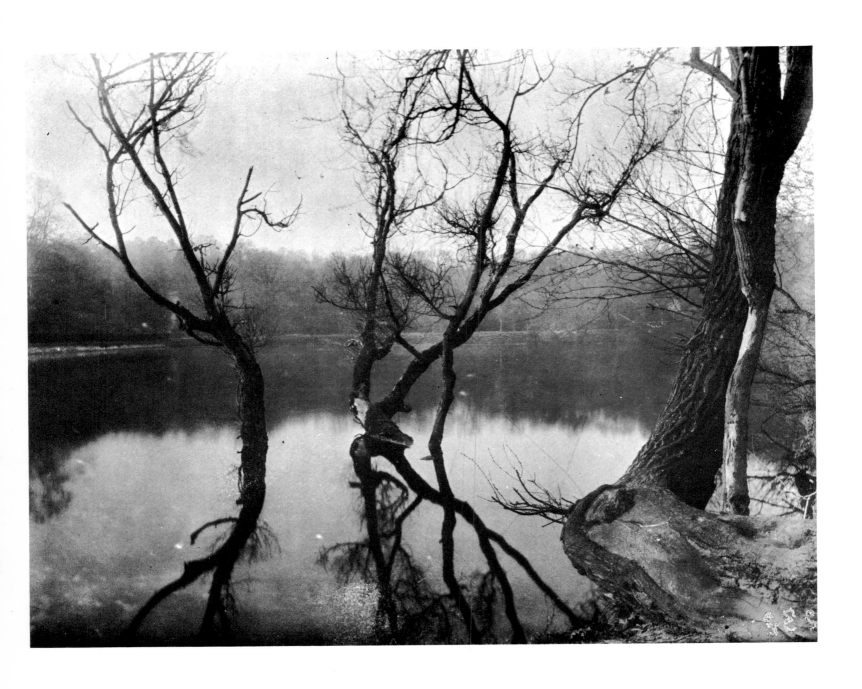

PLATE 165 / COROT'S POND

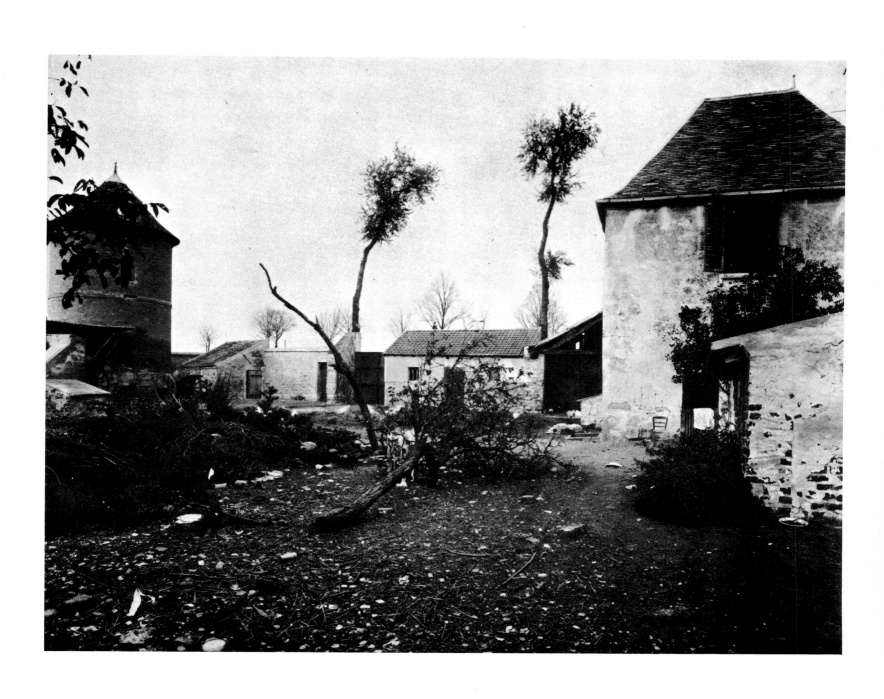

PLATE 166 / FARM QUARTER OF AN OLD CHATEAU. VILLEJUIF

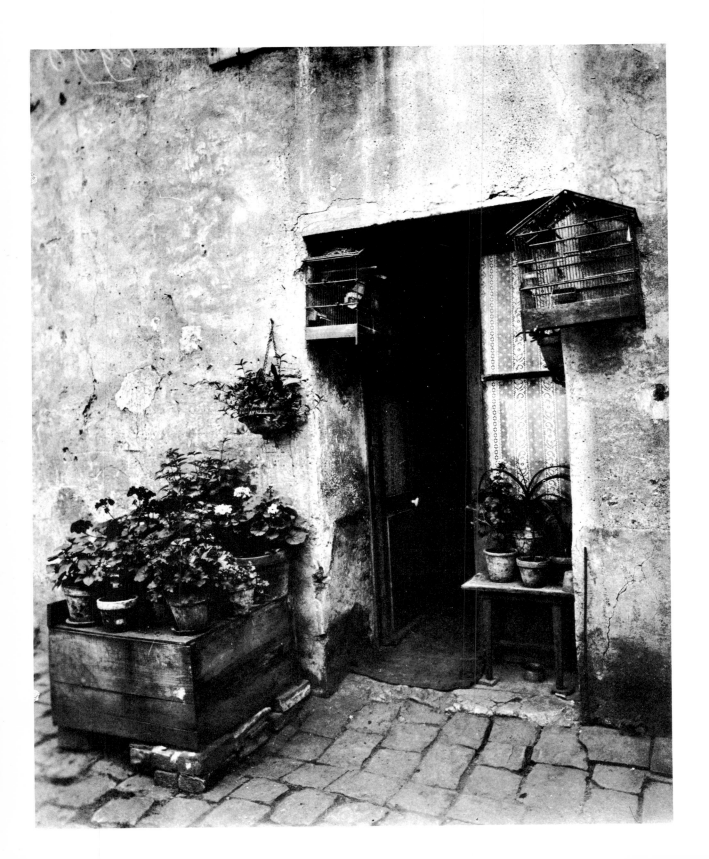

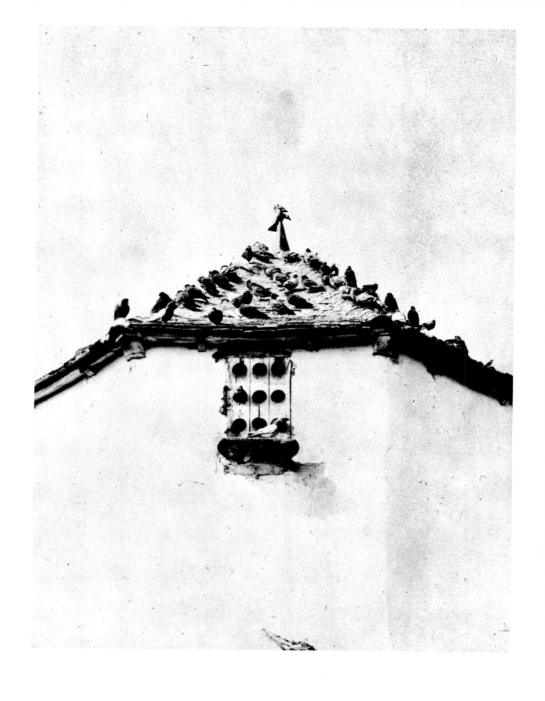

PLATE 168 / PIGEONS ON A ROOF

PLATE 169 / GROWERS

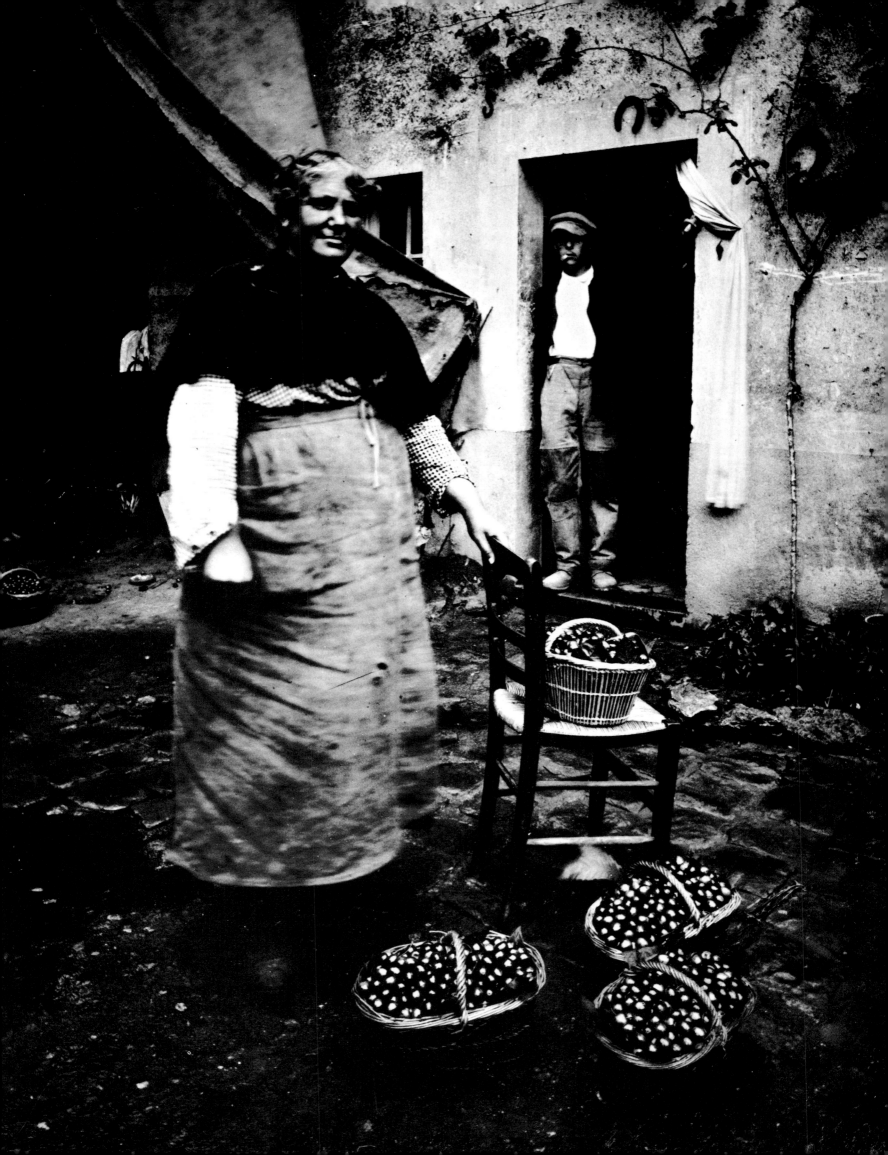

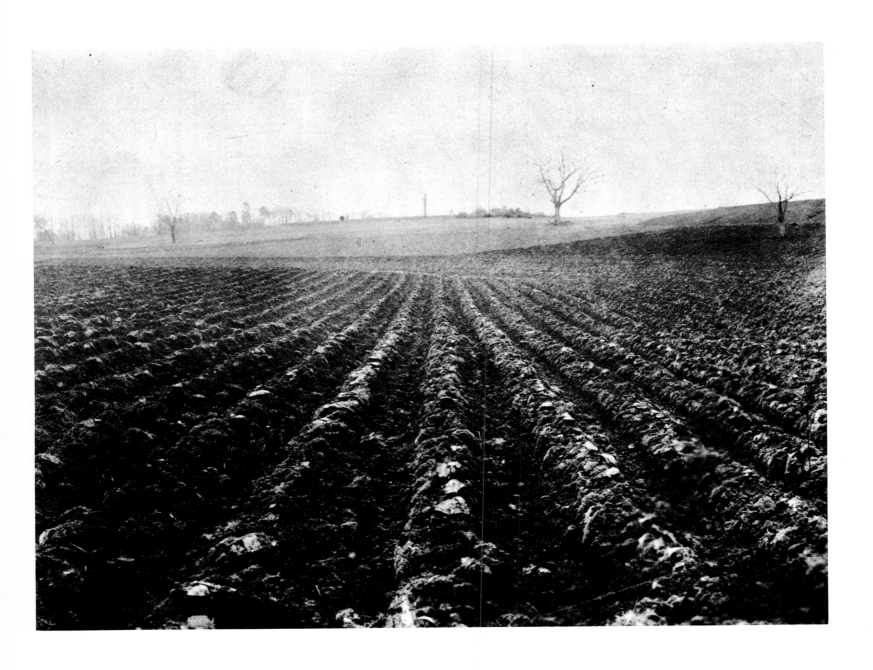

PLATE 170 / LAND. LIMOGES

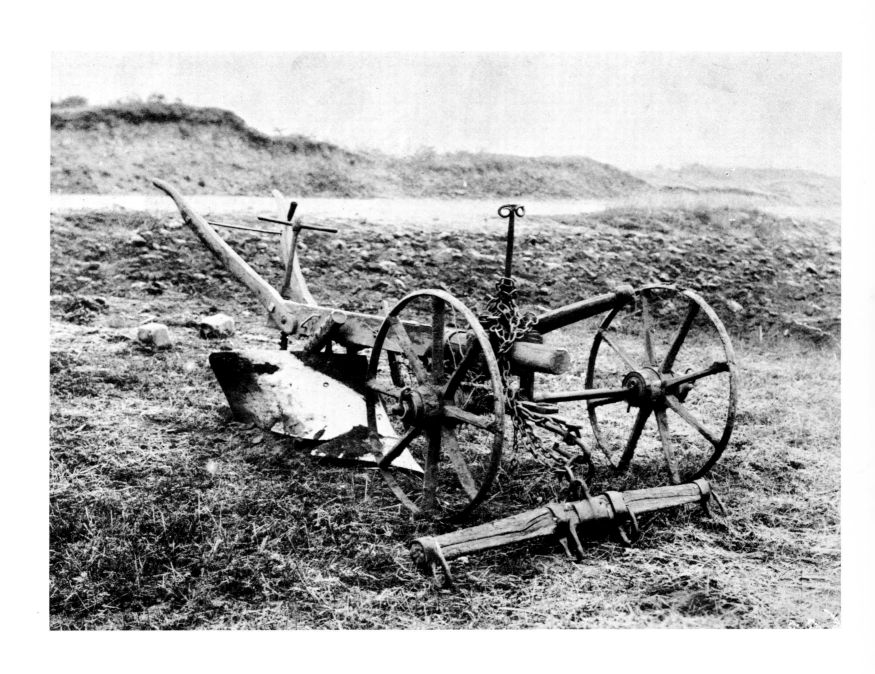

PLATE 171 / PLOUGH

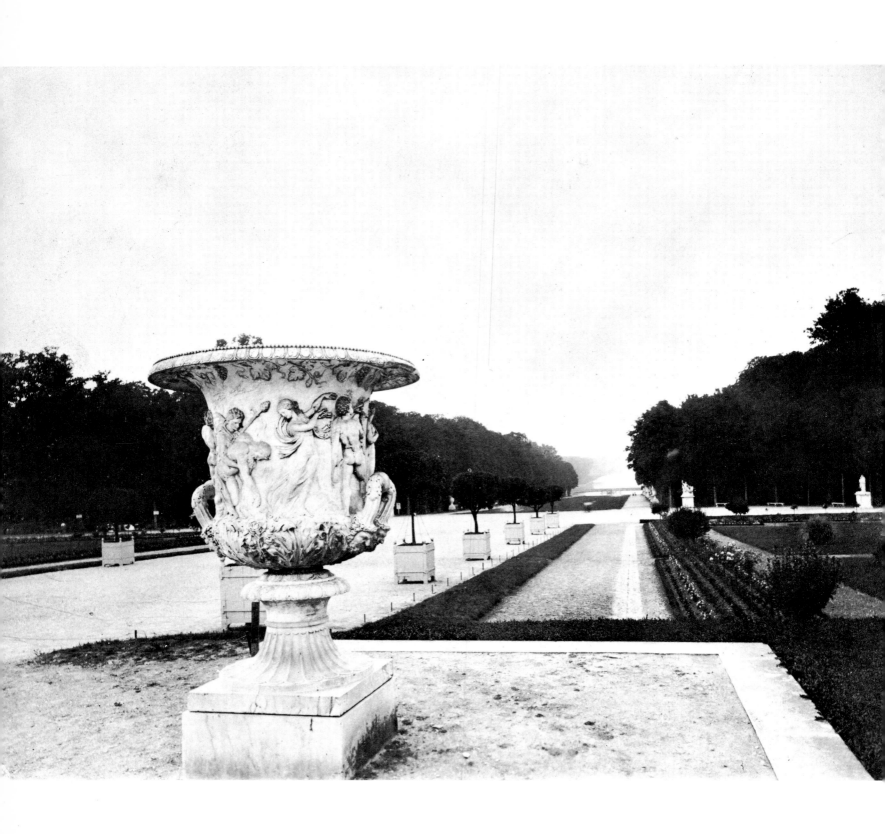

PLATE 172 / PARK. VERSAILLES

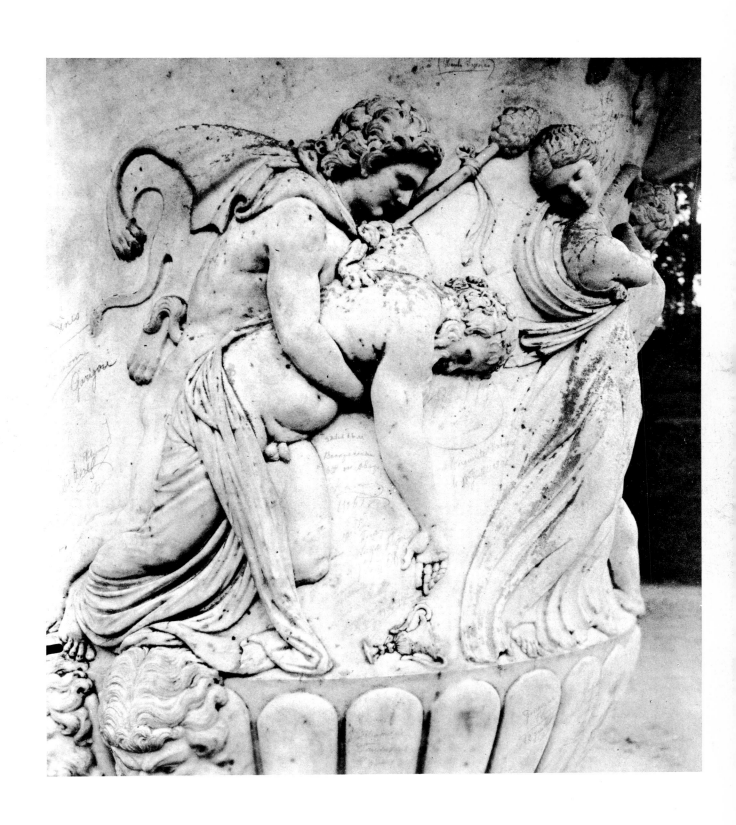

PLATE 173 / DETAIL. URN AT VERSAILLES

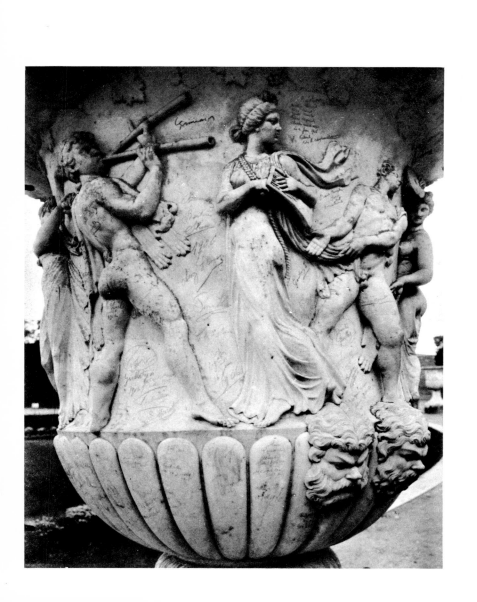

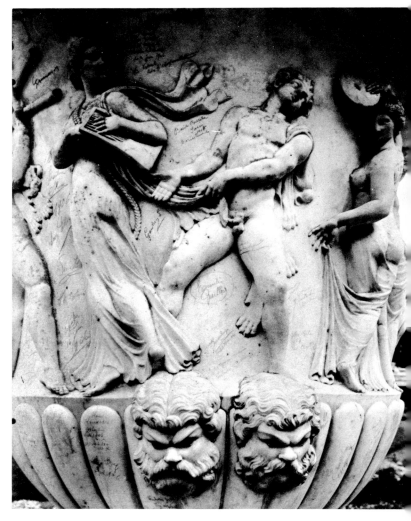

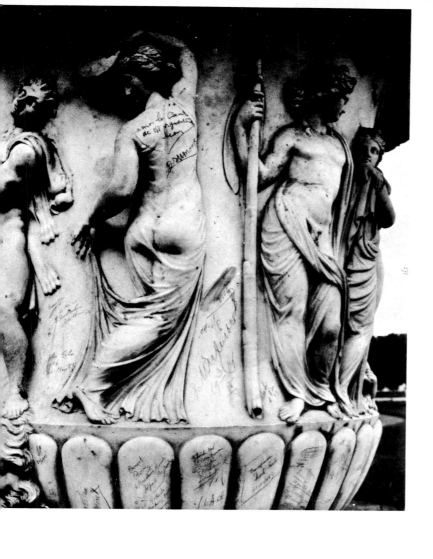

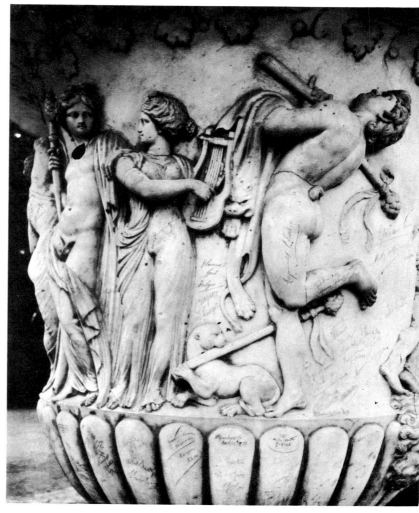

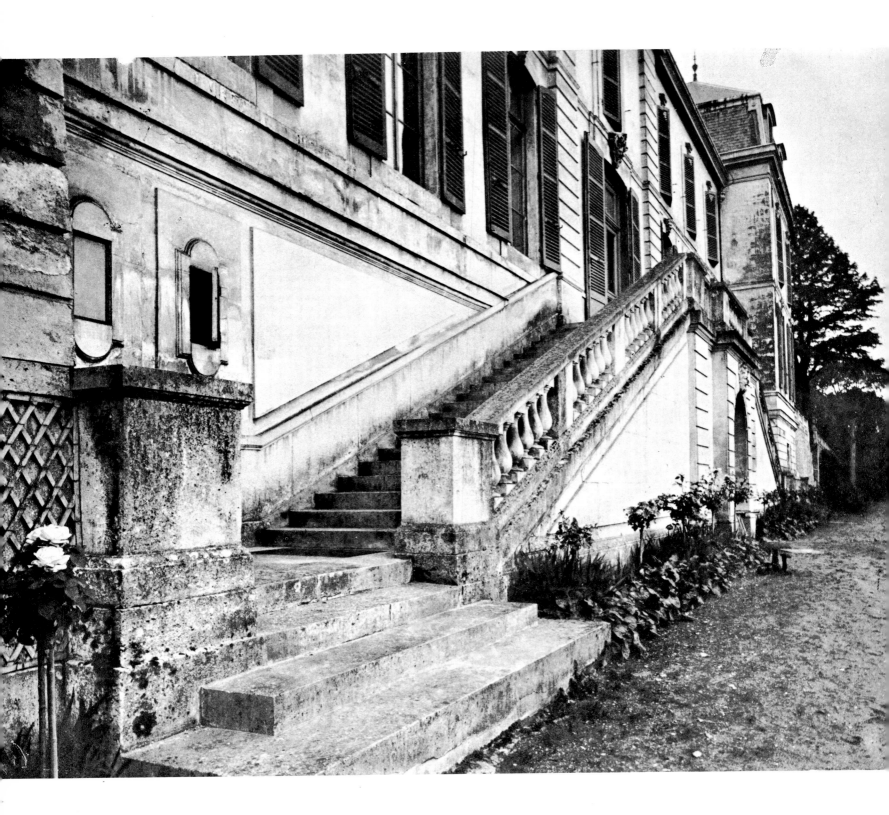

PLATE 178 / CHATEAU. ST. CLOUD

PLATE 179 / ATGET BY BERENICE ABBOTT

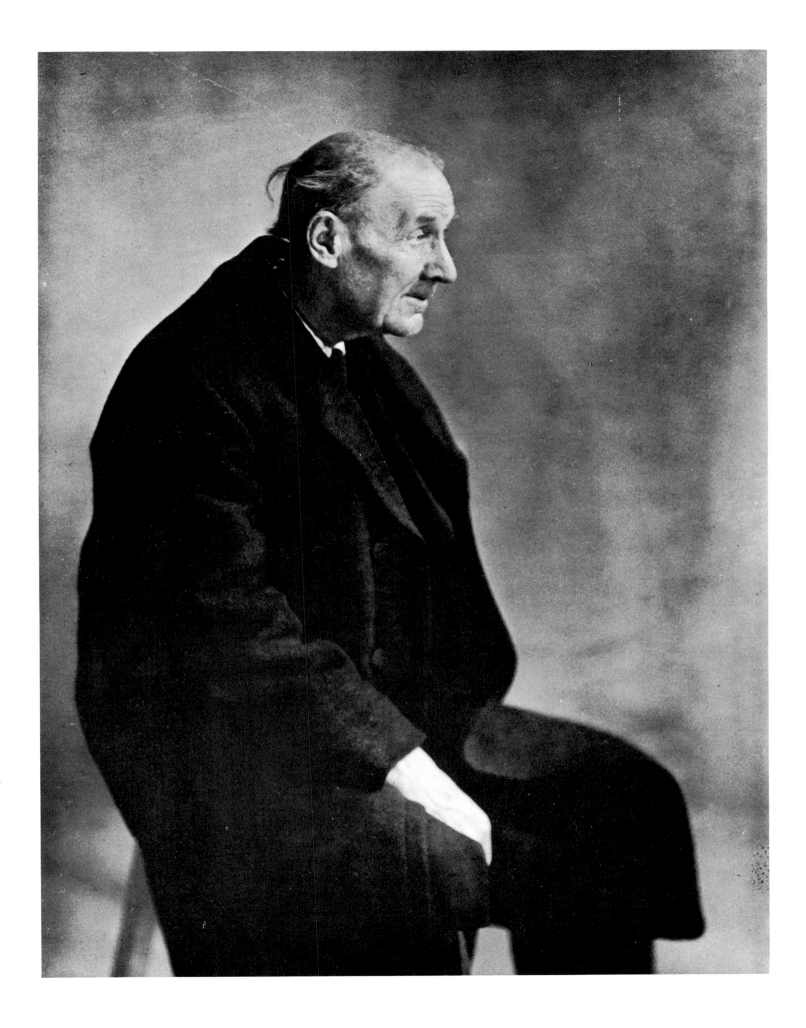

PLATE 180 / RIVER BANK. VILLE D'AVRAY

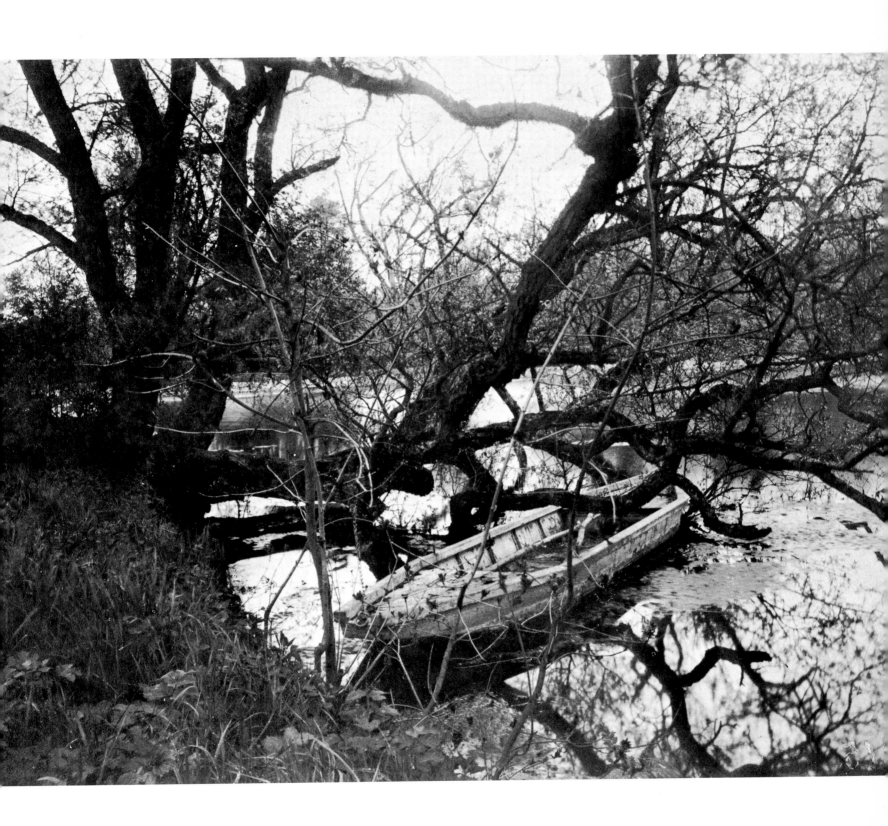

SUBJECT GUIDE

Numbers refer to the plates

INVENTORY 1983